ORIGINAL SIX DYNASTIES
DETROIT RED WINGS

BOB DUFF

ORIGINAL

Six

DYNASTIES

DETROIT
RED WINGS

BIBLIOASIS

FIRST EDITION

Library and Archives Canada Cataloguing in Publication

Duff, Bob
 Detroit Red Wings / Bob Duff.

(Original six dynasties)
Issued also in electronic format.
ISBN 978-1-927428-27-6

 1. Detroit Red Wings (Hockey team)--History. I. Title.
II. Series: Original six dynasties

GV848.D4D93 2013 796.96'2640977434 C2012-901785-X

Edited by Dan Wells
Copy-edited by Tara Murphy
Typeset by Chris Andrechek

Biblioasis acknowledges the ongoing financial support of the Government of Canada through the Canada Council for the Arts, Canadian Heritage, the Canada Book Fund; and the Government of Ontario through the Ontario Arts Council.

PRINTED AND BOUND IN THE USA

Contents

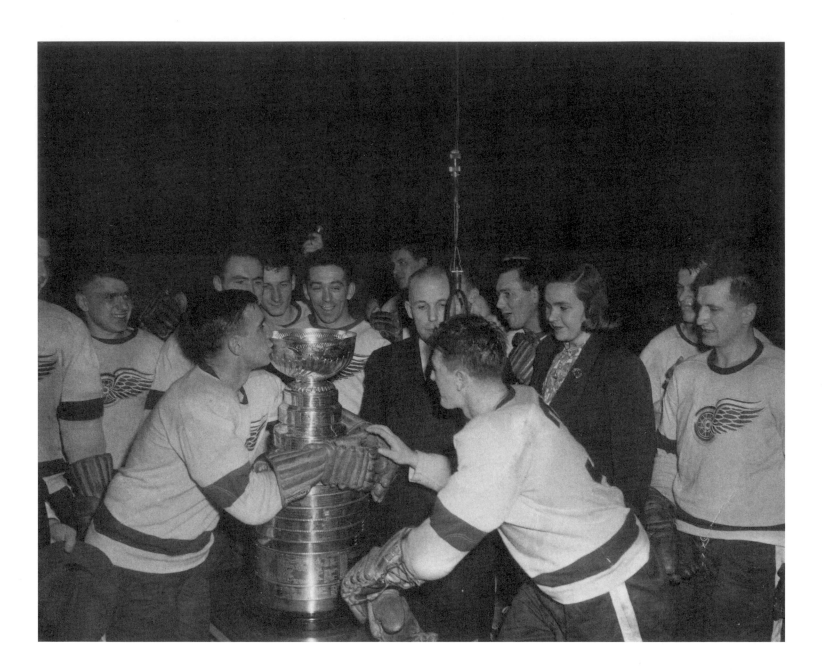

Introduction

THE NATIONAL HOCKEY LEAGUE entered a new era of play in the fall of 1942. The Detroit Red Wings entered this era as one of the league's elite clubs, and as a club with something to prove.

The Wings had played in the Stanley Cup final in each of the previous two springs, only to come up short. Detroit dropped a four-game sweep at the hands of the Boston Bruins in 1940-41, but the pain from that setback would prove minor compared to the hurt they'd feel in 1941-42. Racing to a 3-0 series lead against the favoured Toronto Maple Leafs, the Wings then dropped four straight games, the first time in Stanley Cup history and the only time to date in a final series that a team squandered a 3-0 advantage to drop a best-of-seven-set.

1942-67 was the golden era of Original Six hockey, when the NHL existed with the same six clubs: the Detroit Red Wings, the Toronto Maple Leafs, the Montreal Canadiens, the New York Rangers, the Boston Bruins and the Chicago Blackhawks. The period had the longest consistent tenure of solid membership in league history. And it began, perhaps unsurprisingly after their losses in 1941-42, with the Red Wings on a mission.

The Wings rolled to a first-place finish with a 25-14-11 slate in 1942-43 and just kept rolling through the playoffs, avenging their 1941 defeat by sweeping the Bruins in the Cup final series. As would be the case with all of Detroit's championship clubs of the six-team era, this squad was led by a Howe. Centre Syd Howe, who like his namesake Gordie Howe would finish his career as the NHL's all-time scoring leader, led the 1942-43

Wings with 35 assists and 55 points. Between the pipes, Johnny Mowers posted six shutouts—one more than the other five NHL teams combined—won the Vezina Trophy and was named to the NHL's First All-Star Team.

The landscape of the NHL was altered dramatically over the next few seasons, however, as many veteran players enlisted in the armed forces to help with the effort of World War II, causing skeptics to suggest that NHL stood for "Nursery Hockey League."

Though the teams didn't change, the dearth of talent led to some wild contests, many of them involving the Red Wings and the Rangers. Detroit blasted the New Yorkers 15-0 on January 23, 1944. Connie Dion kept the sheet clean for the Wings, while Rangers' goalie Ken McAuley fished all 15 pucks out of his net in what stands today as the most lopsided shutout score in league history. Eleven days later, Howe put six pucks past McAuley in a 12-2 drubbing of the Rangers. In the annals of the NHL, only Joe Malone of the Quebec Bulldogs (seven) on Jan, 31, 1920, has ever scored more times in a single game.

Steadily, the Wings introduced a series of new-comers into their midst who would all go on to enjoy Hall of Fame careers and would provide the nucleus for the club's next dynasty. "A bunch of us came in together and we had a strong sense of friendship," recalled defenceman Red Kelly. Goalie Harry Lumley

and defenceman Bill Quackenbush made their NHL debuts in 1943-44. At 17, Lumley was the youngest goaltender in league history. The next season, a gritty left-winger named Ted Lindsay jumped right from the junior ranks into the Detroit line-up. In the fall of 1946, another strapping youngster joined the fold, a right-winger named Gordie Howe. "He's the best prospect I've seen in 20 years," remarked Detroit coach-GM Jack Adams.

In 1947-48, Kelly followed Lindsay's lead and jumped directly from junior to the Wings. That season, Lindsay's star really began to emerge, as he led the NHL with 33 goals, earning a berth on the league's First All-Star Team as Detroit returned to the Stanley Cup final, only to be swept by Toronto.

The Wings were on top of the league in 1948-49, finishing first overall, but again fell to the Leafs in four straight games in the Cup final series. Team captain Sid Abel, one of the few veterans who would remain from the previous Detroit era, won the Hart Trophy that season. The following season Detroit welcomed two more future Hall of Fame rookies in goalie Terry Sawchuk and defenceman Marcel Pronovost, finished first, and won the Stanley Cup in a dramatic seven-game series with the Rangers (Pete Babando scoring the Cup winner after 28:21 of overtime). That season, linemates Lindsay, Abel and Howe—dubbed the Production Line—finished 1-2-3 in scoring, the only

time that a Stanley Cup champion suited up the NHL's top three scorers.

Coach Tommy Ivan had first combined Abel's veteran savvy with the prototypical power forward Howe and the irascible Lindsay during the 1947-48 season, and they were an instant hit. "We'll keep them together as long as they keep going," Ivan said at the time. Howe felt the unit was a natural fit. "We could all carry the puck, we could all skate and check and we could all make plays," Howe explained.

The 1950 Cup win came despite the near-tragic loss of Howe, who suffered serious head injuries after falling into the boards while looking to check Toronto captain Teeder Kennedy in the opening game of the Stanley Cup semi-final series between the two teams. Howe suffered a lacerated eyeball, fractured nose and cheekbone, and a concussion that required surgery to relieve pressure on his brain. Originally listed in critical condition, he pulled through and was able to attend the deciding game of the final series in street clothes. "They still won the Cup, even with Gordie Howe out of the line-up," Adams noted in the victorious dressing room. "That's like taking a .400 hitter out of the World Series."

Adams believed that successful teams had a shelf life of five years and he was in the process of reworking his late 1940s roster. He dealt away Quackenbush to Boston in 1949, feeling Kelly was ready to take on a more major role, and the arrival of Sawchuk and Pronovost made Lumley and defenceman (Black) Jack Stewart expendable. In 1950, they were traded to Chicago.

The 1950-51 Red Wings finished first for the third season in succession, establishing NHL marks for wins (44) and points (101) as centre Alex Delvecchio, another future Hall of Famer, joined the club and Gordie Howe set an NHL record with 86 points—but it was the 1951-52 team that would go down in history as perhaps the NHL's best-ever squad.

That year the Wings equaled their NHL marks for wins and points, becoming the only franchise during the NHL's first 54 seasons to post consecutive 100-point campaigns. Howe scored 47 goals and once more led the league in scoring with 96 points. The team assembled a club record 15-game unbeaten streak from November 27 through December 28 and a 10-0-5 road unbeaten streak from October 18 to December 20. The Wings lost consecutive games just once all season long.

Howe won the Hart Trophy to go with his second straight Art Ross Trophy, Sawchuk earned the Vezina Trophy, and those two plus Kelly and Lindsay were all named to the NHL's First All-Star Team, but the biggest prize would be captured in record fashion. Detroit became the first team to sweep to the Stanley Cup in the minimum eight games, led by Sawchuk,

9

who posted four shutouts on home ice and finished post-season play with an amazing 0.63 goals-against average and an astonishing .977 save percentage. Adams described his team as "the greatest in hockey" and no one was about to argue the point. "We had such chemistry on that team, I really think we could have played all summer and we would have just kept winning," Wings forward Marty Pavelich said.

Preparing to attend Game 4 of the final series at Olympia Stadium, Detroit fishmongers Pete and Jerry Cusimano decided to bring a special guest to the rink—an octopus. They reasoned that the eight tentacles of that mollusc represented the eight wins required to lift the Stanley Cup. When the Wings opened the scoring, Pete reached under his seat and threw the octopus onto the ice, launching a Detroit playoff tradition that continues today.

Another first-place finish followed in 1952-53, as Detroit scored the most goals in the league (222), fronted by Howe's league-leading 49 goals and NHL-record 95 points. As well, Detroit allowed the fewest tallies (133), posting at least one shutout against all five of the NHL's other teams. When Sawchuk was briefly out due to injury, Glenn Hall, another future Hall of Famer, was called up to fill the void.

Owner Jim Norris, who renamed the team the Red Wings when he purchased the club and Olympia Stadium for $100,000 in 1932, died December 4,

1952 and the reins of the team were turned over to his daughter Marguerite Norris, who became the first woman to run an NHL club. The following spring, as Detroit defeated Montreal in the Stanley Cup final, Norris would become the first female to have her name inscribed on Lord Stanley's mug.

A sixth straight first overall finish was posted in 1953-54. Howe won his fourth consecutive Art Ross Trophy, while Kelly won his third Lady Byng Trophy and was the first recipient of the Norris Trophy, a new award to be presented annually to the NHL's top defenceman. Sawchuk tied his club mark with 12 shutouts.

A grueling seven-game Stanley Cup final series against Montreal saw Detroit once again win the title in an overtime Game 7. Tony Leswick got the winner at 4:29 of the extra session when his long shot hit the glove of Canadiens defenceman Doug Harvey and changed direction at the last moment, eluding the grasp of Montreal goalie Gerry McNeil. "It seemed like an eternity before that red light went on," Wings coach Tommy Ivan said. The bitterness of the rivalry was revealed when all of the Canadiens save former Wing Gaye Stewart left the ice without taking part in the traditional post-series handshake.

Jimmy Skinner replaced Ivan as coach to start the 1954-55 season when Ivan departed to become general manager of the Blackhawks, and there were signs of cracks beginning to appear in the Detroit dynasty.

Howe slipped to 62 points, while Lindsay skidded to 38 points, his worst showing since 1945-46. Sawchuk was a rock in net, winning his fourth Vezina Trophy. Skinner never lost faith in his charges either: "This team of ours can win anytime it wants to," the rookie coach said. "It's all in their minds."

A 5-0 loss to the Canadiens at Olympia Stadium was notable because it would prove to be Detroit's final home-ice loss of the campaign. The Wings closed the regular season 13-0-5 at home and went 5-0 during the playoffs. Finishing the season with a club record nine-game win streak, Detroit grabbed first place for an unprecedented seventh straight season, something no other team in pro sports history has ever achieved.

"We were 10 points behind Montreal with 10 games to go," remembered Pronovost. "We were two points behind when we beat them 4-1 down there, and then we beat them in our rink to clinch first place and home ice in the playoffs." After sweeping Toronto in the semi-finals, Detroit dropped Montreal in a seven-game final series in which the home team won every game, making that late-season rally for first place all the more significant. "I don't know how you can explain it," said forward Earl Reibel, Detroit's scoring leader in 1954-55 with 66 points. "We just kind of got together as a team."

After the triumph, captain Lindsay launched another enduring Stanley Cup tradition when he snatched the silver chalice from its perch upon a table at centre ice and skated around the rink to give the fans an up-close look at hockey's greatest prize. "Everyone's emotions were on high and I guess mine were a little higher," Lindsay said. "It was an impulsive sort of thing."

The Wings actually won 15 games in a row before their first final-series loss to Montreal in Game 3. "Our team had everything—great goaltending, solid offensive and defensive defencemen, toughness, checkers and outstanding talent," recalled Wings defenceman Ben Woit.

It also was about to be dismantled. Sticking to his belief that a championship squad was only good for five years before it went stale, Adams set out to reshape his team. On May 29, 1955, he exchanged forwards Glen Skov, Leswick and Johnny Wilson and defenceman Woit to Chicago for forwards Jerry Toppazzini, John McCormack, Dave Creighton and Bucky Hollingworth. Five days later, Adams dealt forwards Marcel Bonin, Vic Stasiuk and Lorne Davis to Boston along with Sawchuk for goalie Gilles Boisvert, defenceman Warren Godfrey and forwards Norm Corcoran, Real Chevrefils and Ed Sandford. By the time the club reported for training camp in the fall, only 10 players—Howe, Lindsay, Reibel, Delvecchio, Kelly, Bill Dineen, Bob Goldham, Pronovost, Pavelich and Larry Hillman—were left from the team which had won the Stanley Cup.

"Jack certainly knew his hockey and he wanted to help out Chicago and Boston, but I think he made a big mistake in making such wholesale changes," Wilson said. "It was still a young team. Most of us were 27 or 28 and we had a few more years of good hockey left."

The moves sent shock waves through the Detroit hockey community, not to mention the Red Wings' dressing room. "It was unbelievable the way it happened," Skov said. "We couldn't believe why Jack Adams would trade away eight players off a Stanley Cup team."

The Red Wings fell to second place in 1955-56 and lost the Stanley Cup final to Montreal, the first of five straight successes by the Canadiens. By 1958-59, Detroit was a last-place hockey club.

Adams took issue with Lindsay's attempts to organize a players' association and shipped him and Hall to Chicago in 1957. Hall was the reason Sawchuk had been let go, but now the club dealt a promising forward named Johnny Bucyk to Boston to get Sawchuk back.

"They gambled on some young defencemen who didn't develop," Howe said. "They got mad at Red Kelly and traded him to Toronto. Glenn Hall was another great one they let go. And Boston's whole Uke Line (Bucyk, Stasiuk, Bronco Horvath), they all used to be with Detroit. They just got rid of so much great talent. They made bad trades, the people didn't come

up through the system to replace them and they made more bad trades trying to fill the holes. It was the old case of two wrongs not making a right."

It wasn't a complete disaster. Hall was the NHL's rookie of the year in 1955-56. The Wings returned to first place in 1956-57 and Lindsay led the NHL with 55 assists. Howe captured the Hart Trophy for the fourth time in 1957-58, the same season that saw Abel replace Skinner behind the Detroit bench.

There would be a revival of sorts under the tutelage of their long-time captain. By 1960-61, Abel had the Wings back in the Stanley Cup final, though they lost in six games to Chicago. It marked the only season from 1942-69 that one of Detroit, Toronto or Montreal did not win the Cup.

Meanwhile, Howe was taking a hatchet to the NHL record book. He became the NHL's all-time scoring leader on January 16, 1960 with 947 points and on November 16, 1960, became the first player in league history to record 1,000 points. That spring, he surpassed Doug Harvey (59) to become the NHL's all-time playoff assists leader. The next season, he became the NHL's first 1,000-game player. When Detroit missed the playoffs in 1961-62, however, another Red Wings legend was gone: Adams, who'd been the club's GM since 1927, was let go.

Abel took over both posts and led the Wings back to the Stanley Cup final in 1962-63, where

12

they lost to the Leafs in five games. Howe was a big reason why the Wings had their resurgence. He won the Art Ross and Hart Trophies that season at age 35, capturing each bauble for a league-record sixth time. This was also the season that Delvecchio took over as captain, a position he'd fill into the 1973-74 campaign.

Despite enduring an injury-riddled season that saw them suit up 33 skaters and a record six netminders, the Wings again found their way to the Stanley Cup final in 1963-64. Sawchuk was stellar in goal; Pronovost and newly acquired Bill Gadsby were rocks on defense, while Howe, Delvecchio and Norm Ullman paced the attack. On November 10, 1963, Howe scored his 545th NHL goal to surpass Rocket Richard and become the all-time leader in this department. He finished the postseason with 127 career playoff points, a Stanley Cup record. Detroit held a 3-2 edge in the final series against Toronto, but the Leafs rallied to win Game 6 at Olympia Stadium in overtime and then blanked the Wings 4-0 in Game 7 at Maple Leaf Gardens to retain the Cup.

A familiar face wearing an unfamiliar number once again donned the Winged Wheel in 1964-65. Lindsay ended a four-year retirement and earned a spot with Detroit in training camp, wearing No. 15 because Ullman was entrenched as No. 7. Lindsay scored 19 goals and led the team with 173 penalty minutes as the Wings earned a surprising first-place finish. But they were upset by Chicago in the semi-finals.

Roger Crozier had taken over for Sawchuk in the Detroit goal, winning the Calder Trophy as the league's top rookie in 1964-65, and in 1965-66 he came close to bringing a magical moment to the Wings. Future Hall of Famer Andy Bathgate was added from Toronto in a multi-player deal and came up big in the 1966 Stanley Cup semi-final series against Chicago, scoring six power-play goals as the Wings ousted the second-place Blackhawks in a six-game set. "This is the most harmonious club I've ever played for," Bathgate said.

Detroit went into the Montreal Forum and won the first two games of the final series from the Canadiens, only to see Montreal rally and take the next four to win the Cup, the clincher coming on a Game 6 overtime goal that Canadiens forward Henri Richard appeared to shove into the net with his glove, an illegal move. "If they had replay back then, it could have changed the outcome," Gadsby said. Despite the loss, Crozier was awarded the Conn Smythe Trophy as Stanley Cup MVP.

It would be the last glory seen in Detroit for some time. The Wings missed the playoffs again in 1966-67, something that would become common during the first 15 seasons of the NHL's expansion era.

The Wings began the Original Six era on top of the hockey world. As the league expanded, Detroit would slide all the way to the bottom.

13

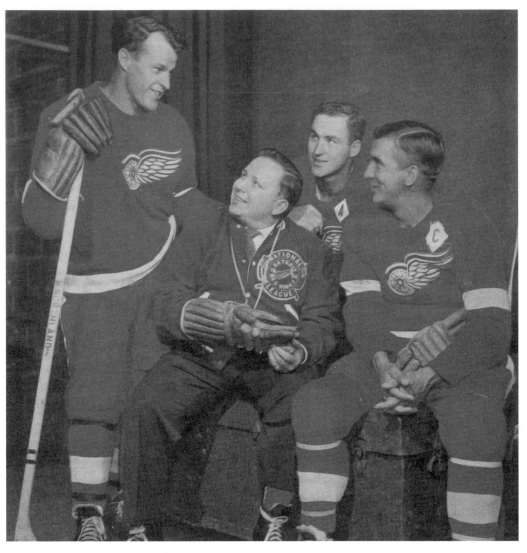

Some of the leaders of Detroit's 1954-55 Stanley Cup championship team—Gordie Howe, Red Kelly and captain Ted Lindsay—surround coach Jimmy Skinner. Replacing Tommy Ivan as coach that season, rookie Skinner led the Wings to the title, the last Cup the franchise would win until 1996-97.

Chapter One:
The Production Line

WHEN HE WAS A YOUNG LAD of 12, Gordie Howe showed up at the Bessborough Hotel, hatching a plan to get into the Saskatoon Arena for free that night to watch the Detroit Red Wings, who were in town for an exhibition game. Howe knocked on the door of Red Wings captain Sid Abel and enquired as to whether he needed someone to carry his skates to the rink.

Not many years after, the two—along with Ted Lindsay—would carry the day as the very best forward line in the National Hockey League. Some would even venture to say the very best forward line in hockey history.

Red Wings coach Tommy Ivan first put youngsters Howe, in his second NHL season, and Lindsay, entering his fourth campaign in the league, on the wings of veteran centre Abel during 1947-48.

They were an instant hit. Detroit qualified for the Stanley Cup final in the spring of 1948 and again in 1948-49, and Abel, Lindsay and Howe were a big reason why. During a seven-game semi-final series against the Montreal Canadiens in 1949, the trio accounted for 12 of the 17 goals Detroit scored during the series. In 1949-50, as Detroit rolled to a Stanley Cup title, Lindsay, Abel and Howe finished 1-2-3 in the NHL scoring race.

It was that sort of output which led to the enduring nickname for the group—The Production Line.

"It was a unit," Lindsay said. "We all liked being together," added Howe. "We just read each other. We sat together in the dressing room, sat together to eat and on the train. We had 24 hours of discussion and we had faith in each other."

Hockey was a different game in the Original Six era. Forward units tended to remain unified. There wasn't the line-juggling that is so prevalent in the sport today. "We were all taught the same things," Howe recalled. "Lines were created and left together. Conversations took place."

Each man brought distinctive characteristics to the line. Abel, a Red Wing since 1938 and the team captain, was the glue, the veteran savvy who served to offer sage advice to his young protégés. "There was never a question about his leadership," Howe said. "The thing about being a good captain and leader is to have respect and Sid was very much respected.

"Sid liked to coach and he just told me 'When I'm in the corner fighting for the puck, I'd consider it a favour if you'd stay out somewhere in the middle of the ice so if I get it, I don't have to look around where to pass it, you'll be there.' I got my first goal that way."

Howe grew to become the NHL's greatest superstar, winning six scoring titles and as many Hart Trophies. "Playing on the Production Line, I couldn't miss," Howe said. "Sid was left-handed and he was able to give me the puck all night."

In Howe's opinion, what made the Production Line so dangerous was the communication between the three men both on the ice and on the bench between shifts. "I learned more with the guys I played with than any coach I ever had," Howe said.

All were enduring Detroit icons. Howe skated in a Red Wings uniform for 25 of his 26 NHL seasons. Along with his work as coach, general manager and broadcaster for the club, Abel was part of the Red Wings organization for 32 years. Lindsay played 14 of his 17 NHL seasons with the Red Wings and later served as coach and GM of the club.

Irascible on the ice, Lindsay garnered 1,808 penalty minutes in 1,067 games, topping 100 minutes in 10 seasons and leading the NHL in penalty minutes twice. Lindsay led the NHL in goal-scoring with 33 in 1947-48, but will be forever remembered for his unmatched competitive streak.

"I had the idea that I should beat up every player I tangled with and nothing ever convinced me it wasn't a good idea," Lindsay said of his style of play. "You had to play tough in those days, or they'd run you out of the building."

All three players have seen their sweater numbers retired by the Red Wings. Fittingly, Abel's No. 12 hangs between Lindsay's No. 7 and Howe's No. 9 in a place of honour high in the rafters at Joe Louis Arena.

"To go up there between my old buddies Gordie and Ted again is a very touching moment," Abel said when his sweater joined the other two in 1995. "I look back and I realize I was very fortunate to hook up with two pretty talented hockey players and let them carry me along."

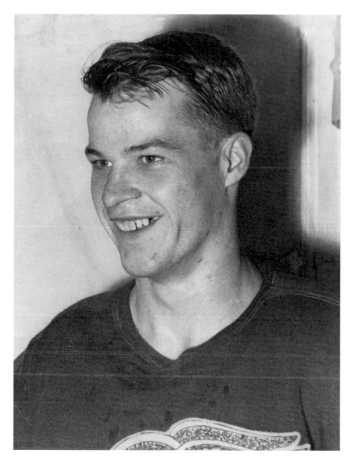

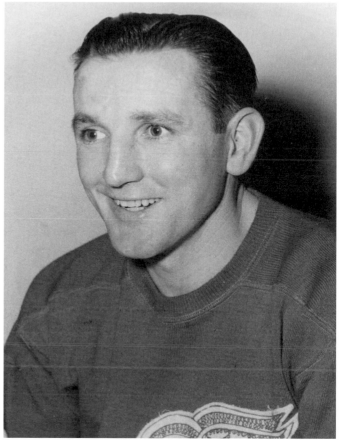

This fuzzy-faced youngster would go on to become the greatest Red Wing of all time. Gordie Howe is seen here at training camp in the fall of 1946, prior to his first NHL season with Detroit. When he was done as a Wing in 1971, Howe had played more games (1,687), scored more goals (786), and collected more points (1,809) than any player in franchise history.

The linchpin of the Production Line, Sid Abel was the veteran of the bunch. He broke into the NHL during the 1938-39 season and was named team captain at the age of 24 in 1942. Abel led the Wings to Stanley Cups in 1942-43, 1949-50 and 1951-52, and served as a father-figure to the younger Ted Lindsay and to Gordie Howe. Abel won the Hart Trophy as MVP of the NHL in 1948-49.

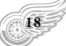

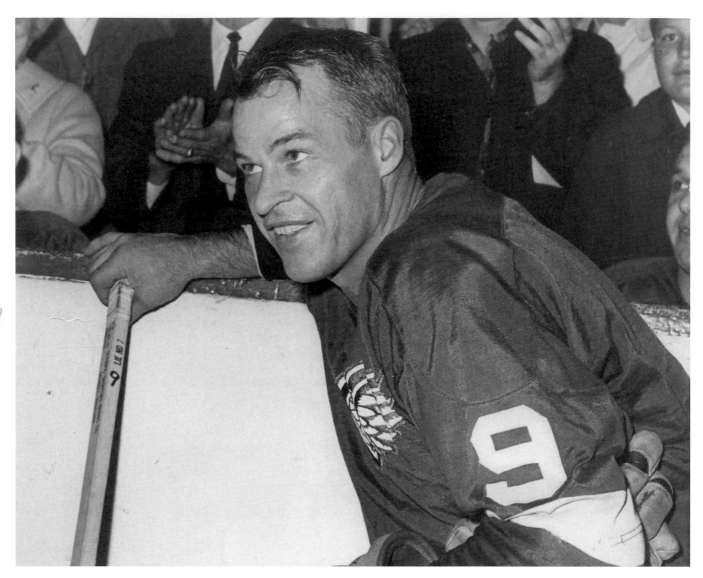

The man they call Mr. Hockey has just scored his 545th career NHL goal at Olympia on Nov. 10, 1963, besting the previous NHL record of 544 held by Maurice (Rocket) Richard. Gordie Howe kneels by the boards as fans behind offer him uproarious applause.

The Production Line

Detroit's Alex Delvecchio slips a shot between Toronto goalie Ed Chadwick and Leafs defenceman Jimmy Thomson (2), as Lorne Ferguson closes in, searching for a rebound. When Sid Abel left the Wings following their 1951-52 Stanley Cup win to take over as player-coach of the Chicago Blackhawks, Delvecchio garnered the chance to centre the Production Line. Delvecchio played his entire 22-season NHL career, a total of 1,549 games, with the Red Wings, and captained the team from 1962-73. In NHL history only one other player—fellow Red Wings captain Nicklas Lidstrom (1,564)—skated in more games while enjoying a career played entirely for one franchise.

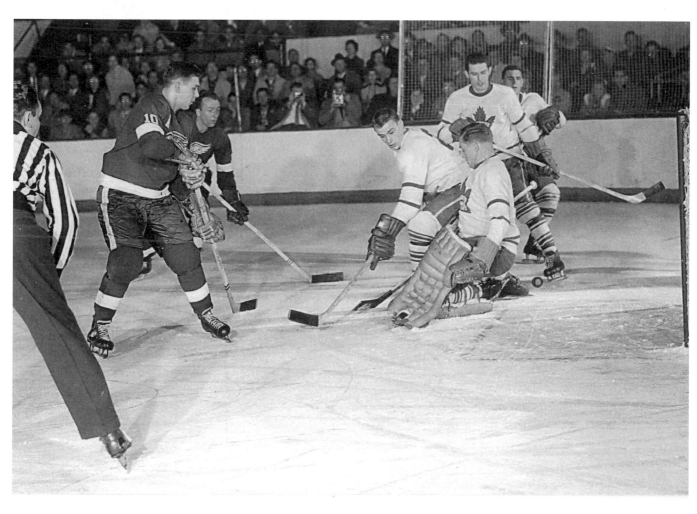

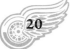

"Stick with me, kid, and I'll show you the way." That seems to be what Syd Howe is telling a young Gordie Howe in this photo. Gordie Howe is wearing the uniform of the United States Hockey League's Omaha Knights, where he spent 1945-46, his first pro season, which was also Syd Howe's last in the NHL with Detroit. The two Howes weren't related and never played as teammates in an official game, though Wings coach Jack Adams often yelled, "Get our there, Syd," to Gordie during his rookie season with the Wings, in 1946-47.

A victory earned, the Wings swoop in to congratulate goalie Glenn Hall, led by Ted Lindsay (7), the team captain. They called him Terrible Ted and Scarface. Lindsay could beat you with his skill, his physical play, and with his fists, and there was no question as to who was the leader of the Wings during his time in Detroit.

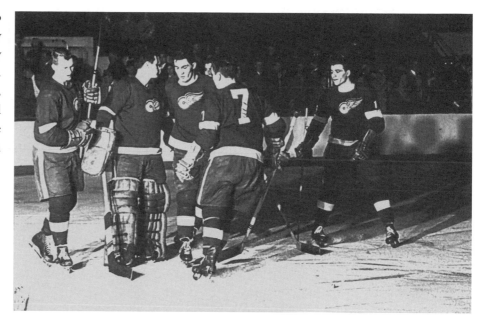

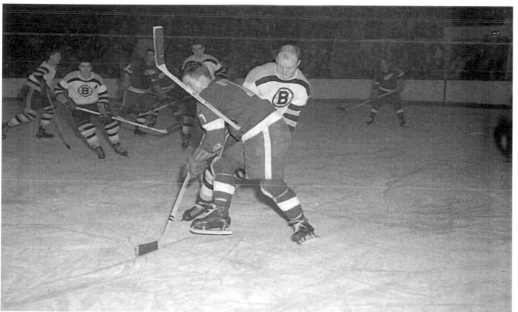

Ted Lindsay could dish it out, and he could take it. He gets the worst of it during this interaction with Boston Bruins defenceman Bob Armstrong, who seems to be trying to saw Lindsay in half with his stick. Lindsay was an Original Six rarity in that he jumped right from the junior ranks to the NHL, playing 1,090 career NHL games without ever seeing a second of minor-league action.

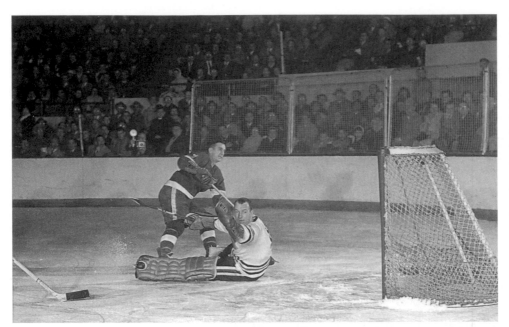

Chicago Blackhawks goalie Al Rollins sprawls, but is too late with his glove hand to prevent Ted Lindsay from snapping the puck into the net. Left-winger Lindsay led the NHL with a career-high 33 goals in 1947-48. Two seasons later, he won the NHL scoring title, establishing career bests in assists (55) and points (78), as he and linemates Sid Abel (34-35-69) and Gordie Howe (35-33-68) finished 1-2-3 in the Art Ross Trophy race.

22

It didn't pay to make Ted Lindsay angry, because you never knew what he might do when he was mad. Boston defenceman Allan Stanley obviously did something to raise Lindsay's ire, and he grimaces as Lindsay bounces his stick off of Stanley's back. Ten times during his Detroit days, Lindsay topped 100 minutes in penalties.

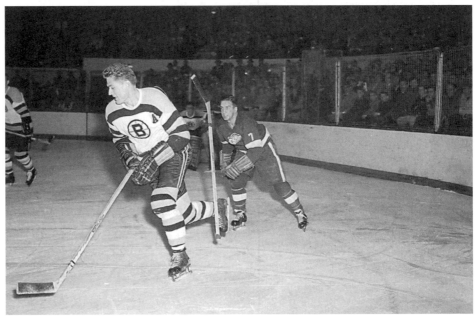

The Production Line

Somewhere in the midst of all those Montreal Canadiens bodies is Gordie Howe. The Habs required four players to stymie Mr. Hockey's attempt to jam the puck home—goalie Jacques Plante, left-winger Gilles Tremblay (21), and defencemen Jean Gauthier (11) and Jean-Guy Talbot (seated on ice). Meanwhile, Canadiens right-winger Bernie Geoffrion (5) holds off Parker MacDonald (20), while Detroit's Alex Delvecchio (10) appeals to referee Bill Friday to call a penalty on the Canadiens. One of many attempts to reincarnate the Production Line, journeyman MacDonald benefitted from playing alongside Howe and Delvecchio during the 1962-63 season, scoring 33 times.

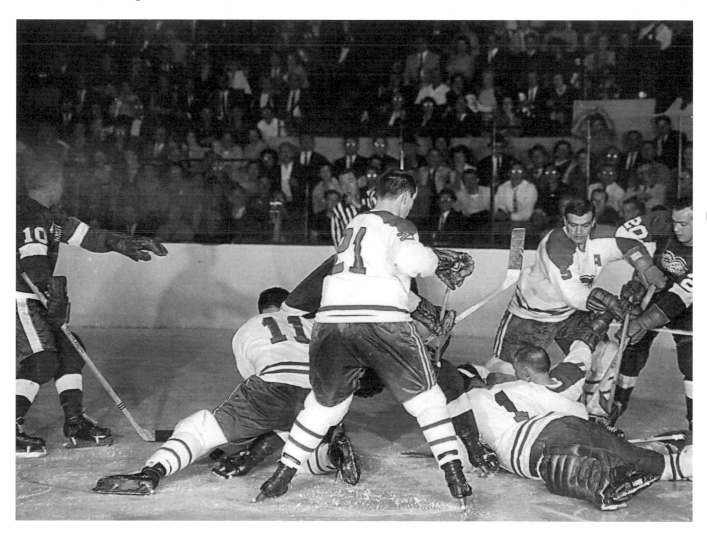

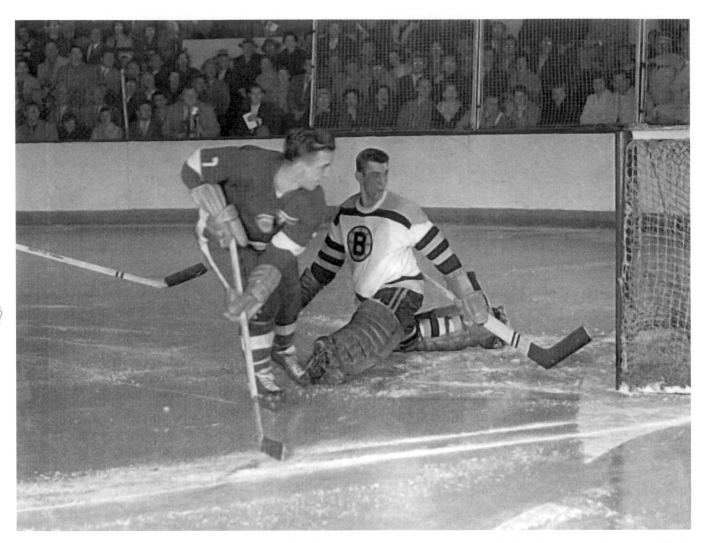

Detroit left-winger Ted Lindsay goes to the backhand and buries one past Boston Bruins goalie Don Simmons, who can only look back at his net helplessly. During the 1956-57 season, Lindsay led the NHL with 55 assists and posted a career-high 85 points. Hall of Fame former NHL referee Bill Chadwick described Lindsay as, "The toughest guy who ever played hockey. He never backed off from anybody. When Lindsay took a penalty, it was never a cheap one. It was for fighting or for giving it to some guy in the corner of the rink."

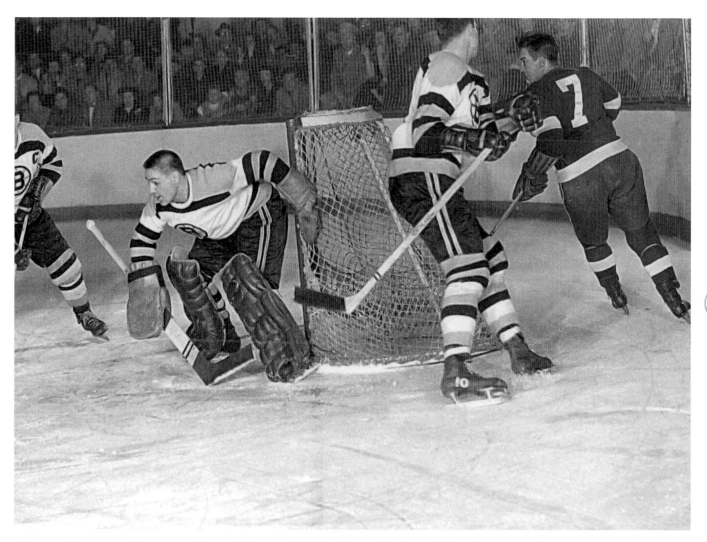

Always at the centre of the action, Detroit left-winger Ted Lindsay circles the net behind Boston goalie Terry Sawchuk, but never takes his eyes off the puck. Lindsay won three of his four Stanley Cups with Sawchuk as his netminder and always speaks highly of Sawchuk's talents. "If you threw a handful of rice at him," Lindsay once said of Sawchuk, "he'd catch every kernel."

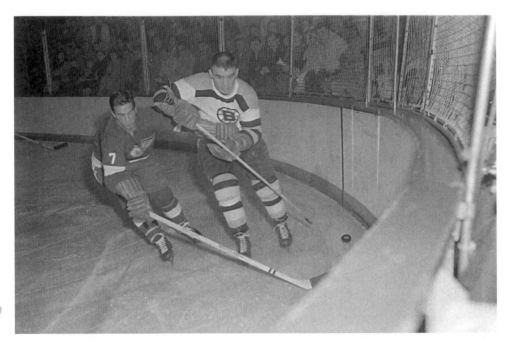

Hard in on the forecheck, Ted Lindsay strips the puck away from Boston Bruins defenceman Jack Bionda. Hall of Fame right-winger Andy Bathgate, a Red Wing from 1965-67, recalled the intense competitiveness of Lindsay, which even spilled over into supposed social events such as the NHL All-Star Game. "You didn't associate with the other players back then," Bathgate said. "You'd get to the All-Star Game and Ted Lindsay would walk by and grunt. That's the only words you'd get out of him."

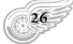

26

The face looks familiar, the uniform not so much. Angered over his work to organize the NHLPA, Detroit GM Jack Adams shipped Ted Lindsay to the Chicago Blackhawks in July of 1957, even though he'd just enjoyed a career season with the Wings, finishing second in the NHL scoring race with 85 points. That's fellow former Wing Glenn Hall in the Chicago goal. Adams felt Hall was too close to Lindsay, so he shipped the pair to the Blackhawks for Johnny Wilson, Forbes Kennedy, Hank Bassen and Bill Preston. None of them were inducted into the Hockey Hall of Fame, but both Lindsay and Hall were when their playing days were done.

Detroit captain Ted Lindsay is already over the chicken wire and into the crowd, seeking out a heckling fan, while Red Wings net-minder Terry Sawchuk is well on his way to joining the fray. Glen Skov (12) is a more than interested onlooker. The Wings were leaving the ice during a 1-0 loss to Toronto at Olympia Stadium on Nov. 11, 1954, when a spectator threw some choice words in Lindsay's direction and Lindsay went after the fellow, whose name was Bernard Czeponis. He opted not to press charges against the Red Wings left-winger.

Going to his backhand, Red Wings captain Alex Delvecchio is foiled by sprawling Boston Bruins goalie Bob Perreault. When Sid Abel left to become player-coach of the Chicago Blackhawks following Detroit's 1951-52 Stanley Cup season, many were tried at centre on the Production Line, but the eventual winner was Delvecchio. He and Gordie Howe were virtually inseparable as linemates from that point until Howe retired in 1971, while a variety of left-wingers followed Ted Lindsay as part of the unit.

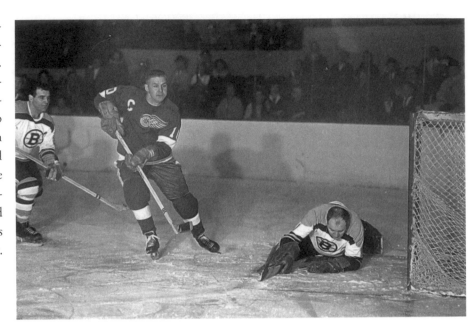

28

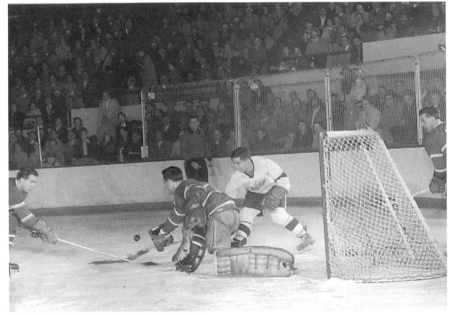

Everyone is reaching for the puck, but it's the outstretched goal stick of Montreal's Jacques Plante that wins the battle. Detroit left-winger Ted Lindsay strains to get his right arm in there in time, while Montreal centre Phil Goyette looks to hack the puck clear from the front of the Canadiens' net. Helpless to pitch in, but watching intently as he circles behind the net is Canadiens' right-winger Maurice (Rocket) Richard. Detroit teammate Marcel Pronovost listed Lindsay alongside the fiery Richard as the toughest competitors of their era. "A guy like Lindsay would carve your eyes out," Pronovost said. "The Rocket would go through you if he couldn't go around you."

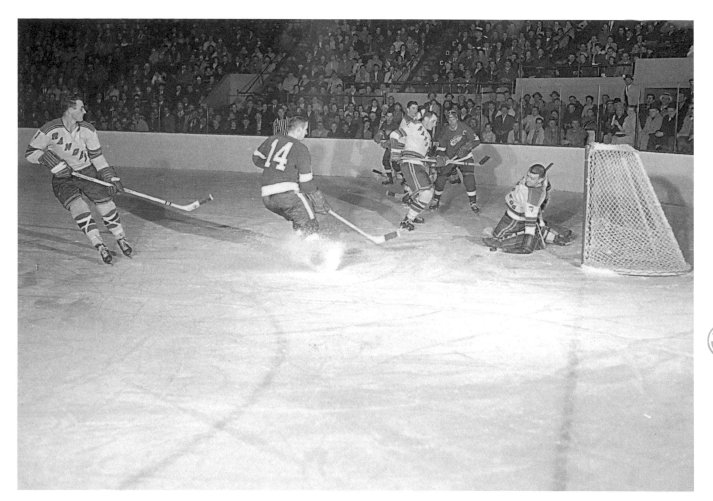

Detroit centre Jerry Melynk fires a shot toward New York Rangers goalie Gump Worsley as Rangers defenceman Bill Gadsby positions himself to prevent Detroit's helmeted captain from getting to any rebound. Take a closer look at the man in the helmet from this game during the 1960-61 season and you'll see that it's Gordie Howe. Mr. Hockey donned headgear for a brief time that season after suffering a concussion in a collision with Toronto Maple Leafs forward Eddie Shack during a January 4, 1961 game.

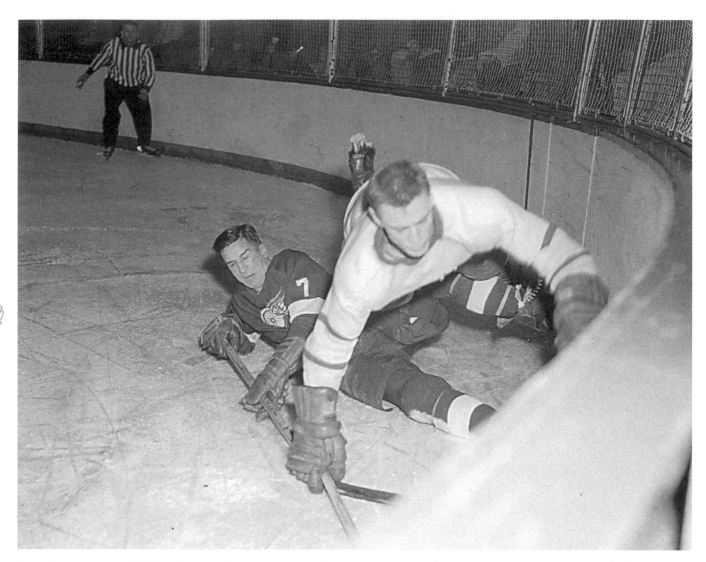

Down but never out, Ted Lindsay gets his stick out to spill Toronto Maple Leafs left-winger Ray Timgren along the boards. Nine times during his NHL career, Lindsay was assessed more than 100 penalties during a season, and when he retired following a comeback year with the Wings in 1964-65 after four seasons off, he was the NHL's all-time penalty-minute leader with 1,808 (a mark he held until 1976).

Sticks aloft, Detroit captain Gordie Howe and linemate Alex Delvecchio (10) celebrate Howe's goal against his good friend Johnny Bower of the Toronto Maple Leafs, who looks sadly back into his cage. Toronto's Ron Stewart (next to Howe) and Carl Brewer are equally chagrined. Howe and Bower played youth hockey against each other, but grew close in later years when they summered together in Waskesiu, Saskatchewan, where Bower operated a restaurant.

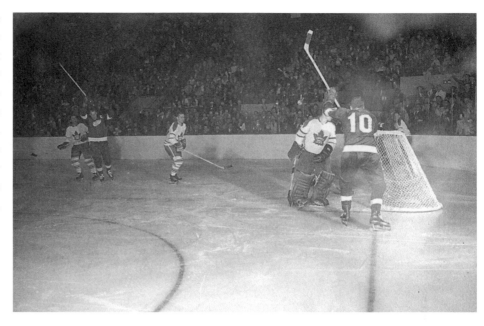

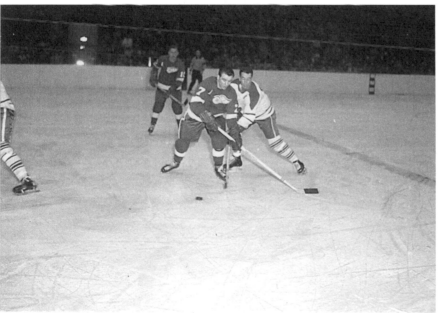

Detroit centre Norm Ullman looks to be winning this puck battle with Toronto Maple Leafs forward Bert Olmstead. Alex Delvecchio looks on from behind the dueling duo. One of the many successful reincarnations of the Production Line saw Delvecchio move from his natural centre position to left wing to play with Ullman and right-winger Gordie Howe. All three members of this trio made season-ending NHL All-Star Teams under this formation—Howe was an ever-present All-Star on right wing, while Delvecchio was the Second Team left-winger in 1958-59, and Ullman the First Team centre in 1964-65 and a second-team selection in 1966-67.

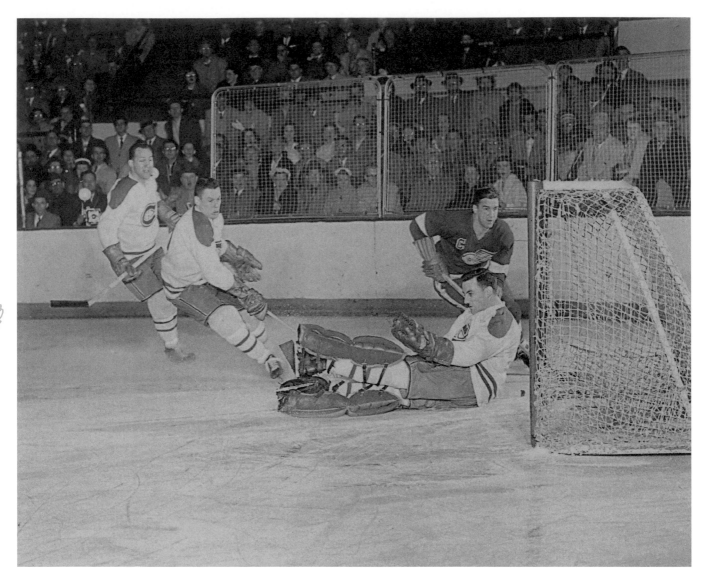

One legend thwarts another as Montreal Canadiens Hall of Fame puckstopper Jacques Plante stacks the pads to prevent Detroit Hall of Fame left-winger Ted Lindsay from adding to his NHL career goals total of 401. Lindsay took over as captain of the Wings from Production Line teammate Sid Abel to start the 1952-53 season, and wore the C for Detroit through the 1955-56 campaign.

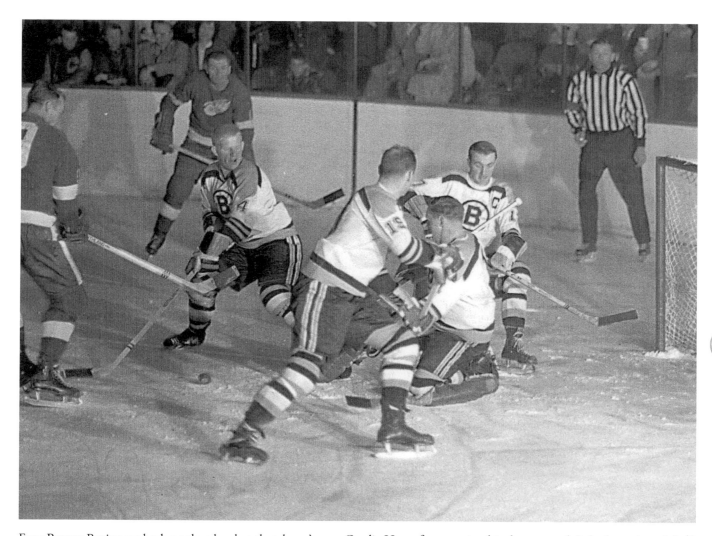

Four Boston Bruins are back on the play, but that doesn't stop Gordie Howe from getting his shot on goal. It looks as though he'll be first to the rebound as well, as goalie Don Head kicks it right back in Howe's direction. Pat Stapleton (4) tries to get his stick in Howe's path, while Doug Mohns (19) and captain Don McKenney seek to provide further aid. Detroit's Vic Stasiuk watches from the corner of the rink.

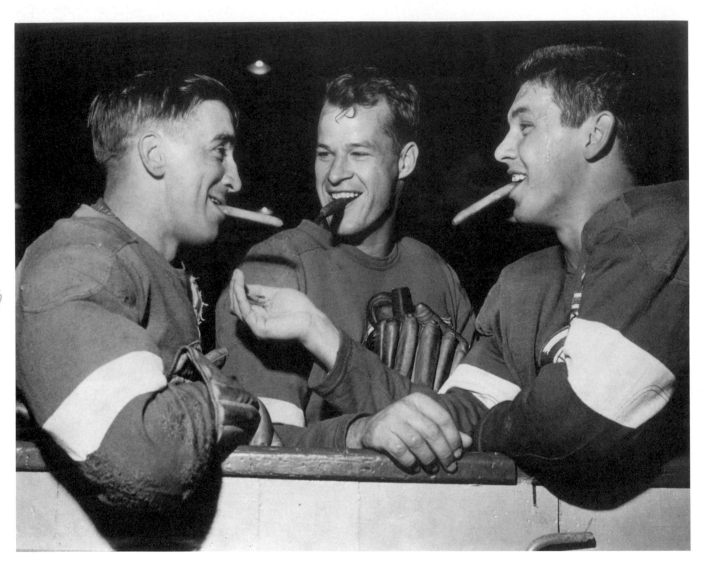

A later version of the Production Line featuring Ted Lindsay on left wing, Gordie Howe at right wing and Alex Delvecchio at centre in place of Sid Abel, who'd gone on to coach Chicago. The curious element to this staged photo? Not one among the group was a smoker.

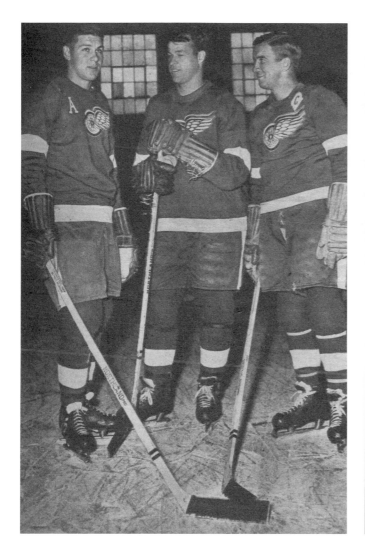

35

Alex Delvecchio was an intriguing part of the restructuring of the Production Line, because in different incarnations, he played both centre and left wing as part of the unit. Here, he was the centre between Gordie Howe (centre) and Ted Lindsay (right). Later on, after Lindsay was dealt to Chicago, Delvecchio slipped over the left side, with Howe on the right and Norm Ullman skating down the middle of the trio. If you look them up in the Olympia Stadium program, Lindsay wore No. 7, Howe wore No. 9 and Delvecchio had No. 10 on his back.

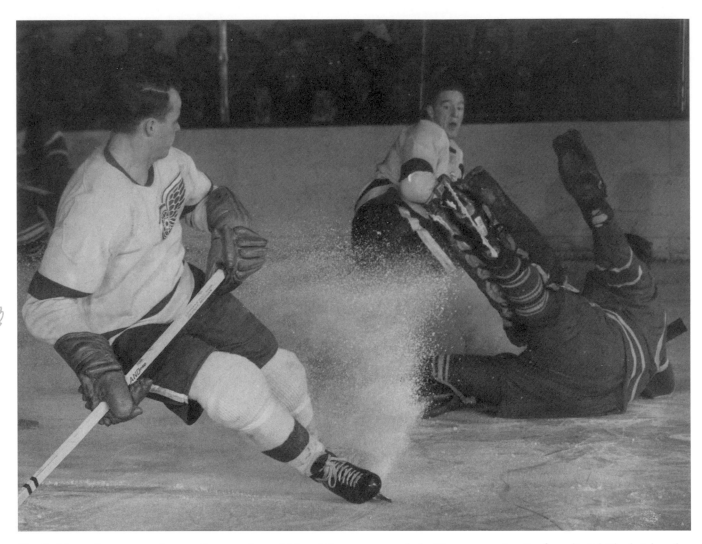

Gordie Howe throws up a shower of snow as he and Marcel Pronovost attack the Toronto net, but Leafs goalie Ed Chadwick makes the save on this occasion. Pronovost's big break came during the 1950 Stanley Cup playoffs. In Detroit's semi-final opener against the Leafs, Howe suffered a season-ending head injury when he fell face-first into the boards. Detroit coach Tommy Ivan moved Red Kelly from defence to Howe's right-wing spot on the Production Line and called up rookie Pronovost from Omaha of the USHL to fill Kelly's role along the blue line as Detroit won its first Stanley Cup since 1943.

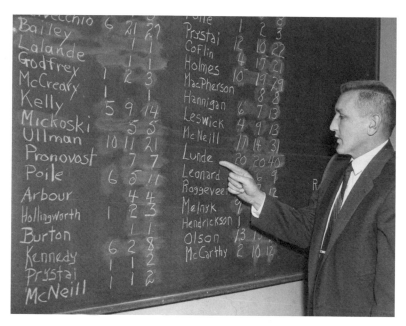

Sid Abel studies his roster on the blackboard in the team offices at Olympia Stadium shortly after being named coach of the Red Wings in early January of 1958. Abel left the Wings in 1952 to assume player-coaching duties with the Chicago Blackhawks, but later returned to Detroit to replace Jimmy Skinner behind the bench. Abel guided the Wings to four Stanley Cup final appearances between 1961-66 and to a first-place finish in 1964-65. He also followed Jack Adams as general manager of the team in 1962.

Ted Lindsay had been out of the NHL for four seasons when his old Production Linemate Sid Abel, now coach and GM of the Red Wings, asked him if he'd be interested in making a comeback. Lindsay skated with the Wings in training camp on a try-out basis and made the squad. He quickly showed that he'd lost none of his abrasiveness. Lindsay was assessed a misconduct in the season opener and was later suspended indefinitely by the league when he announced that he wouldn't sit for NHL president Clarence Campbell's "Kangaroo Court." Lindsay later apologized and paid $75 in fines.

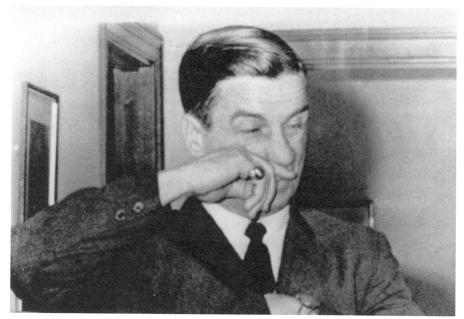

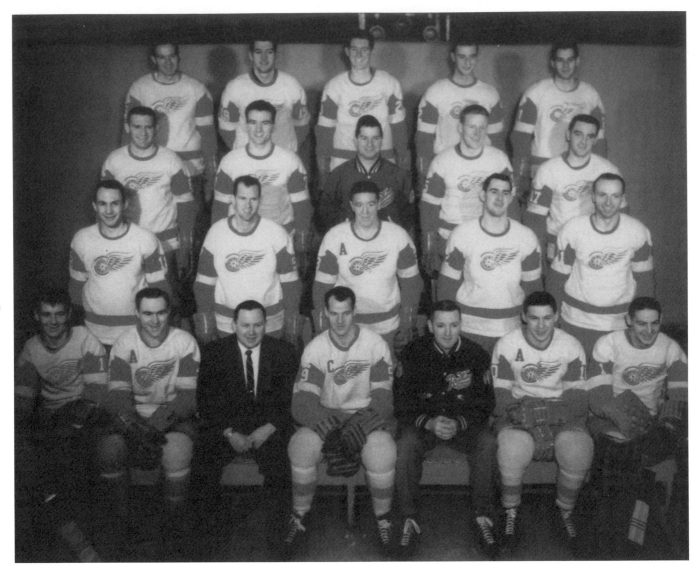

Wearing the C, Gordie Howe is the centre of attention in this team photo of the Red Wings. Next to him is Wings Coach Sid Abel, Howe's former Production Line-mate. All three of the original Production Line members captained the Wings—Abel from 1942-43 and again from 1945-52, Ted Lindsay from 1952-56 and Howe from 1958-62.

Chapter Two:
Legends of the Game

To LEGIONS OF FANS, Bill Gadsby is a Detroit Red Wing through and through. And why not? After all, he played in three Stanley Cup finals with the team, setting NHL records for games played, points and seasons played by a defenceman, all while wearing the winged wheel.

No wonder it's so hard to believe that Gabsby played 15 of his 20 NHL seasons with the Chicago Blackhawks (1946-55) and the New York Rangers (1955-61) before arriving in Detroit following a 1961 trade.

"It is astonishing," Gadsby said of his link with the Wings, a team he was with for only one-quarter of his 20-season NHL career. "But what I'm finding from the people that I meet, unless they are over 70 like me, they don't remember me as anything but a Red Wing."

Gadsby is among many Hall of Famers who were seen in action in a Detroit uniform during the Original Six era. Some of them, like defencemen Marcel Pronovost and Red Kelly or goaltender Terry Sawchuk, were Red Wings for lengthy tenures. Others, such as defenceman Doug Harvey, goaltender Glenn Hall and left-winger John Bucyk, wore the Detroit sweater for only a brief time. But all were legends of the game.

Often overshadowed by glittering Detroit luminaries such as Howe, Kelly, Sawchuk and Lindsay, Pronovost was a quiet superstar. He could skate, puck handle, make plays and put it in the net when required. Pronovost was equally adept without the puck, armed with tremendous lateral movement that made him a devastating open-ice

body checker. "I was more of a complete defenceman," Pronovost said.

Like Pronovost, (Black) Jack Stewart was a hard-nosed defenceman who terrorized the opposition with his physical presence. "He was a defensive defenceman," recalled former Detroit defenceman Clare Martin of Stewart. "There weren't too many that ever got by him, but if they did, he sure looked after them in front of the net. His job was defence and he knew it. He was really tough back there."

Only two defencemen have ever won the Lady Byng Trophy and both were Red Wings—Bill Quackenbush in 1948-49 and Kelly on three occasions in the 1950s. Every winner since has been a forward, including Kelly, who won the Lady Byng in 1960-61 after being converted to centre by Toronto coach Punch Imlach.

"I never thought of the Lady Byng being about penalty minutes," Kelly said. "People look at the penalty minutes aspect, but to me, it's an award which goes to a player who displays sportsmanship. Don't tell me about penalty minutes. Tell me how many goals are scored against the team when he is on the ice. I'll bet it's not too many. That's what matters, not that he doesn't get penalties, but that he doesn't get penalties and still gets the job done."

Kelly learned how to perform along the blue line without overdoing it from Quackenbush, his first defence partner. "He taught me how to play the game without taking penalties," Kelly recalled.

Alex Delvecchio was another multiple Lady Byng winner who spent his entire 1,549-game NHL career as a Red Wing from 1950-74, retiring during the 1973-74 season to take over as coach-GM of the club. "I think I had maybe five fights my whole career," Delvecchio said.

Centre Norm Ullman was a hard-luck sort who arrived in Detroit in 1955-56, one season after the Wings had won their fourth Stanley Cup in six seasons. He'd play with Detroit through the remainder of the Original Six era and in five Cup final series, but he would never hoist the cup. The picture of consistency, he scored 20 goals in 16 of his 20 NHL seasons.

The Wings added Andy Bathgate from Toronto in a 1965 trade and he shone as Detroit reached the 1966 Stanley Cup final, scoring six goals in the club's semi-final win over Chicago. After Gadsby retired in 1966, Wings coach-GM Sid Abel turned to seven-time Norris Trophy winner Doug Harvey for help. Harvey was called up in January 1967 from Detroit's American Hockey League farm club in Pittsburgh. "I'm definitely interested in him," Abel said. But after just two games as a Wing, Harvey was returned to Pittsburgh, undoubtedly the most nondescript appearance by a Hall of Famer in a Detroit uniform. 🪽

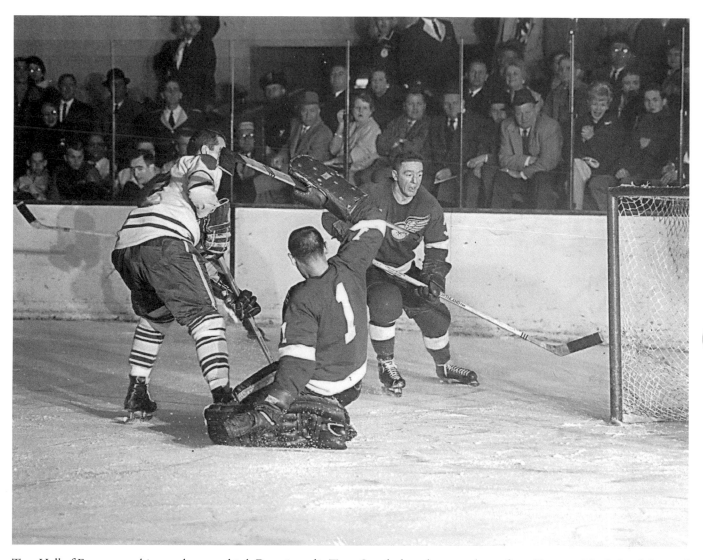

Two Hall of Famers combine to thwart a third. Detroit goalie Terry Sawchuk snakes out a leg to force Toronto Maple Leafs forward Dick Duff to shoot wide, and Red Wings defenceman Marcel Pronovost is hot in pursuit of the loose puck. The Wings and Leafs met in the 1963 Stanley Cup final, with Toronto taking a 4-1 decision in the best-of-seven set. Detroit's only victory was a 3-2 verdict on home ice in Game 3, April 14, 1963.

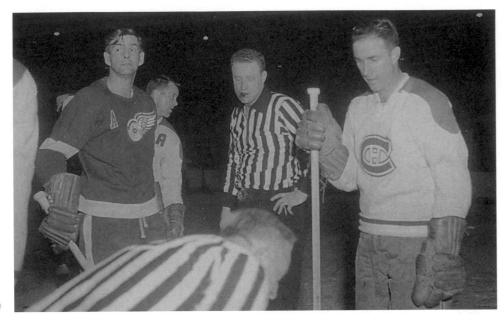

Acquired from Chicago in 1950, defenceman Bob Goldham, here involved in a discussion with game officials and Montreal's Bert Olmstead, was part of the Toronto Maple Leafs team that rallied from a 3-0 series deficit to beat Detroit in the 1942 Stanley Cup final. A supreme shot-blocker whom many hockey people insist should be in the Hall of Fame, Goldham was part of Detroit Stanley Cup winners in 1951-52, 1953-54 and 1954-55. He retired from the game in 1956 and later gained fame as an analyst on Hockey Night in Canada.

42

Two Detroit superstars lay siege to the net of Toronto Maple Leafs goalie Ed Chadwick. That's Alex Delvecchio (10) digging in the slot, while Ted Lindsay (7) swoops in on left wing. Toronto backchecker Ron Stewart falls to the ice in front of Chadwick. Delvecchio, Lindsay, Art Duncan and Sid Abel are the only people in franchise history to serve as captains, coaches and general managers during their tenure in Detroit.

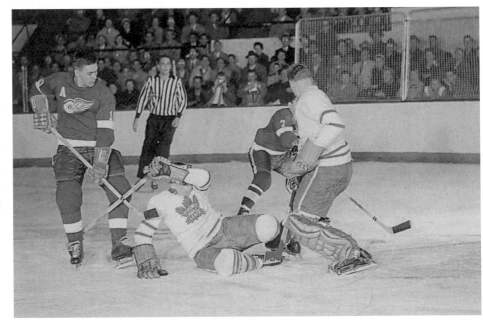

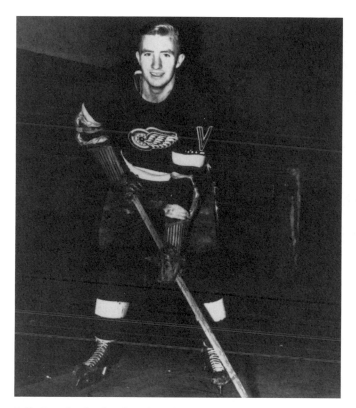

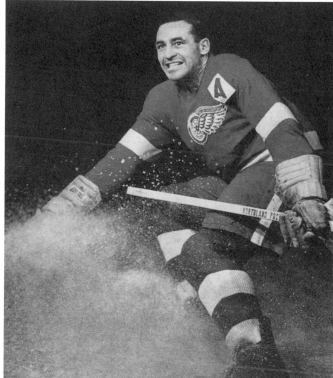

Bill Quackenbush played a thinking man's game along the blueline for the Detroit Red Wings. Not a physical defenceman, he utilized his guile and smarts to outwit the opposition and remove the puck from their possession. The man they called Quack was an outstanding poke-checker who studied opponents endlessly to get a handle on their tendencies. He once played 131 consecutive games on defence without receiving a single penalty. Quackenbush played in four Stanley Cup finals, but never finished on the winning side. Note the V on the left sleeve of his uniform. The V stood for victory and was worn by all six NHL teams during the Second World War as a symbolic gesture supporting the troops overseas and boosting morale back home.

Black Jack Stewart was never fond of his nickname. While Bill Quackenbush was Detroit's finesse defenceman during the 1940s, Stewart was the punisher along the back end. He was a devastating body checker and although certainly rough, Stewart didn't play a dirty game. He did lead the NHL in penalty minutes in 1945-46 and was named to the NHL's Second All-Star Team. Stewart estimated that he collected over 50 scars and 200 stitches during his playing days. A three-time NHL First All-Star Team selection, he was elected to the Hockey Hall of Fame in 1964.

While New York Rangers forward Dave Creighton supplies Detroit captain Red Kelly with a glove facial, young Norm Ullman is on the puck and about to make a clean getaway. Ullman, best known for wearing No. 7 as a Red Wing, started his Detroit career as No. 16. The Hall of Famer was guilty of bad timing, though. He broke in with the Wings in 1955-56, one season after their last Stanley Cup win until 1996-97, and was traded to Toronto in 1967-68, one season after the Leafs' most recent Cup triumph.

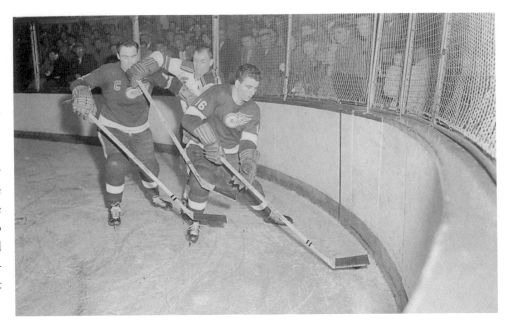

44

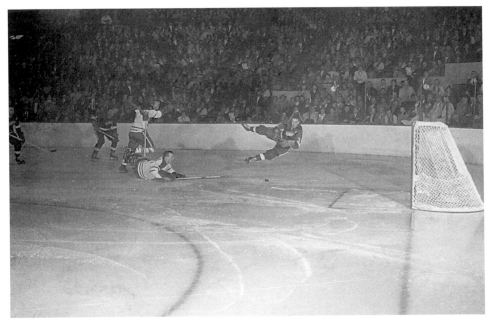

Sometimes, Toronto Maple Leafs goalie Johnny Bower got the puck with his world-famous poke-check, and sometimes, he got the puck carrier. This time, he's sent Wings defenceman Marcel Pronovost airborne. Inducted into the Hockey Hall of Fame in 1978, Pronovost won four Stanley Cups with Detroit. He was called up from the minor leagues during the 1950 playoffs after Gordie Howe was injured, and is one of 25 players in NHL history to earn an inscription on the Stanley Cup before playing his first regular-season game.

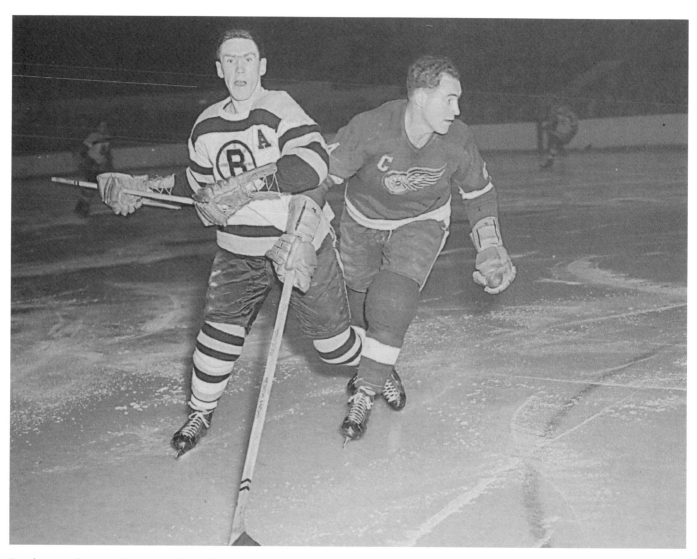

45

Just because he won three Lady Byng Trophies for his gentlemanly play while with the Red Wings—he and fellow Detroiter Bill Quackenbush remain the only defencemen to win the award—don't go thinking Red Kelly didn't like to mix it up on the ice. Boston forward Leo Labine testifies to that as he's rubbed out of the play by Kelly, who is trying to pursue a puck into the Detroit zone. Kelly was enshrined in the Hockey Hall of Fame in 1969.

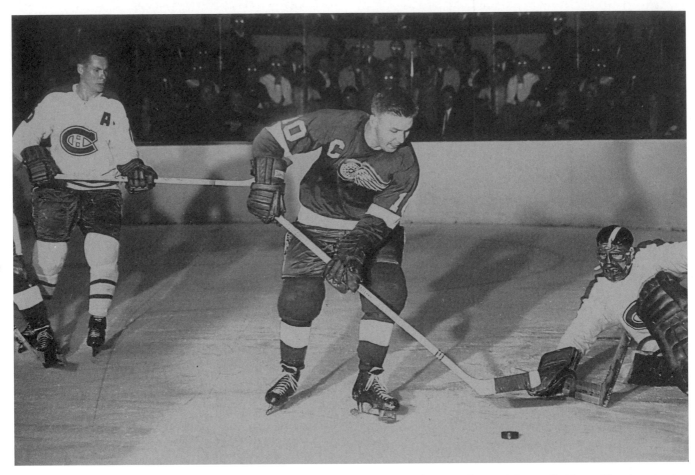

Alex Delvecchio has Montreal goalie Jacques Plante down and at his mercy, and Tom Johnson, Montreal's Norris Trophy-winning defenceman, isn't going to get there in time to help. One of the most gentlemanly players in NHL history, Fats—as Delvecchio was known—won Lady Byng Trophies in 1958-59, 1965-66 and 1968-69. He garnered just 383 penalty minutes in his 1,549 NHL games for Detroit, which is just 15 minutes shy of the club record 398 penalty minutes served by Bob Probert during the 1987-88 season.

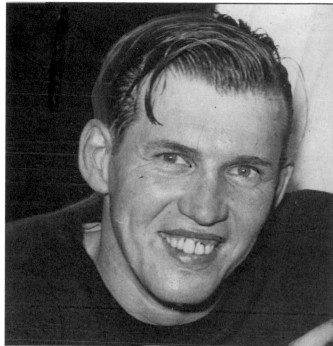

Bill Quackenbush had a cup of coffee with the Wings during their 1942-43 Stanley Cup-winning campaign, playing 10 games and scoring his first NHL goal. Quackenbush made it for good the following season and was a First Team NHL All-Star selection with the Wings in 1947-48 and 1948-49. He played in three Stanley Cup finals as a Wing, but never came out on the winning side. During the 1948-49 season, he played the entire season without incurring a penalty and became the first NHL defenceman to win the Lady Byng Trophy as the league's most sportsmanlike player. That wasn't what Detroit GM Jack Adams was looking for from a blue-liner, and that summer he traded Quackenbush and Pete Horeck to the Boston Bruins for Pete Babando, Lloyd Durham, Clare Martin and Jimmy Peters Sr.

Detroit's first Howe was also an NHL superstar. Detroit GM Jack Adams unleashed a blockbuster deal on Feb. 11, 1935, shipping Teddy Graham and a whopping $50,000 to the St. Louis Eagles for forward Syd Howe and defenceman Ralph (Scotty) Bowman. Howe helped Detroit to three Stanley Cup victories and led the Wings in scoring with a club record 55 points in 1942-43. He set a Red Wings single-game mark, scoring six times during a 12-2 drubbing of the New York Rangers on Feb. 3, 1944. On March 8, 1945, Howe set up Joe Carveth for a goal against the Rangers for his 516th NHL point, moving him past Nels Stewart into the NHL's all-time scoring lead.

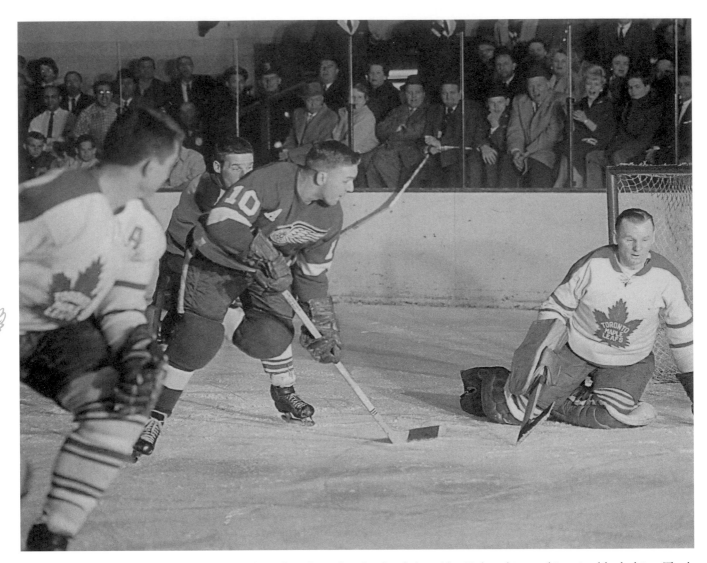

Toronto Maple Leafs goalie Johnny Bower clears the rebound aside after foiling Alex Delvecchio on this point-blank drive. That's the stick of Leafs' defenceman Tim Horton wedged into Delvecchio's midsection. Inducted into the Hockey Hall of Fame in 1977, Delvecchio was the third player in NHL history to accumulate 1,000 career points, following teammate Gordie Howe and Montreal's Jean Beliveau.

Legends of the Game

Four future Hall of Famers find themselves engaged in heated action around the Detroit net. Detroit goalie Terry Sawchuk gets his pad in the path of a shot by Montreal's Maurice (Rocket) Richard, while Red Wings defenceman Red Kelly does his best to prevent Canadiens centre Jean Beliveau from getting to the rebound.

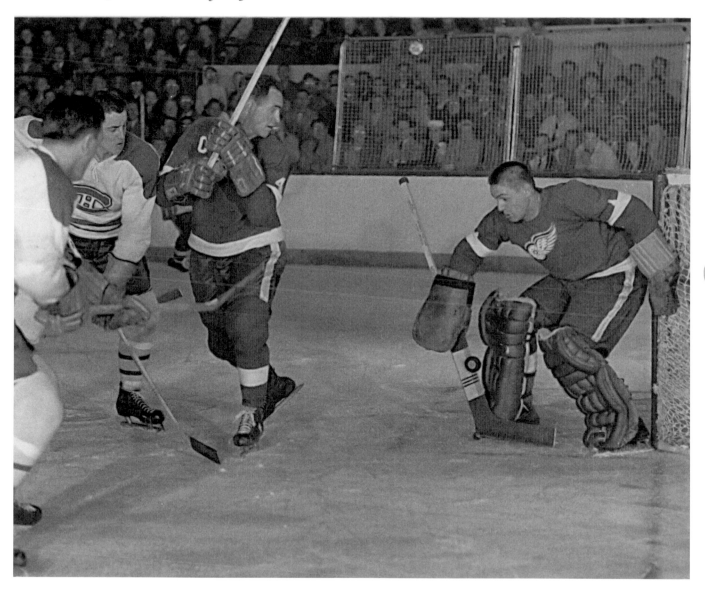

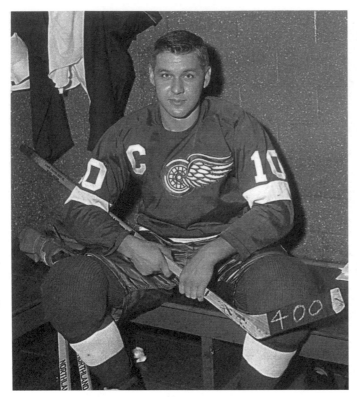

50

The captain celebrates a milestone. Alex Delvecchio poses with the stick he used to garner his 400th NHL point. The historic digit was registered with an assist during a 4-3 victory over the Boston Bruins on January 3, 1960. Always ready to lend a helping hand, Delvecchio was one of the best pure passers in the history of the game. Though he never led the Wings in scoring during a single season, he did top the Stanley Cup playoffs with 11 assists during the spring of 1966.

Long before he was the hero of all Canadians, Paul Henderson was a Red Wing. A Memorial Cup winner with the Hamilton Red Wings in 1961-62, the following season Henderson led all OHA Junior A shooters with 50 goals, earning a two-game call-up to the big club. He made it for good the following season and produced back-to-back 20-goal campaigns for Detroit in 1964-65 and 1965-66. Traded to the Toronto Maple Leafs in 1968, Henderson became a national hero during the 1972 Summit Series, scoring game-winning goals for Canada against the Soviet Union in Games 6, 7 and 8 of the set, rallying Canada from a 3-1-1 deficit to victory in the epic eight-game hockey showdown.

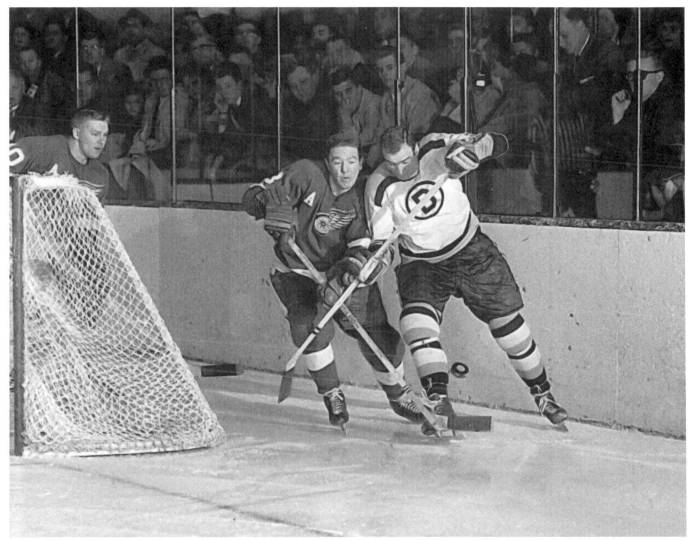

51

Red Wings defenceman Marcel Pronovost tangles for the puck behind the Detroit net with Boston Bruins right-winger Ed Westfall, while Alex Delvecchio watches the battle unfold. One of the most underrated players in Detroit history, Pronovost was a four-time NHL All-Star Team selection who won four Stanley Cups as a Red Wing and was runner-up in the Norris Trophy voting as the NHL's best defender following the 1959-60 season.

Montreal Canadiens goaltender Jacques Plante is at his acrobatic best as he sprawls to get into the path of a Norm Ullman shot, as Montreal's Bernie (Boom-Boom) Geoffrion arrives too late to help. The seventh player in NHL history to reach the 400-goal plateau, Ullman's best season as a Red Wing came during the 1964-65 campaign, when he finished second in NHL scoring with 42-41-83 totals.

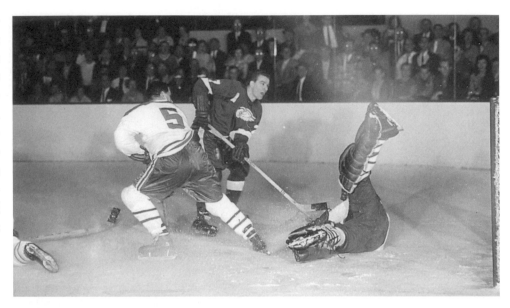

52

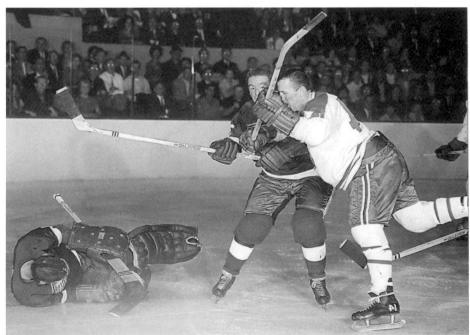

Red Wings goalie Terry Sawchuk is down and covering the puck, and Detroit defenceman Marcel Pronovost is protecting the house. One of the most punishing body checkers in NHL history, Pronovost delivers a stiff shoulder check into Montreal forward Claude Provost, crumpling Provost's face in the process. At the end of the NHL's six-team era in 1967, only Detroit's Gordie Howe (241) and Red Kelly (197) had appeared in more Stanley Cup games in NHL history than Pronovost (170).

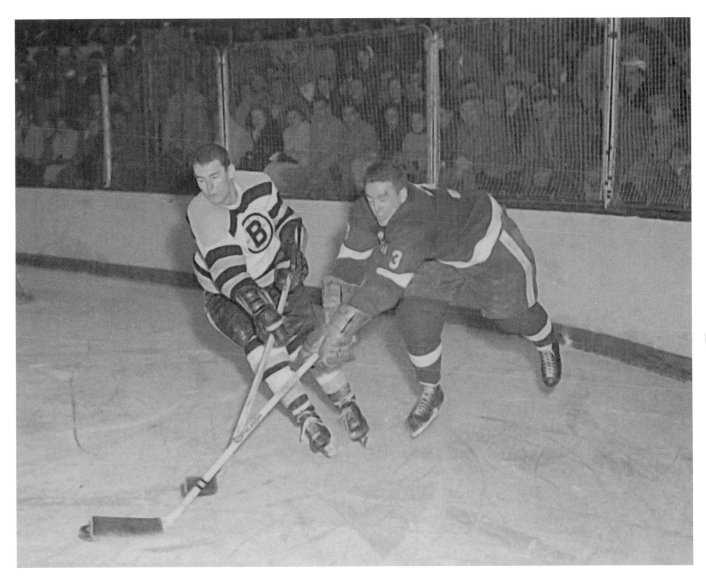

53

Detroit defenceman Marcel Pronovost duels for the puck with one of the NHL's toughest customers, Boston Bruins defenceman Ted Green. Pronovost owns the Stanley Cup record for the longest stretch between first and last inscriptions. He won the Cup as a rookie with the Wings in 1950, and 53 years later won his eighth Cup as a scout for the New Jersey Devils.

Two Hall of Famers who shared three Stanley Cup wins as Red Wings teammates find themselves on opposite sides of the battle on this occasion. Detroit centre Alex Delvecchio, who played all 1,549 games of his NHL career as a Red Wing, gives Boston Bruins goalie Terry Sawchuk a snow shower after he stops a shot on goal. Sawchuk broke in with the Wings during the 1949-50 season, was traded to Boston in 1955, and then reacquired from the Bruins in 1957.

54

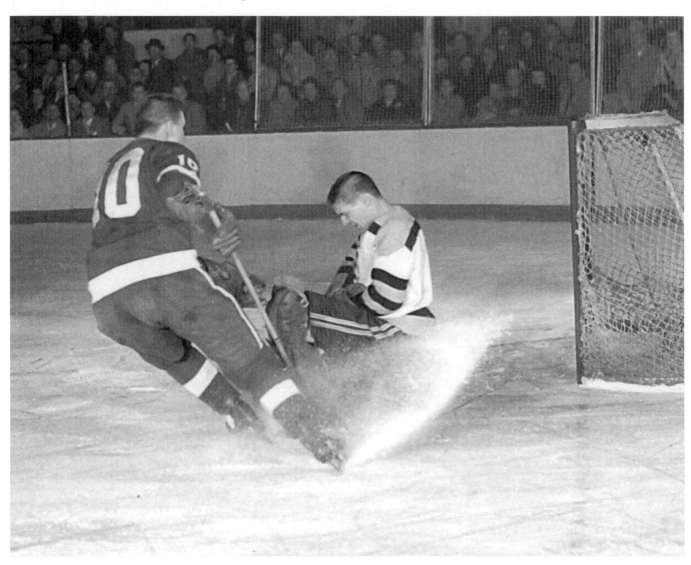

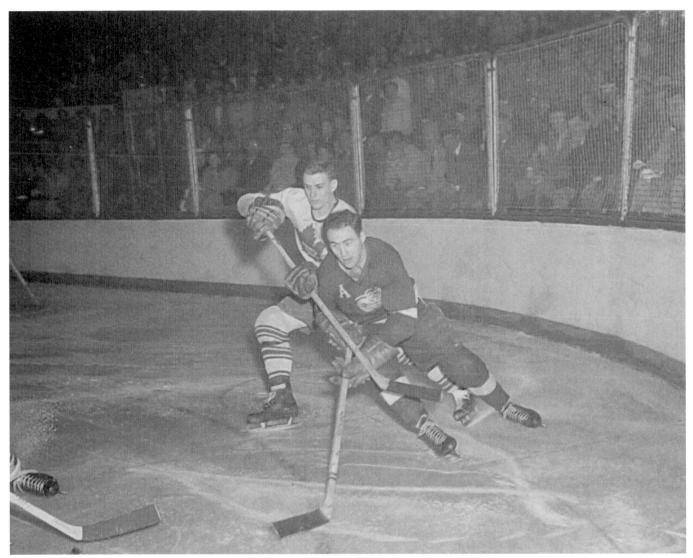

Detroit defenceman Red Kelly gets inside position on Toronto Maple Leafs left-winger Earl Balfour in pursuit of a loose puck, forcing Balfour to apply the hook to Kelly. The Leafs let Kelly escape their clutches when he was a junior playing for Toronto St. Michael's, and the Wings swooped in and added him to their protected list. His Hall of Fame career began in 1947, and Kelly played in seven Stanley Cup final series as a Red Wing, winning four times.

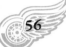

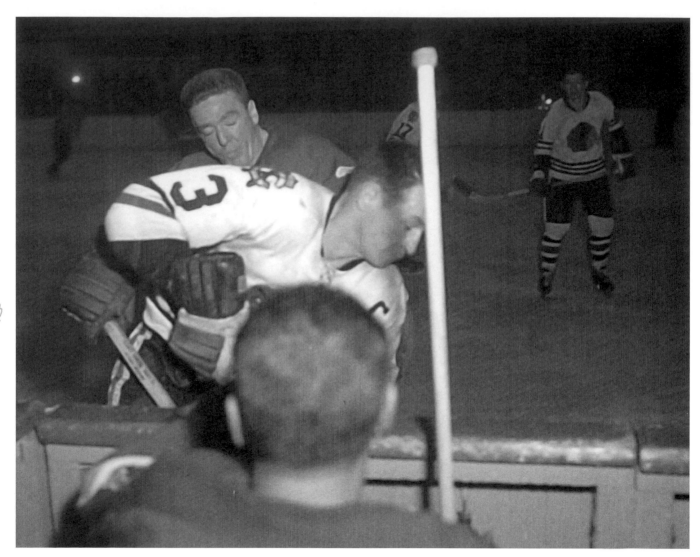

A pair of Hall of Famers duel for the puck along the boards in front of the penalty box, as Detroit defenceman Marcel Pronovost pins Chicago Blackhawks captain Pierre Pilote while Chicago centre Stan Mikita watches the action unfold. Pilote would play his farewell season as an NHLer with the Toronto Maple Leafs in 1968-69, with Pronovost as one of his teammates and himself playing his second-last NHL campaign that season.

Detroit defenceman Bill Gadsby makes sure the Golden Jet's flight pattern is disrupted, as he stands up Chicago Blackhawks left-winger Bobby Hull at the blue line. Two number 11s—Chicago's Bill Hay and Detroit's Vic Stasiuk—seek to avoid becoming collateral damage. The Wings acquired Gadsby from the New York Rangers on June 12, 1961 for minor-leaguer Les Hunt. While Hunt never played an NHL game, Hall of Famer Gadsby was part of three Detroit Stanley Cup finalist teams during the 1960s, and was the third NHLer to play 20 seasons, following Gordie Howe and Dit Clapper.

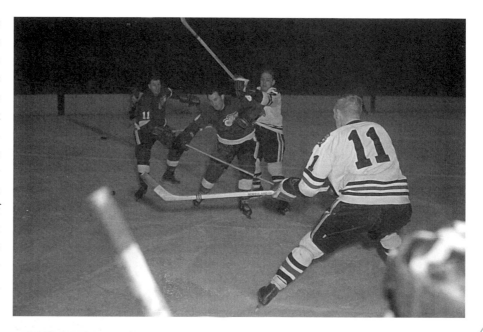

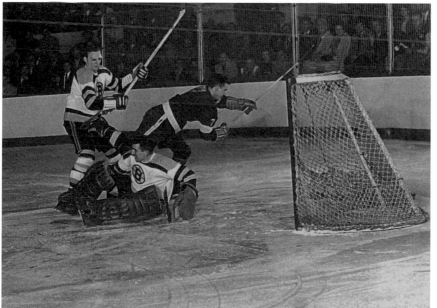

Ted Lindsay crashes the Boston Bruins' net, with a little help from Bruins defenceman Bill Quackenbush. Boston goalie Don Simmons stays with the puck and directs it to safety. Quackenbush and Lindsay both broke into the NHL with the Wings during the mid-1940s and both later turned to coaching after their careers were done. While Lindsay coached the Wings in the NHL, Quackenbush worked his magic in the NCAA ranks, guiding the men's and women's hockey teams and the men's golf team at Princeton, where he won three Ivy League women's hockey titles and eight men's golf crowns.

57

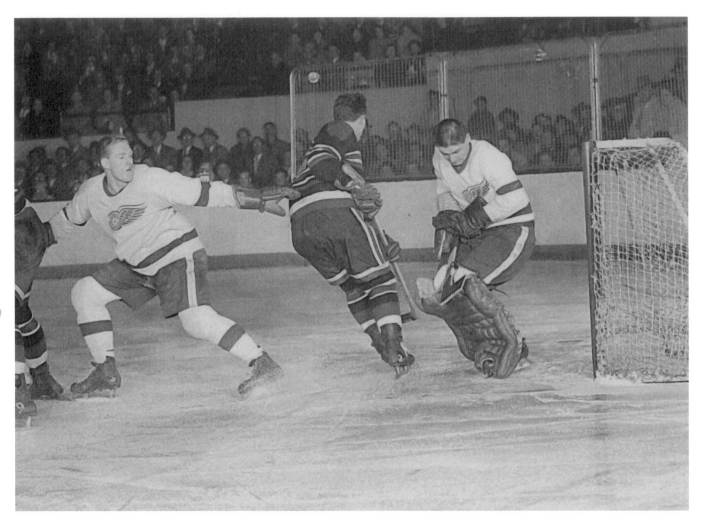

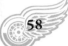

The Red Wings' net is under siege from the Chicago Blackhawks' attack, but a young Terry Sawchuk has things under control, corralling a shot in his midsection and ensuring that there will be no chance for a rebound. Turning to see if his netminder requires assistance is defenceman Larry Hillman. Both players were part of Detroit's 1954-55 Stanley Cup championship squad, which would be the last Red Wings team to lift Lord Stanley's mug until 1996-97. Later, Sawchuk and Hillman teamed up again to help the Toronto Maple Leafs win the last Stanley Cup of the Original Six era in 1966-67. That remains the most recent Cup captured by the Maple Leafs.

Legends of the Game

Red Wings centre Alex Delvecchio gets the worst of it as he tries to split the Boston Bruins defensive pairing of Bob Armstrong and Larry Hillman. Getting caught like this was unusual for Delvecchio, who saw the ice about as well as anyone who played the game. Maybe Hillman had inside knowledge, though. Delvecchio and Hillman were teammates on Detroit's 1954-55 Stanley Cup.

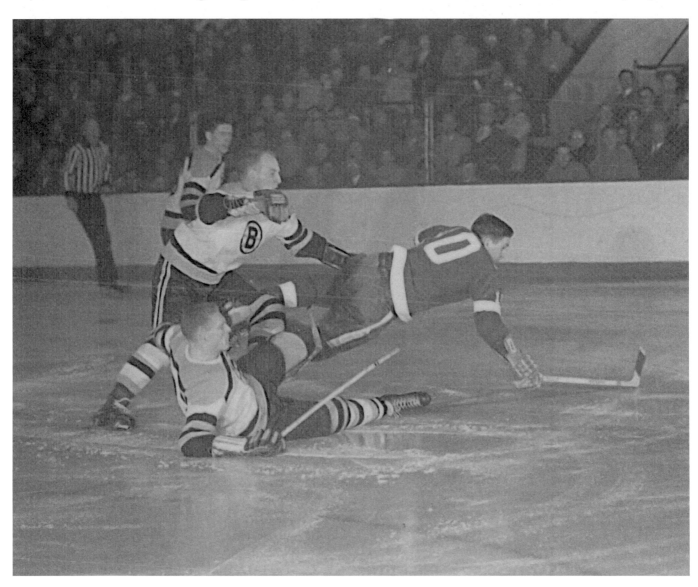

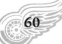

Detroit defenceman Red Kelly gains inside position on Toronto Maple Leafs centre Rudy Migay as they duel for the puck in the corner of the Red Wings end, while the old-school chicken wire stares them in the face. For someone who won four Lady Byng Trophies for the NHL's best combination of gentlemanly play and ability, Kelly never was one to shy away from close quarters in competition. He was an eight-time NHL All-Star selection as a Red Wing.

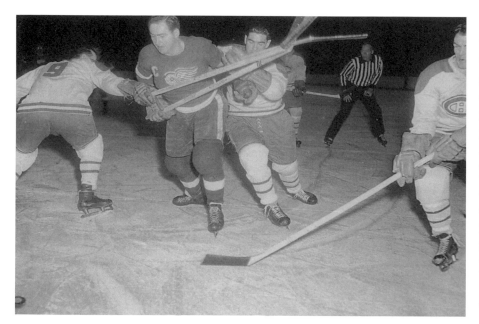

Detroit captain Red Kelly appears to be taking on the majority of the Montreal Canadiens all on his lonesome, and he's garnering plenty of attention for his efforts to pursue the loose puck. That's Montreal right-winger Maurice (Rocket) Richard (9) with his stick draped across the winged wheel on Kelly's chest, while left-winger Andre Pronovost drives a cross-check into Kelly's back. With Kelly otherwise occupied, Montreal centre Henri Richard, Maurice's little brother, heads off to chase down the loose disk. Kelly served as Detroit captain from 1956-58, at which point the C was given to Gordie Howe.

Detroit defenceman Marcel Pronovost is in all alone on Montreal goalie Gerry McNeil, but McNeil has the answer this time. Pronovost nearly netted the Cup winner for Detroit in the third period of Game 7 of the 1954 Stanley Cup final series with the score tied 1-1, but it was left to Tony Leswick to decide the issue with his tally in the first overtime session, giving the Wings their third title in four seasons.

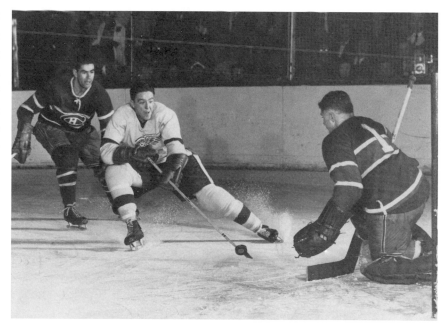

Bleeding from over his left eye, referee Bill Chadwick looks to have gotten the worst of this altercation between Detroit defenceman Red Kelly and Toronto forward Ron Stewart (12). Though a four-time Lady Byng Trophy-winner as the NHL's most sportsmanlike performer, Kelly was no stranger to physical play. In fact, during the 1953 NHL All-Star Game, of all places, he and Bert Olmstead of Montreal dropped the gloves and were assessed fighting majors.

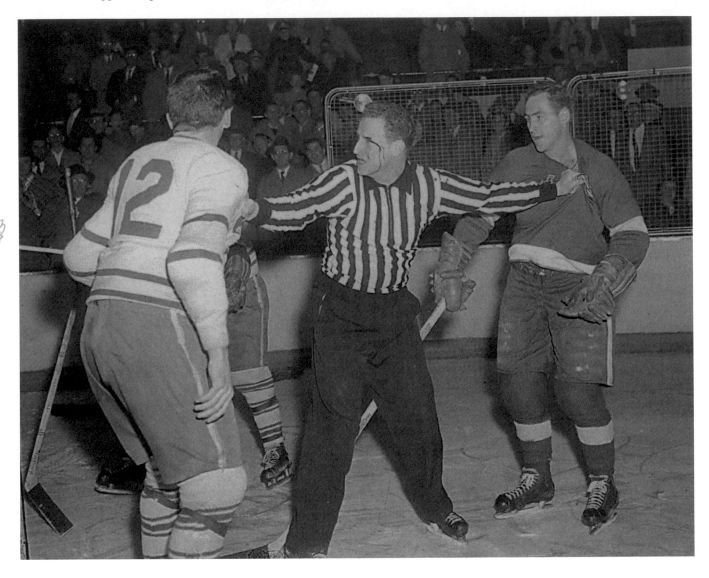

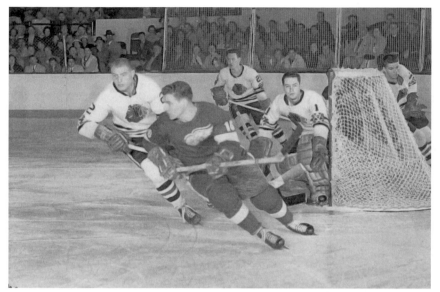

A young Norm Ullman turns in front of Chicago goalie Glenn Hall's net with Blackhawks defenceman Elmer (Moose) Vasko hot on his heels. The action takes place during the 1957-58 season, Ullman's third as a Red Wing and the last in which the Detroit centre would wear No. 16. He switched to his more familiar No. 7 the following season.

These wide-eyed youngsters can't believe their good fortune as they crowd around to get an autograph from Red Wings Norris Trophy-winning defenceman Red Kelly. Detroit GM Jack Adams demanded that his players be accountable to the fans and required that they head to and from the ice surface and the arena through avenues that were accessible to the public.

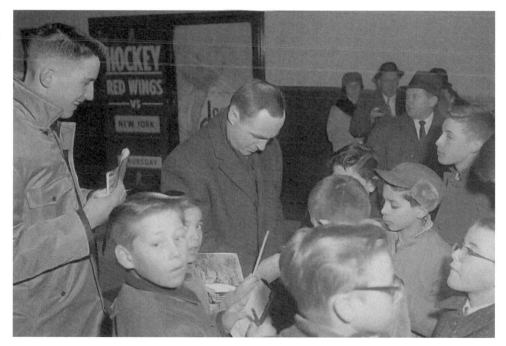

63

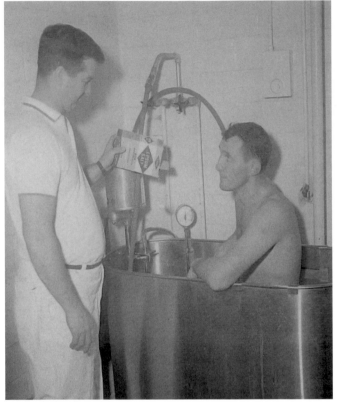

64

A little Epsom salts, Bill? Detroit trainer Ross (Lefty) Wilson looks after Red Wings defenceman Bill Gadsby as he recovers with a post-game whirlpool bath. Acquired by Detroit from the New York Rangers in 1962, Gadsby had never won a Stanley Cup series before coming to the Wings, but played in three Stanley Cup finals with Detroit (1963, 1964, 1966). He was also the first player in NHL history to play 300 career games for three different teams—the Red Wings, the Rangers and the Chicago Blackhawks.

Toronto Maple Leafs left-winger Sid Smith clears the puck to safety as Detroit centre Norm Ullman bears down on his check. The seventh player in NHL history to reach the 400-goal plateau, Ullman set a Stanley Cup record playing for the Wings in the semi-finals against the Chicago Blackhawks when he scored two goals in five seconds, part of a hat trick he recorded during Detroit's 4-2 victory in Game 5 of the series on April 11, 1965.

Legends of the Game

Chicago Blackhawks centre Bill Hay, today the CEO of the Hockey Hall of Fame, here is being quite unkind to one of the Hall's honoured members, Detroit defenceman Bill Gadsby. Gadsby actually began his career with the Blackhawks during the 1946-47 season, and that spring he finished ahead of Detroit rookie right-winger Gordie Howe in the Calder Trophy voting for the NHL's top rookie player.

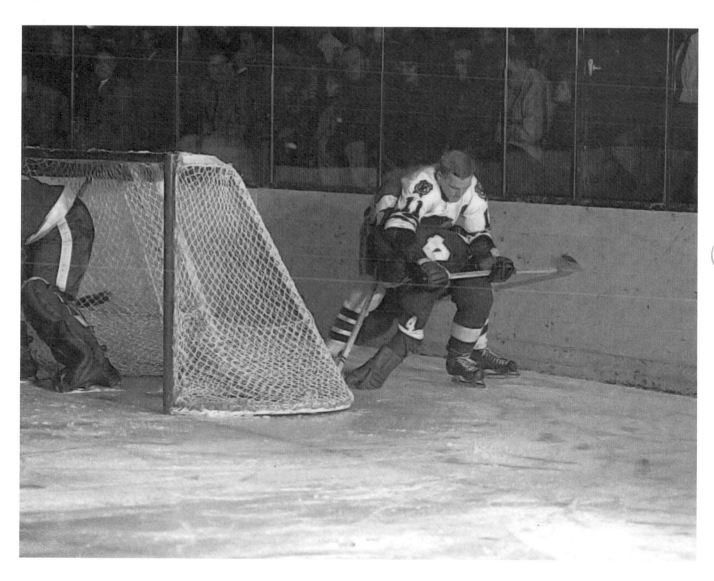

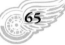

Original Six Dynasties: Detroit Red Wings

Detroit centre Norm Ullman looks between his legs at the puck as he seeks to free himself from the clutches of Boston Bruins centre Bob Beckett. Bruins goalie Bruce Gamble hugs his post and keeps tabs on the situation. Ullman donned No. 7 for Detroit for the first time to begin the 1958-59 season, two years after the number's previous wearer, Ted Lindsay, was dealt to Chicago. Ullman would wear it until he was traded to Toronto in 1968. But the No. 7 got quite the workout during 1957-58, the first season after Lindsay's departure. Centres Billy Dea (29 games), Brian Kilrea (one game), Murray Oliver (one game), Stu McNeill (two games) and Hec Lalande (12 games) all donned the digit that season.

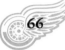

66

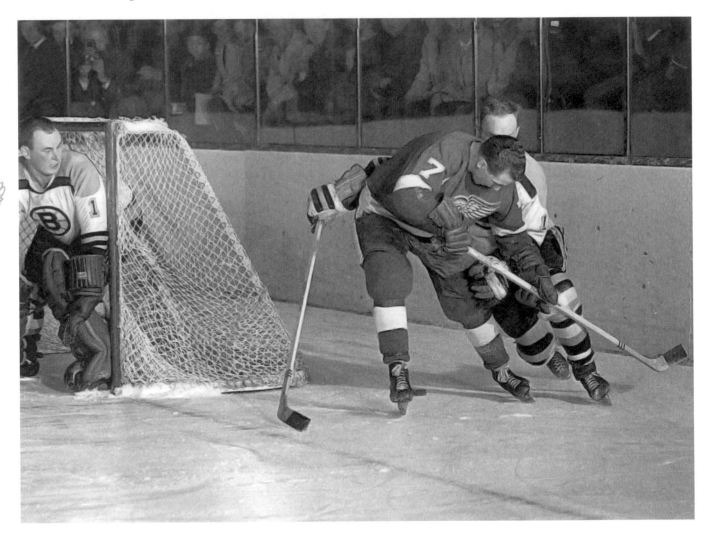

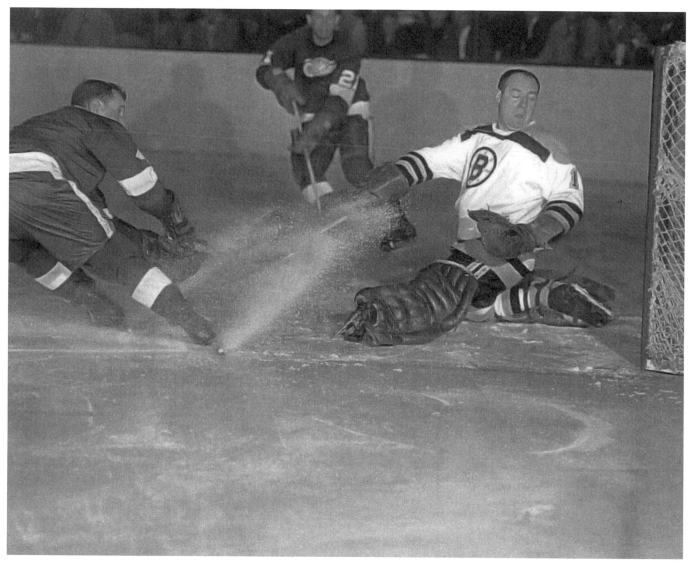

67

A defenceman with a flair for the offence, Detroit's Bill Gadsby (4) drives to the net looking to chip a puck past Boston Bruins goaltender Bob Perreault, as Ed Joyal (21) looks on. With an assist November 4, 1962 on Parker MacDonald's game-winning goal in a 3-1 win over the Chicago Blackhawks, Gadsby became the first defenceman in NHL history to collect 500 career points.

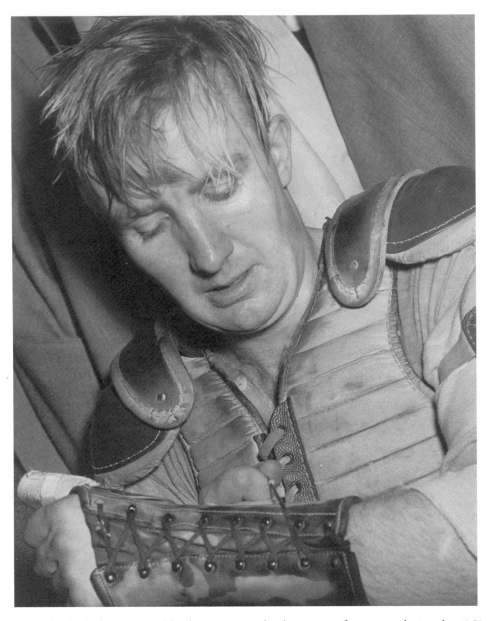

Detroit's Bill Quackenbush dons a special leather wrist-guard as he suits up for a game during the 1948-49 season.

Chapter Three:
The Puck Stops Here

MOST NHL TEAMS WOULD FEEL fortunate to produce just one Hall of Fame netminder over the course of a generation. During the Original Six era, the Detroit Red Wings suited up no less than four future Hall of Fame puckstoppers.

The line of success started with Harry Lumley. When he broke into the big leagues at 17 in 1943-44, Lumley was the youngest netminder in NHL history. "There was such a shortage of players due to World War II," Lumley explained. A year later, as he backstopped the Wings to a seven-game Stanley Cup final loss to the Toronto Maple Leafs, Lumley became the youngest goaltender to ever appear in a final series.

In 1947-48, Lumley led the NHL in shutouts, once again taking Detroit to the final. The Wings were back in the final again in 1948-49 with Lumley barring their net.

The next spring, the Wings were finally a success, as Lumley backstopped them to the 1949-50 Stanley Cup, winning a seven-game final series from the New York Rangers. Known as Apple Cheeks for his ruddy complexion, Lumley was not one to be messed with on game day. He had his routine. "If he gave up a goal, his face would turn as red as the goal light," recalled former teammate Red Kelly.

Joking around as a forward in an exhibition game between the Wings and the International Hockey League All-Stars during the 1949-50 season, Lumley actually opened the door to his exit from Detroit. He suffered

a badly sprained ankle in the game, and a young Terry Sawchuk was recalled from Indianapolis of the American Hockey League to serve a seven-game stint between the Detroit pipes. That was enough for Wings GM Jack Adams to be convinced Sawchuk was his goalie of the future. In the summer of 1950, Adams dealt Lumley to Chicago and installed Sawchuk as his team's new No. 1 goalie.

Instantly, he was successful. Sawchuk was the NHL's rookie of the year in 1950-51, and he won three Vezina Trophies and earned seven All-Star selections as a Red Wing. "He'd always say, 'Get me a couple and we'll win,'" recalled former Detroit coach Jimmy Skinner. "He didn't say it in a bragging kind of way. He was just that confident."

Off the ice, Sawchuk may have also been the NHL's most tortured soul. He endured terrible mishaps— punctured lungs, chronic back pain, severed tendons in his hand, and a broken arm that healed improperly and was shorter than his other arm. "We are the sort of people who make health care popular," Sawchuk said. "The hardest thing for a goaltender to do is relax. The pressure out on the ice during a game is tremendous."

When he was a young Red Wings prospect playing across the Detroit River with the junior Windsor Spitfires, Glenn Hall would slide over to Olympia Stadium, situate himself behind the Detroit net and study Sawchuk's work. "I tried to copy his style, to use that low crouch which he played," Hall said.

In 1955, after watching Hall fill in a few times for an injured Sawchuk, Adams decided he'd found his next goalie and shipped Sawchuk to Boston. Again, his logic seemed to pay dividends. Hall was the NHL's rookie of the year in 1955-56, and he backstopped Detroit into the Stanley Cup final. But when Detroit didn't win the Cup and Sawchuk became available, Adams reacquired his old goalie and dealt Hall to Chicago in 1957.

In his second tenure, Sawchuk held forth as Detroit's No. 1 goalie through 1964, leading the club to three Cup final appearances. Again, injuries opened the door to another understudy, and Roger Crozier was handed the job in the summer of 1964; Sawchuk was lost to Toronto in the NHL's Intra-League draft.

Like Sawchuk and Hall before him, Crozier was the NHL's top rookie in 1964-65, playing in all 70 games, the last NHL goalie to appear in every one of his team's games. He carried Detroit to the Cup final in 1966 and even though the Wings lost to Montreal, Crozier was awarded the Conn Smythe Trophy as playoff MVP.

As with Sawchuk, Crozier was a tortured soul who battled lifelong pancreatitis. "I like everything about hockey except the games," Crozier once said. "If I could go back and do it over again, I'd be a forward or defenceman for sure."

Johnny Mowers was known as Mum in the Detroit dressing room, and Mum was the word when it came to puckstopping in the NHL during the 1942-43 season. Mowers led all NHL goalies that season in wins (25), shutouts (6) and goals-against average (2.47) capturing the Vezina Trophy as the league's leading netminder. Selected to the NHL's First All-Star Team, Mowers continued to excel in the playoffs, leading Detroit to a Stanley Cup final sweep of the Boston Bruins, posting back-to-back shutouts in Games 3 and 4 of the series. But it would prove to be the last hurrah of his career. Mowers joined the Canadian military after the season and never won another NHL game.

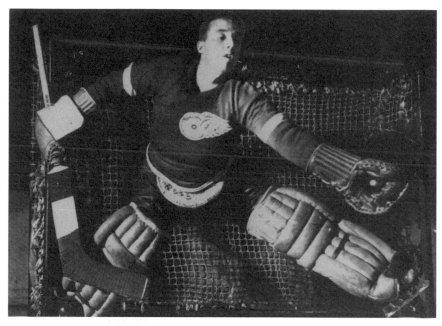

71

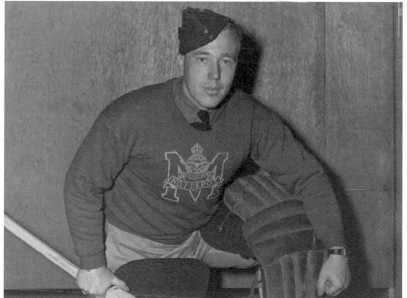

Detroit goalie Johnny Mowers poses in his military uniform and goalie gear. Shortly after carrying the Wings to the 1943 Stanley Cup title with back-to-back shutouts in Games 3 and 4 of a four-game sweep of the Boston Bruins, Mowers enlisted in the armed forces. He led the NHL in wins and earned the Vezina Trophy during the 1942-43 campaign, but he'd never win another NHL game.

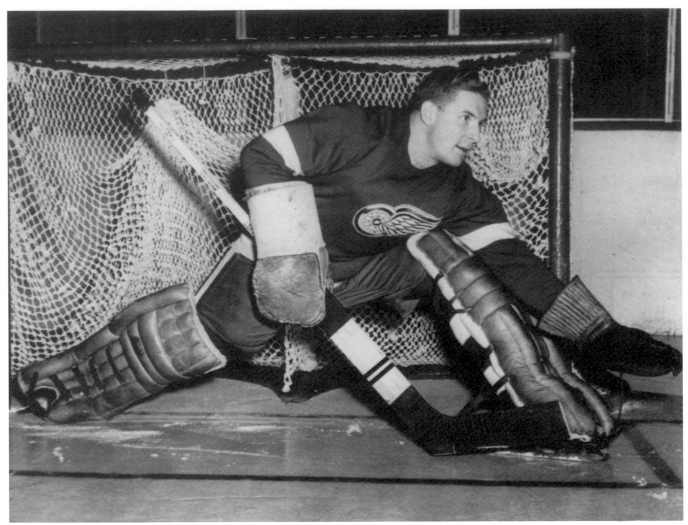

72

Harry Lumley set an NHL record that still remains on the books when he first donned the pads for the Red Wings during the 1943-44 season. After Jimmy Franks lost 5-1 to Montreal, veteran Normie Smith—Detroit's goalie during their Stanley Cup triumphs in 1935-36 and 1936-37—came out of retirement to beat the Habs 4-1. But Smith's wartime job prevented him from making any road trips, so Detroit coach Jack Adams recalled rookie Lumley from Indianapolis of the AHL. He was just 17 when he made his NHL debut for Detroit in a 6-2 loss to the New York Rangers (1943), making Lumley the youngest goalie in league history.

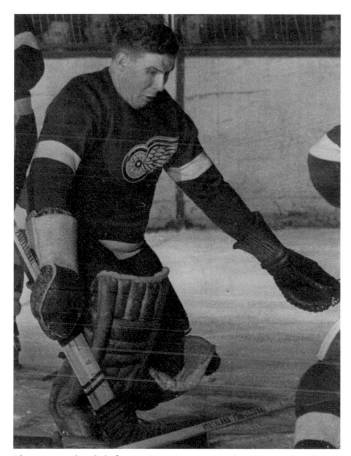

Showing splendid form, Detroit netminder Harry Lumley is square to the shooter and has his eyes fixed on the puck as he prepares to make a save. Lumley was 18 when he backstopped Detroit to the 1944-45 Stanley Cup final, making him the youngest goalie to play in a Cup final series. He played in four Stanley Cup finals between 1945-50 and was known as one of the nastiest netminders in hockey, willing to drop the gloves with anyone who dared enter his goal crease and not averse to carving his initials into the back of the legs of anyone foolish enough to venture too close to his territory.

A rare glimpse of troubled Red Wings goalie Terry Sawchuk with a smile on his face. Sawchuk led the NHL in wins in each of his first five full seasons and had posted 57 shutouts by the end of the 1954-55 season.

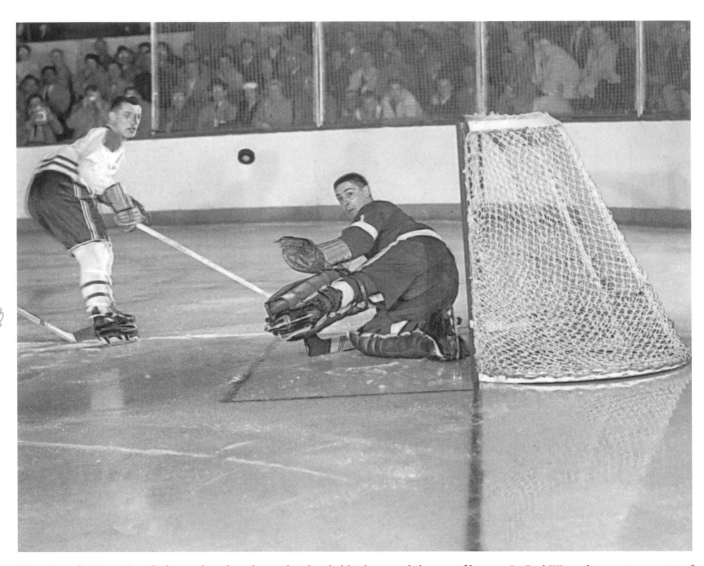

74

Detroit goalie Terry Sawchuk goes low, but the puck is headed high toward the top of his net. In Red Wings history, just a trio of players have served three tenures in Detroit, and all were goalies—Jim Rutherford, Dominik Hasek, and Sawchuk. Sawchuk broke in with the Wings during the 1949-50 season and stayed through 1954-55. He returned in 1957-58 and guarded the Detroit goal until 1963-64. His final stint wearing the Winged Wheel came during the 1968-69 season.

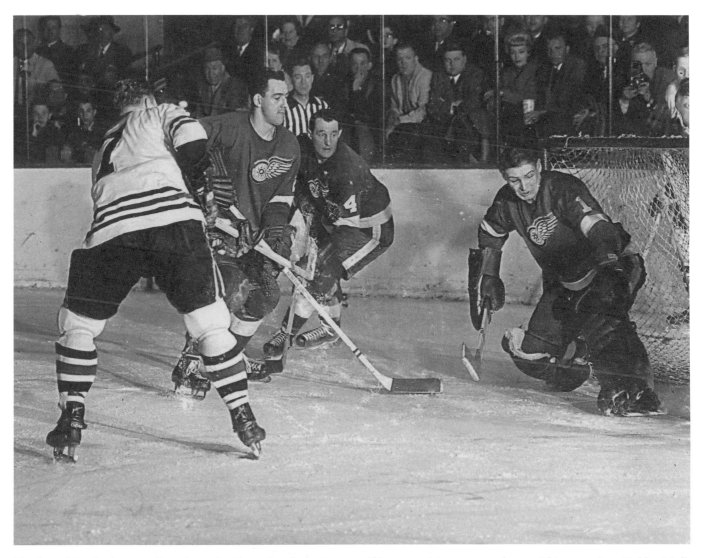

The best foils the best, as Detroit goalie Terry Sawchuk moves swiftly across his crease to thwart Chicago sniper Bobby Hull. Sawchuk won three Vezina Trophies as the NHL's top goalie with Detroit, while Hull was a three-time NHL scoring champ for the Black Hawks. Detroit defencemen Pete Goegan (2) and Bill Gadsby (4) can only watch as Sawchuk kicks out his left pad to parry Hull's drive.

Terry Sawchuk puts the paddle down to foil Ron Stewart of the Toronto Maple Leafs on a breakaway. The lives of these two players would be tragically intertwined forever. During the 1969-70 season, they were teammates with the New York Rangers and shared a home in Long Beach. Shortly after the season ended, the two were at a Long Beach bar when an argument ensued, later breaking out into a fight during which Sawchuk suffered internal injuries after falling into a barbecue pit. He died May 31, 1970 from a pulmonary embolism. An investigation was launched, but no charges were laid against Stewart.

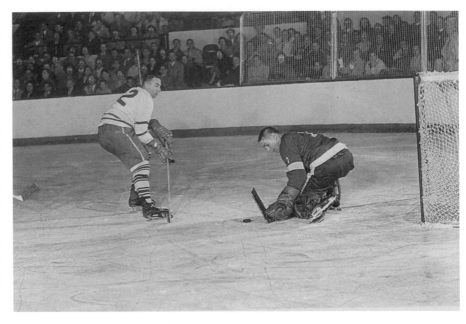

76

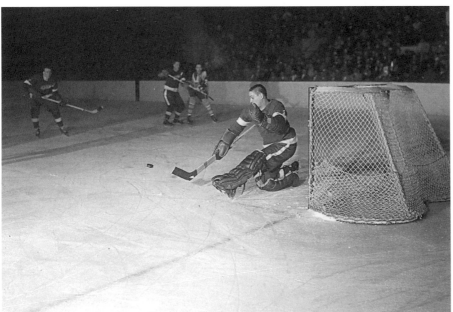

Terry Sawchuk kicks out a leg and uses his stick to parry a long drive away from his net. Few goalies broke into the NHL with the sort of success enjoyed by Sawchuk after he launched his Red Wings career. He was named the NHL's rookie of the year in 1950-51, and the following season he led the league with 44 wins, 12 shutouts and a 1.90 goals-against average. In the playoffs, he redefined stingy as Detroit swept to the Cup with a perfect 8-0 record. His GAA was a minuscule 0.63, his save percentage an astounding .977. Sawchuk didn't allow a goal in games at Olympia Stadium that spring, posting four shutouts.

Trailing the Montreal Canadiens late in a game, Red Wings coach Jimmy Skinner pulls Terry Sawchuk for the extra attacker during a stoppage in play. Gordie Howe looks forlorn as he skates to the bench, while Marcel Pronovost climbs over the boards to get into the fray. In 1950-51, his first full season as Detroit netminder, Sawchuk set a club record with 44 wins, then equaled it the following season as he led the Wings to the Stanley Cup.

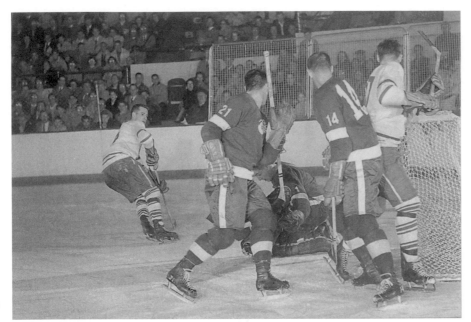

There's a crowd around the Detroit goal, but netminder Terry Sawchuk has everything well under control, freezing the puck in his body after a shot by Toronto Maple Leafs forward Willie Marshall. Centre Charlie Burns (21) loses his stick as he looks over at his goalie, while left-winger Claude Laforge (14) ensures that Toronto's Gerry Ehman (17) is getting nowhere near Sawchuk. Sawchuk is the franchise career leader in wins (351), shutouts (85) and minutes played (43,636).

78

Detroit goalie Glenn Hall focuses on the puck as Red Wings defenceman Marcel Pronovost takes defensive position against Boston Bruins forward Johnny Peirson, while Detroit left-winger John Bucyk has already driven Boston forward Vic Stasiuk to the ice. In his first full season as Red Wings netminder, Hall posted a league-leading 12 shutouts and a 2.11 goals-against average, backstopping Detroit to the Stanley Cup final and earning the Calder Trophy as the NHL's top rookie.

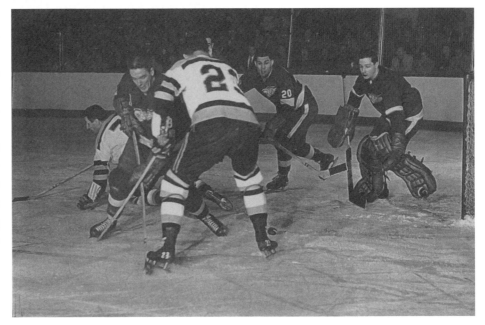

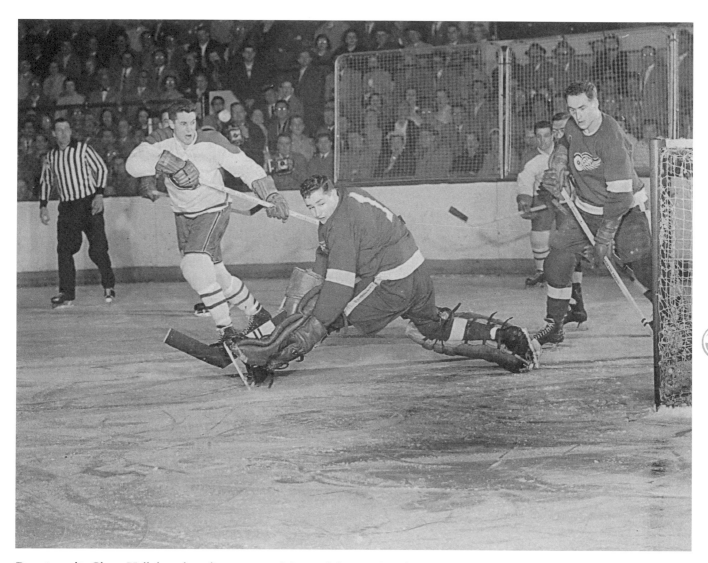

Detroit goalie Glenn Hall does the splits to parry a Montreal drive as Canadiens centre Jean Beliveau moves to the front of the net in search of a rebound. Wings defenceman Red Kelly looks mesmerized by Hall's work. It isn't often that a team can say it suited up two Hall of Fame goalies at the same time, but that was the case in Detroit from 1952-55. After the Wings won the Stanley Cup in 1954 55, they opted to trade Terry Sawchuk to Boston and handed the goaltending reins to Hall.

Glenn Hall is square to the shooter and has made the save, though he probably wasn't counting on also stopping the snow shower about to be delivered by Montreal Canadiens right-winger Floyd (Busher) Curry. After going 6-1-1 with a shutout and a stellar 1.50 goals-against average in eight games while filling in on two occasions for the injured Terry Sawchuk between 1952-55, Hall was handed Sawchuk's job to start the 1955-56 season. Hall took Sawchuk's crouching style of goal and modified it to the beginnings of what today is known as the butterfly style.

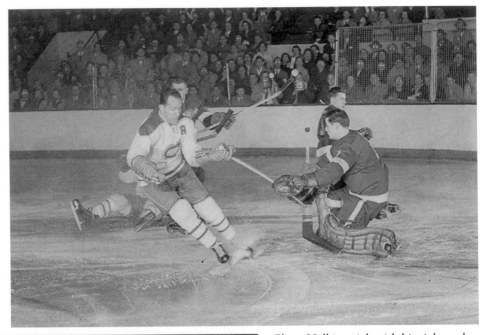

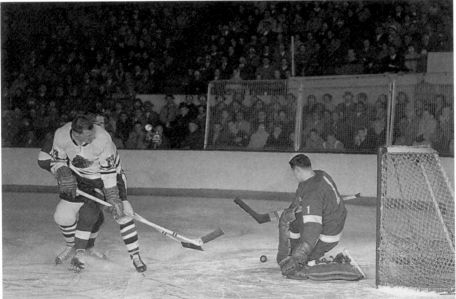

Glenn Hall is quick with his right pad to foil a scoring attempt by lanky Chicago Blackhawks forward Hank Ciesla. Bespectacled Detroit defenceman Al Arbour does his best to impede Ciesla's shooting attempt. Both Hall and Arbour would end up with the Blackhawks later in their careers, and in 1960-61, they were teammates on Chicago's Stanley Cup-winning team that defeated Detroit in a six-game final series.

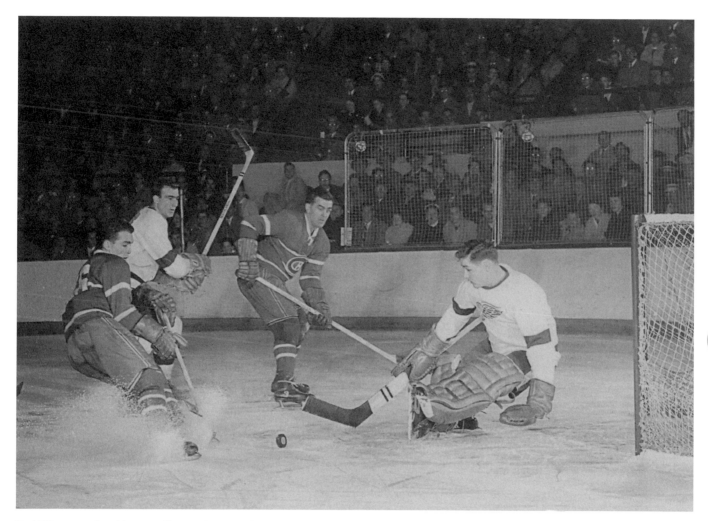

Red Wings goalie Glenn Hall is under siege from the Richard brothers, but he's winning the battle. Canadiens centre Henri (The Pocket Rocket) throws up a snow shower as he looks to get his stick on the rebound of a shot taken by his brother, legendary Canadiens right-winger Maurice (Rocket) Richard. Detroit GM Jack Adams shocked the hockey world when he dealt All-Star goalie Terry Sawchuk to the Boston Bruins shortly after the Wings won the Stanley Cup for the second straight season in 1954-55, handing the netminding chores to Hall. But it was hardly an unprecedented move. Back in 1950, just after the Wings had also won the Cup, Adams dealt goalie Harry Lumley to Chicago and gave the No. 1 puckstopping position to Sawchuk.

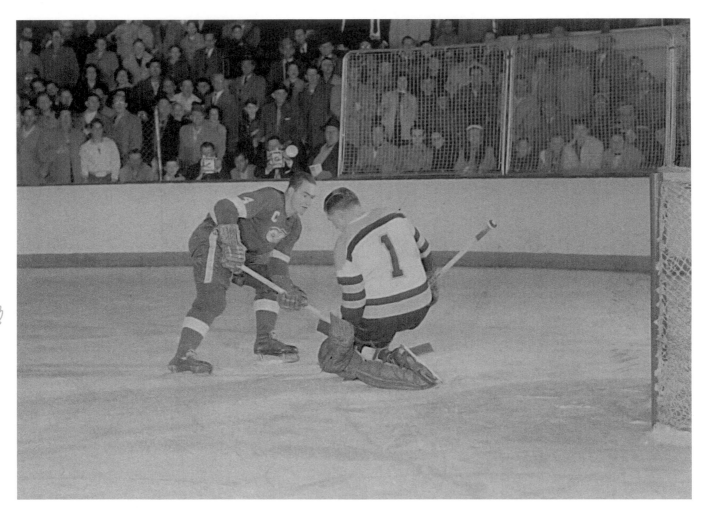

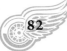

Boston Bruins goalie Harry Lumley comes way out on his angle to challenge Detroit defenceman Red Kelly on this breakaway chance. Apple Cheeks, as Lumley was known, was near the end of his NHL days when he played for the Bruins from 1957-60. He broke into the NHL with the Wings in 1943-44, setting an NHL record as the youngest goalie at 17 years of age. Lumley was part of Detroit's resurgence as an NHL power in the late 1940s. He backstopped them to the Stanley Cup final in 1945 at the age of 18, and led the Wings back there in 1947-48, 1948-49 and 1949-50, winning the title in his fourth try while leading the NHL with 33 wins. Lumley was traded to Chicago by Detroit with Jack Stewart, Al Dewsbury, Pete Babando and Don Morrison for Metro Prystai, Gaye Stewart, Bob Goldham and Jim Henry on July 13, 1950.

Who are those masked men? Detroit goalies Terry Sawchuk and Dennis Riggin pose with the newfangled masks they were experimenting with during training camp in 1962. When Sawchuk opted to don facial protection to begin the 1962-63 season, he became the first Detroit goalie ever to wear a mask in a game. Both of their masks were designed by Red Wings trainer Ross (Lefty) Wilson, himself a former NHL goalie.

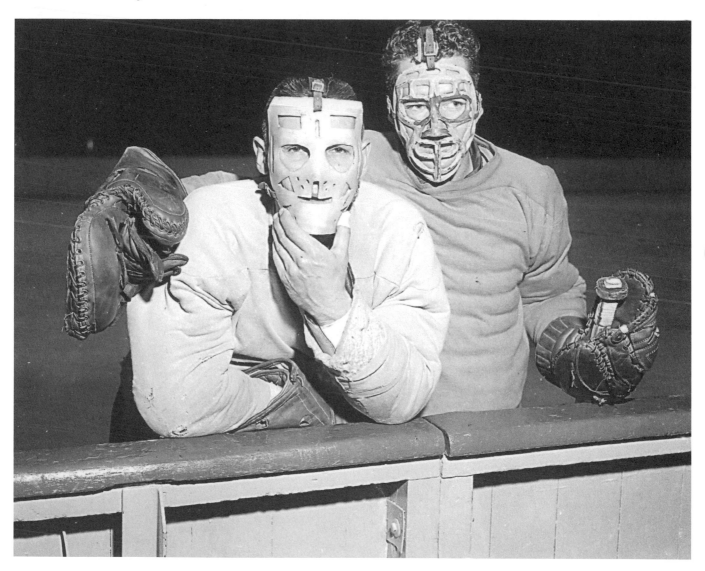

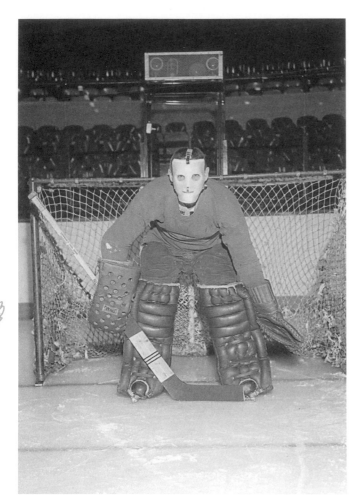

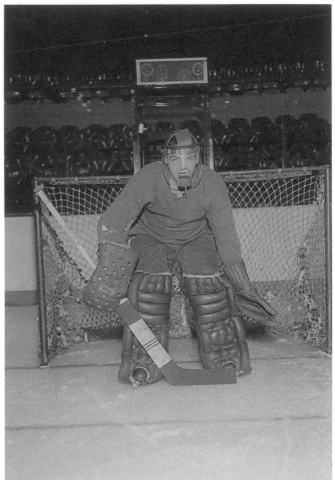

An early version of the mask that Terry Sawchuk would don for good to begin the 1962-63 NHL regular season. The mask was handcrafted by Red Wings trainer (Ross) Lefty Wilson. Wilson produced them from five sheets of fibreglass and charged about $35 for one of his creations.

No, Red Wings goalie Terry Sawchuk hasn't joined the Detroit riot police. This odd-looking contraption was a mainstay of NHL netminders in the days before the mask became a standard piece of the goaltender's gear. Made from Plexiglas, with a small opening around the mouth for breathing, goalies would wear this faceguard during practice to assure they wouldn't be needlessly injured by errant pucks fired by their own teammates.

An up-close look at the Plexiglas facial protection goalies wore during the late 1950s and into the mid-1960s. Detroit goalie Terry Sawchuk models the mask, which looks like something a welder might wear. Because they fogged up easily, this mask design, though it offered excellent sight lines, was impractical for game use. In the other two photos, Sawchuk squints through the eyeholes of the goalie mask designed for him by Red Wings trainer Ross (Lefty) Wilson.

Hockey people were ready to write a eulogy for Sawchuk's career after Detroit missed the playoffs in 1961-62. But wearing his new mask during training camp the following spring, Sawchuk beat out Hank Bassen and Dennis Riggin to retain his job, and led Detroit to the Stanley Cup final. "I don't know what it is really, but I feel I am playing better with a mask," Sawchuk told the *Canadian Press* during the 1962-63 season. Sawchuk followed Montreal's Jacques Plante and Toronto's Don Simmons as the third NHL goalie to don facial protection for good. "I'm sold on the mask," Sawchuk explained to the *Montreal Gazette* on September 28, 1962. "I'm going to make a switch or two in the one I wear. I'm going to use one that has a little ventilation." He'd wear the same mask through 1969-70, his farewell NHL season.

85

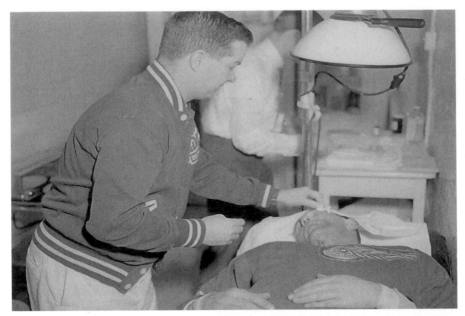

Detroit trainer Ross (Lefty) Wilson tends to wounded Red Wings defenceman Bill Gadsby. Besides his work as a trainer, Wilson also served as Detroit's practice goalie and played in emergency situations in three games—one each with Detroit, Boston and Toronto. He's the only player in NHL history to play three games and play them with three different teams, posting a career goals-against average of 0.71 in the process. But Wilson's ability between the posts was best summed up by Detroit GM Jack Adams, who once said of Lefty, "as a goalie, he makes a pretty good trainer."

Ever wonder what the well-dressed netminder is wearing this season? Detroit goalie Terry Sawchuk hunches over to collect a bowler hat tossed to the ice by an excited Red Wings fan moments after Gordie Howe completed a hat trick in the third period as the Wings downed the Toronto Maple Leafs 4-2 on New Year's Eve, 1961.

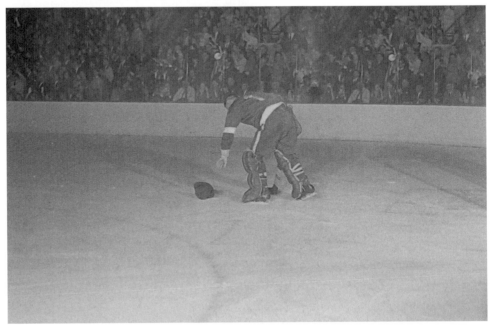

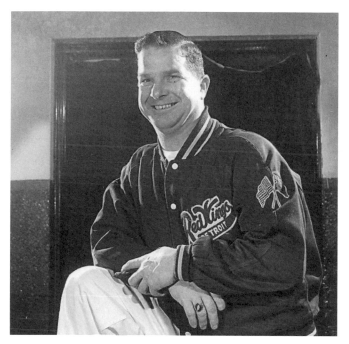

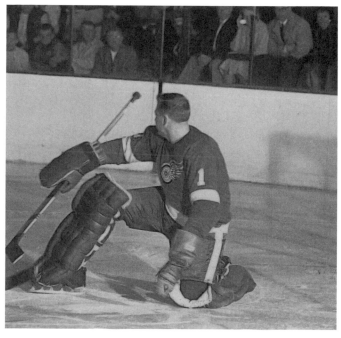

87

Detroit trainer Ross (Lefty) Wilson is all smiles. A goalie who played four seasons in Detroit's farm system from 1945-50 with St. Paul and Omaha of the USHL and Indianapolis of the AHL, Wilson served as Detroit's practice goalie, and three times got into NHL action between the pipes under emergency conditions in the days when teams did not suit up a back-up goaltender. Wilson replaced the injured Terry Sawchuk in the Detroit net during the third period of a 4-1 loss to the Montreal Canadiens on October 10, 1953. On the other two occasions, Wilson opposed the team that employed him. He subbed for injured Toronto goalie Harry Lumley in the third period of Detroit's 4-1 victory over the Maple Leafs on January 22, 1956. And when Boston Bruins goalie Don Simmons was injured in the first period of a December 29, 1957 game against the Red Wings, Wilson took over and held Detroit to a 2-2 tie.

Wings goalie Hank Bassen watches the puck sail into the corner after making a stick save. For a brief time in the early 1960s, it appeared that Bassen was about to usurp the No. 1 goalie position in Detroit from veteran Terry Sawchuk. Bassen played 35 games during the 1960-61 season, posting a 13-13-8 slate and a 2.89 goals-against average, and also appeared in four playoff games as Detroit reached the Stanley Cup final before bowing to the Chicago Blackhawks in six games. Bassen played another 27 games the following season, and 17 more in 1962-63, but never could push Sawchuk aside, and eventually was passed on the depth chart by Roger Crozier. He was traded to the Pittsburgh Penguins for fellow goalie Roy Edwards on September 7, 1967 and was in goal for their first-ever NHL game, a 2-1 loss to the Montreal Canadiens on October 11, 1967.

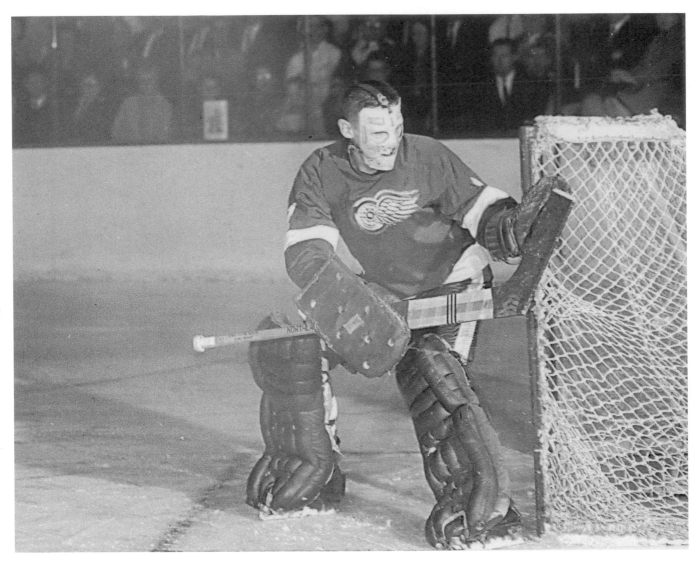

Wearing his new-look mask to start the 1962-63 season, Detroit goalie Terry Sawchuk follows the path of the puck as it misses his net. Written off by some as washed-up after Detroit missed the 1961-62 playoffs, Sawchuk experimented with the mask in training camp during the fall of 1962 and felt it gave him more confidence. The evidence was there to see, as he backstopped the Wings to successive Stanley Cup final appearances in 1962-63 and 1963-64 after donning facial protection.

The Puck Stops Here

No less than four future Hall of Famers battle for the puck during a scramble in the Detroit goal crease, but Red Wings netminder Hank Bassen has it safely tucked away in his pads. That's Detroit's Norm Ullman (7) and Bill Gadsby (4) who are imprisoning Toronto Maple Leafs defenceman Tim Horton, who has fallen to the ice, while Leafs captain George Armstrong moves into the fray from behind the pile-up. Parker MacDonald (20) and Al Johnson back up Bassen on the play. A Red Wing from 1960-67, Bassen mostly performed as an understudy in Detroit. He briefly usurped the No. 1 job from Terry Sawchuk during the 1960-61 season, playing a career-high 35 games, but by playoff time, Sawchuk was back again as Detroit's go-to goalie.

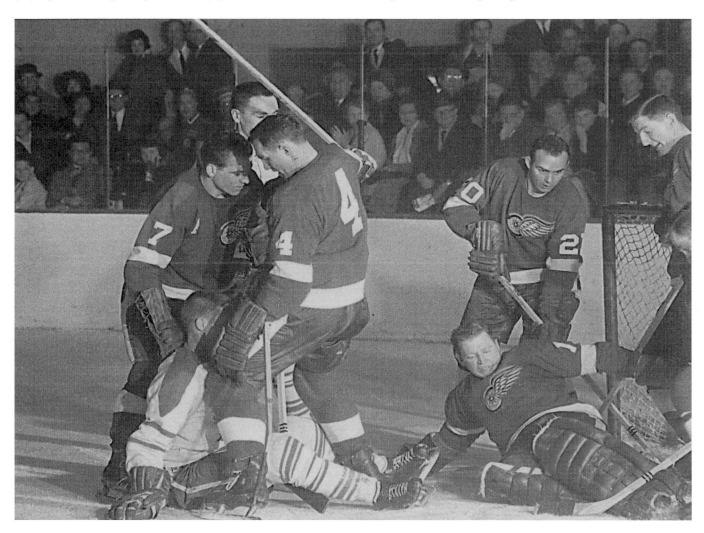

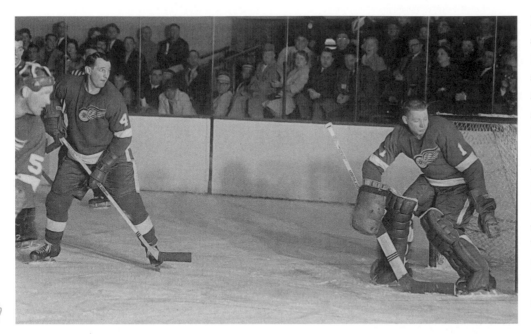

Detroit goalie Hank Bassen and defencemen Bill Gadsby (4) and Warren Godfrey (5) all watch intently as the puck scoots wide of the Wings' net and into the corner of the rink. Known as Mr. Emergency, Bassen was a second-stringer who played behind three Hall of Famers during his NHL days—Hart Trophy-winner Al Rollins in Chicago, Vezina Trophy-winner Terry Sawchuk and Conn Smythe Trophy-winner Roger Crozier in Detroit.

Deep in his crease, Hank Bassen snakes out his right pad to thwart a New York Rangers' scoring attempt, as defenceman Pete Goegan (2) looks on. Bassen played with Detroit from 1960-67, and though never the club's No. 1 goalie, he proved a capable backup, subbing four games for an injured Terry Sawchuk during the 1961 playoffs and again for the ailing Roger Crozier during the 1966 Stanley Cup final against Montreal.

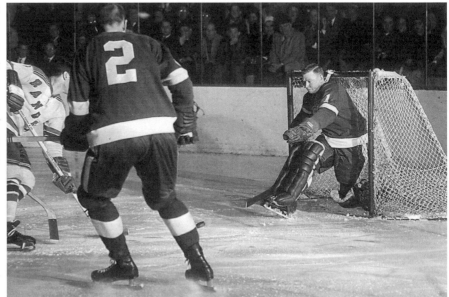

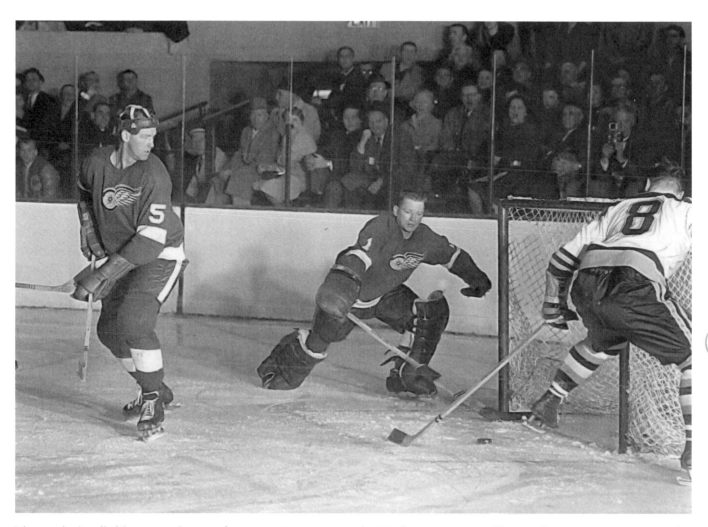

This is what's called being caught out of position. Detroit netminder Hank Bassen is out of his net, leaving Boston Bruins right-winger Wayne Connelly (8) with a tap-in goal. Wings defenceman Warren Godfrey (5) can't believe his eyes at their misfortune. The MVP of the Western League with Vancouver in 1959-60 after leading the loop in wins (44) and shutouts (5), Bassen began a seven-season stint in Detroit during the 1960-61 season. Connelly, meanwhile, was acquired by the Wings from the Minnesota North Stars in 1968 and scored 23 goals for Detroit during the 1969-70 campaign as the Wings made the playoffs for the first time since 1965-66.

Moving into his crouch, Detroit goalie Dennis Riggin steadies to block an incoming shot with his stick. The second goaltender in Red Wings history to don facial protection when he played nine games during the 1962-63 season, he did so out of necessity. Riggin suffered an eye injury during the 1960-61 Western Hockey League season while playing for the Edmonton Flyers, an ailment that led to his retirement from the game following the 1962-63 campaign. Riggin's son Pat followed in his footsteps nonetheless, playing goal in the NHL from 1979-88.

Balding and pudgy, Bob Perreault looked nothing like a major-league goalie, but don't try telling that to Detroit centre Ed Joyal, who watches as the Bruins goalie kicks a shot clear. Boston defenceman Pat Stapleton moves to aid his netminder. While he closed out his NHL playing days with the Bruins in 1962-63, Perreault enjoyed a successful three-game stint as a Red Wing from January 21-25 of 1959. Recalled from Hershey of the American Hockey League to fill in for the injured Terry Sawchuk, who was out with a shoulder problem, Perreault beat Chicago 3-2 in his Detroit debut, blocking 21 shots. He followed that up with a 24-save, 2-0 shutout of the Blackhawks. Perreault's bubble burst against the reigning Stanley Cup champion Montreal Canadiens, who blasted him and the Red Wings 7-3.

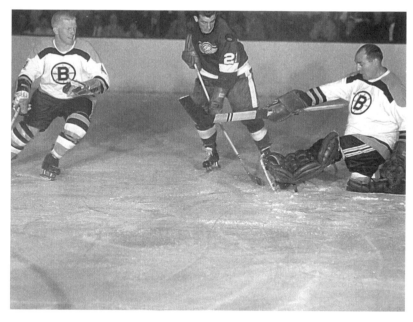

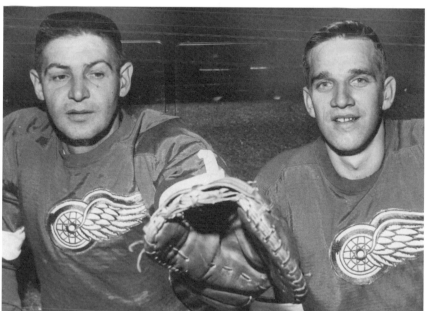

When the Red Wings opened training camp in 1963, they felt they had a legitimate netminder to challenge Terry Sawchuk for the club's No. 1 goaltending position. The club dealt Ron Ingram and Howie Young to Chicago to acquire Roger Crozier. A Memorial Cup winner with St. Catharines in 1959-60, Crozier was named the AHL's rookie of the year with Pittsburgh in 1963-64. He also played 15 games for Detroit in relief of Sawchuk, wearing No. 22. Despite a 5-6-4 record and 3.40 GAA, Wings coach-GM Sid Abel saw enough of Crozier to make him Detroit's No. 1 goalie starting with the 1964-65 season. Unprotected in the NHL intra-league draft, Sawchuk was claimed by Toronto.

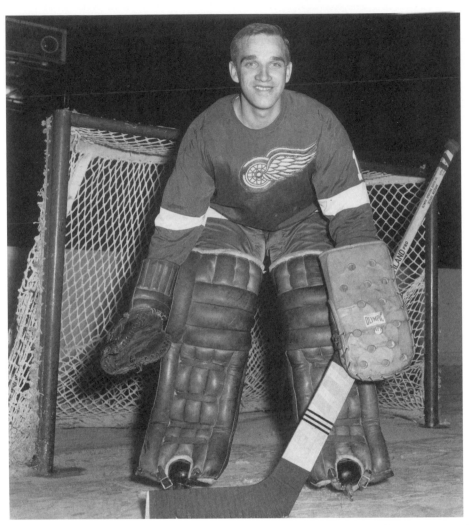

A 15-game stint during the 1963-64 season filling in for an injured Terry Sawchuk was enough to convince Wings coach Sid Abel that Roger Crozier was ready to fill the nets for Detroit, so he left Sawchuk unprotected in the 1964 NHL Intra-League Draft and he was claimed by the Toronto Maple Leafs. Crozier didn't disappoint Abel for his faith. He started all 70 games during the 1964-65 season, leading the NHL with 40 wins and six shutouts, earning the Calder Trophy as the league's top rookie in the process. The following season, Crozier backstopped Detroit all the way to the Stanley Cup final and even though the Wings lost, Crozier was awarded the Conn Smythe Trophy as playoff MVP, the first time a player from the losing team ever won the award.

Chapter Four:
Muckers and Grinders

EVERY CHAMPIONSHIP TEAM is led by its stars. But as much as the Detroit Red Wings were about Gordie Howe, Ted Lindsay and Terry Sawchuk, they were also about players named Metro Prystai, Tony Leswick and Marty Pavelich.

Call them role players, muckers, grinders, whatever. Without a solid corps of them, no team is going anywhere in the games that matter most during the season. "Those teams had a little bit of everything," checking winger Bill Dineen said. "We had talent with guys like Howe and (Red) Kelly, we had a great goalie in Sawchuk, we had toughness—nobody wanted to mess with Howe and Lindsay, and (Marcel) Pronovost was a great hitter. And guys like (Glen) Skov and Pavelich and Leswick were great checkers."

Carefully study any Detroit playoff success story during the Original Six era and you'll see evidence of the contribution of these depth players.

Take Detroit's 1950 Cup win, for example. Working double-overtime in Game 7 against the New York Rangers, the line of George Gee, Pete Babando and Gerry (Doc) Couture came over the boards for a face-off in the New York zone. Gee won the draw from Rangers forward Buddy O'Connor to Babando, who lifted a 25-foot backhand shot past Charlie Rayner and into the New York net.

Two years later, Detroit won eight straight to take the Cup, the first time that had ever happened in the history of Lord Stanley's mug. The Cup-deciding goal in Game 4 against Montreal came from the stick of

grinding forward Metro Prystai, his first goal of the playoffs.

"They used me as a swingman because I could play all three forward positions, though I spent most of the time on right wing," Prystai said. "For a while I was with Ted Lindsay and Gordie Howe, then on a checking line with Marty Pavelich and Tony Leswick, then with Alex Delvecchio and Johnny Wilson."

Two years later, the Wings were back in the final and again won a Game 7 by a 2-1 decision when checker Leswick scored the winner at 4:29 of overtime. His shot tipped off the glove of Montreal defenceman Doug Harvey and over the shoulder of goalie Gerry McNeil. "I just shot as quickly as I could and it happened to go high," Leswick said.

As the Wings moved into the 1960s, new Cup final appearances were fashioned via the aid of other role players. Forwards Howie Glover (21 goals) and

96

Al Johnson (16) were surprising contributors in 1960-61, as was rookie Bruce MacGregor. Alex Faulkner, the first Newfoundland-born player to play in the NHL and in the Stanley Cup final, scored five goals during the 1963 playoffs.

"Nobody remembers the second guy to walk on the moon," Faulkner said. "You ask someone who the second Newfoundlander in the NHL was and they won't have any idea. That's just the way it works."

Andre Pronovost and Larry Jeffrey were among Detroit's scoring leaders in the 1964 playoffs, while Floyd Smith potted five goals and pesky Bryan (Bugsy) Watson checked Chicago's Bobby Hull to a standstill as the Wings rolled to the 1966 final.

"We definitely had the talent, but we also had a lot of heart," Pronovost said of those Cup contenders. "All the successful clubs have that element—character, camaraderie, chemistry—call it whatever you want, that team had it."

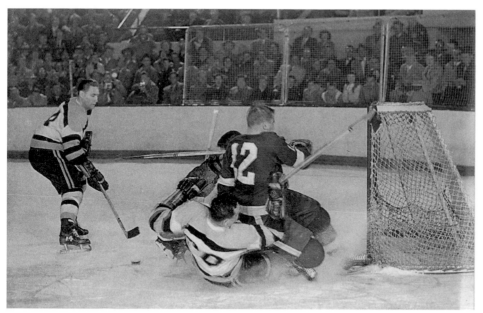

Metro Prystai was a two-time 20-goal scorer for the Wings, but he didn't get the pretty ones. Here he goes hard to the net, spilling Boston Bruins defenceman Leo Boivin (20) in the process. Part of a sensational checking line along with Marty Pavelich and Tony Leswick, Prystai won three Stanley Cups as a Red Wing.

97

Displaying power and balance on his skates, Detroit left-winger Marty Pavelich holds off the entire Cullen family as he looks to get the puck to the front of the Toronto Maple Leafs net and create havoc for Leafs goalie Ed Chadwick. That's Brian Cullen putting the stick into Pavelich's midsection, while brother Barry Cullen rakes Pavelich's back with his lumber. A Red Wing from 1947-57, Pavelich walked away from the game in the prime of his career at age 29 because he'd done so well in a business partnership with teammate Ted Lindsay that there was no need to continue to play hockey.

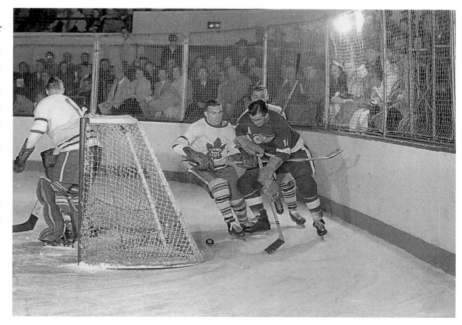

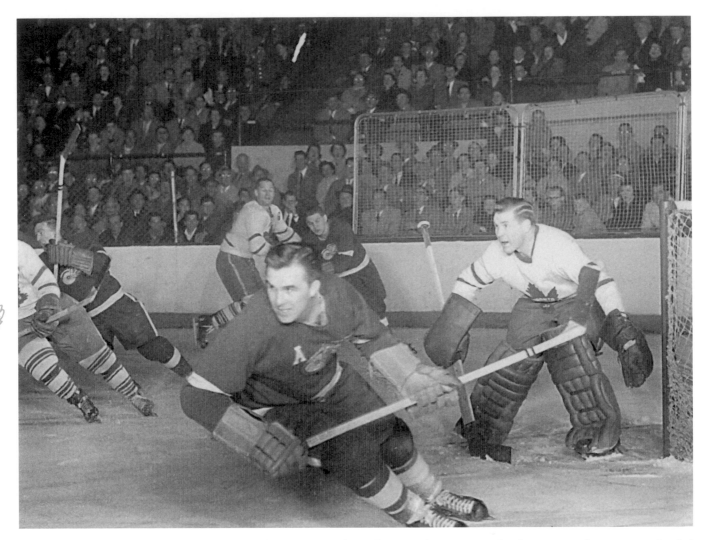

98

There's all kinds of action around the goal area of Toronto Maple Leafs netminder Harry Lumley, but everyone's attention is headed away from the zone. Detroit forward Marty Pavelich (A) cuts a tight loop as he turns to pursue the puck. One of the fastest skaters in the NHL during his day, Pavelich was the Darren Helm of the 1950s, turning his talents to checking the top forwards on the other team. Detroit's Marcel Pronovost is also headed back toward his own end of the rink, while Detroit's Alex Delvecchio tangles with Toronto's Fern Flaman.

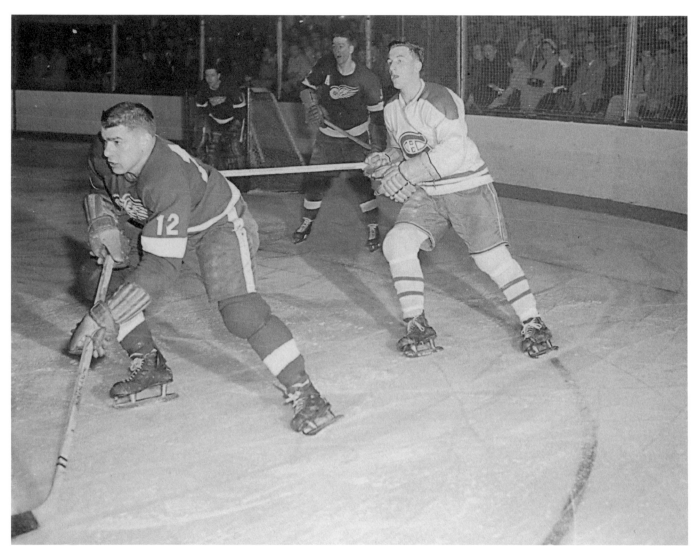

Metro Prystai works the puck out of the Detroit zone as Montreal Canadiens left-winger Dickie Moore pursues. Prystai was a big-time scorer in junior, twice leading the Saskatchewan Junior Hockey League while with the Moose Jaw Canucks, and he potted 29 goals for the Chicago Blackhawks in 1949-50. Moving to Detroit, he was a two-time 20-goal scorer, but checking became Prystai's main forte as a Red Wing.

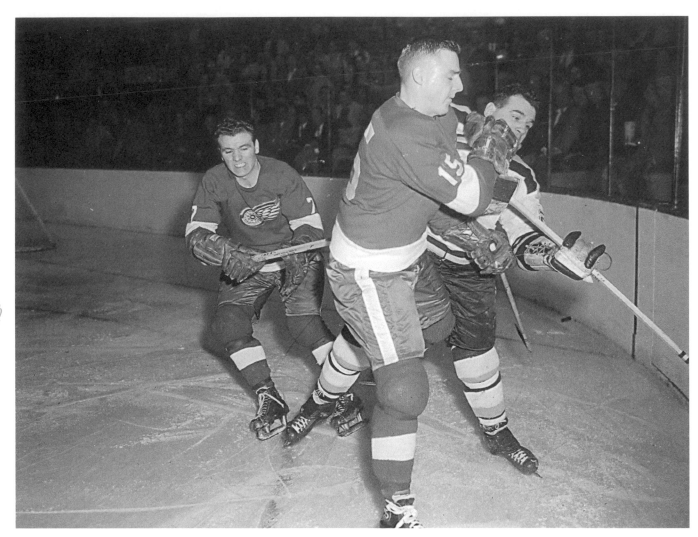

Detroit forwards Andre Pronovost (15) and Norm Ullman (7) combine to give Boston Bruins defenceman Leo Boivin a rough go in the corner away from the Boston net. Pronovost was a four-time Stanley Cup winner with Montreal in a checking role from 1957-60. Picked up by Detroit from Boston for Forbes Kennedy on Dec. 3, 1962, he filled a similar role for Red Wings teams that reached the Stanley Cup finals in 1962-63 and 1963-64, and was especially helpful during the 1964 playoffs, producing 4-3-7 totals in 14 games.

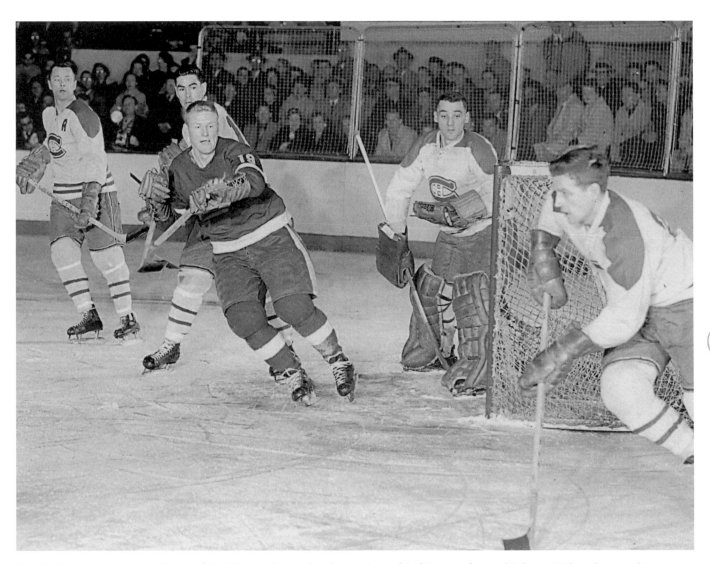

Jean Beliveau moves the puck out of the Montreal zone, but he won't get far if Detroit forward Johnny Wilson has anything to say about it. Canadiens defenceman Dollard St. Laurent looks to apply the hook to slow down Wilson, while Montreal defenceman Doug Harvey and goalie Jacques Plante watch the action unfold. Wilson won four Stanley Cups as a Red Wing. He was called up from the minors in the spring of 1950 for the playoffs along with his brother Larry, and both won the Cup that spring.

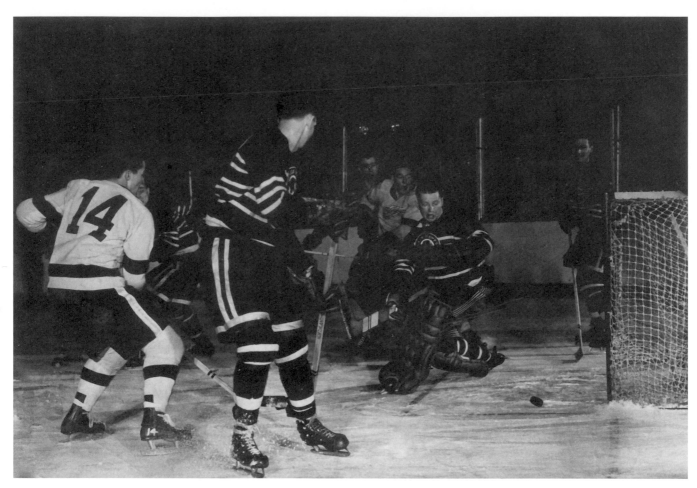

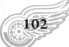

Chicago Blackhawks goalie Sugar Jim Henry can only watch and hope as this backhand shot by Detroit's Bud Poile (14) slides toward the open net. A 21-goal scorer in his lone season as a Red Wing in 1948-49, Poile, whose brother Don also played for the Wings, won a Stanley Cup with Toronto in 1946-47, and was traded to Detroit by Chicago with George Gee for Jim Conacher, Bep Guidolin and Doug McCaig on October 25, 1948. The Wings sold Poile's contract to the New York Rangers on December 22, 1949. Poile made a name for himself as a hockey executive. He was the first general manager of both the Philadelphia Flyers and Vancouver Canucks, and later served as commissioner of both the Central Hockey League (1976-84), and International Hockey League (1984-89). In 1989, Poile received the Lester Patrick Trophy for service to hockey in the United States, and one year later, was inducted into the Hockey Hall of Fame. His son David is GM of the Nashville Predators.

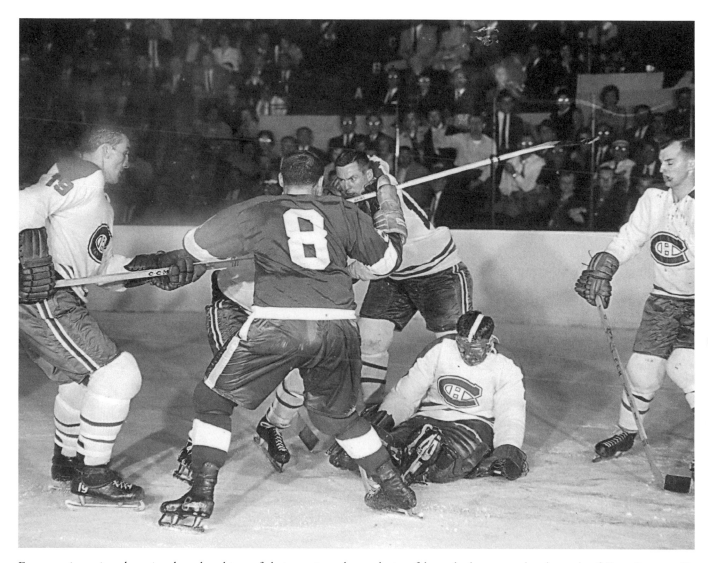

Everyone is paying the price, but the object of their passion, the puck, is safely tucked away under the pads of Canadiens goalie Jacques Plante. Montreal defenceman Dollard St. Laurent (19) drives his stick into Detroit forward Barry Cullen (8), while Tom Johnson skates menacingly toward him. Forward Gilles Tremblay (21) bravely plays safety behind Plante, ignoring the blood trickling down from his mouth and speckling his sweater in crimson.

Two of the best clutch playoff performers go head-to-head during the 1954-55 season. Boston Bruins left-winger Joe Klukay tangles along the boards for the puck with Detroit left-winger Marcel Bonin, as Bruins captain Ed Sandford closes in. Klukay, Milt Schmidt and Woody Dumart formed an effective checking line that stymied Detroit's Production Line during the opening round of the 1952-53 playoffs, leading Boston to a stunning upset win. Bonin won one Stanley Cup as a Red Wing, then three more with the Montreal Canadiens, leading all playoff scorers with 10 goals, including the Cup winner, during the 1959 Stanley Cup tournament.

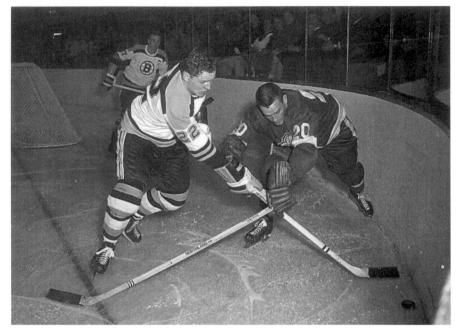

104

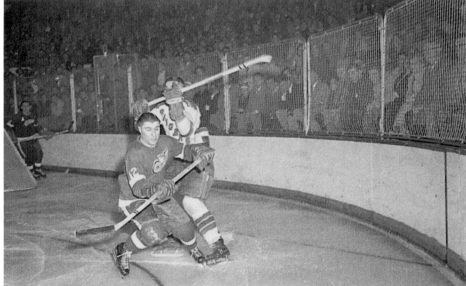

They called him Mighty Mouse, but 5'7", 160-pound Tony Leswick never shied away from contact or competition. Tangling here in the corner in a contest against New York Rangers defenceman Jack Evans, Leswick has won the inside track to the puck, even though he's giving away five inches and 25 pounds to his opponent. The magical moment for Leswick came in Game 7 of the 1954 Stanley Cup final, when he beat Montreal Canadiens goalie Gerry McNeil 4:29 into overtime to give the Wings a 2-1 victory and the Cup.

Coaches frequently utilized defencemen to take defensive zone draws during the Original Six era. It was felt that with the edge in strength, even if they didn't win the puck cleanly, they could easily outmuscle the opposing centre and regain control of the puck. Here, Wings defenceman Marcel Pronovost gets the better of Jean Beliveau of the Montreal Canadiens at the dot. Note centre Alex Delvecchio (10) stationed in Pronovost's defensive position. Terry Sawchuk (1) guards the goal, Howie Young (2) protects the slot, Vic Stasiuk (11) gets ready to move in, while Len Lunde (20) is already full bore for the puck.

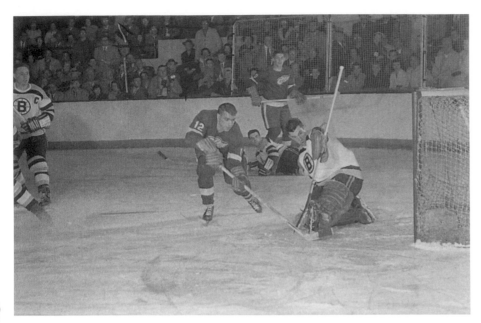

He may have been a mainstay on Detroit's checking line, but don't try telling Boston Bruins goalie Don Simmons that Metro Prystai didn't have some magic in his hands. He puts the moves on Simmons and tucks a backhand home beyond the outstretched leg of the Boston netminder while Bruins captain Fern Flaman looks on helplessly. Prystai also encountered some hard luck at the hands of the Bruins. A broken leg he suffered during a Dec. 28, 1957 game ultimately ended his playing career.

106

Who says players showed more respect for each other during the Original Six era? Certainly not Detroit centre Metro Prystai, who is about to bury Boston Bruins right-winger Larry Regan head-first into the boards in pursuit of the puck—a move like that today would cost Prystai a five-minute boarding major and a game misconduct, and would likely lead to an invite for a face-to-face meeting with NHL disciplinarian Brendan Shanahan.

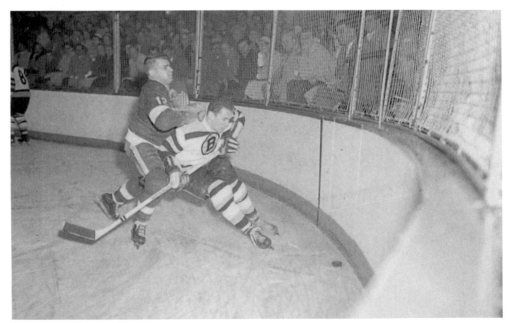

Detroit right-winger Bill Dineen takes a glove to the face from Montreal Canadiens defenceman Jean-Guy Talbot as he fights for space in tight quarters behind the Habs net. Dineen broke in with the Wings during the 1953-54 season, scoring 17 goals as Detroit won the Stanley Cup. He was also part of Detroit's 1954-55 Cup win, and played for the Wings into the 1957-58 season. He was traded to the Chicago Blackhawks with Billy Dea, Lorne Ferguson and Earl Reibel for Nick Mickoski, Bob Bailey, Hec Lalande and Jack McIntyre on December 17, 1957. Dineen later coached Detroit's Adirondack American Hockey League team from 1983-89, and coached the Philadelphia Flyers from 1991-93. His son Kevin is currently the coach of the Florida Panthers.

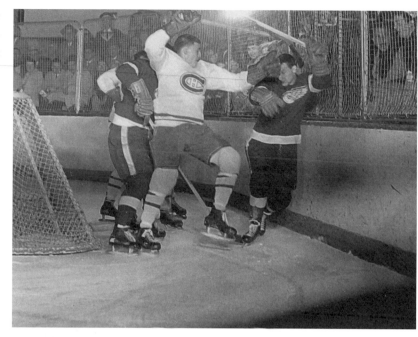

107

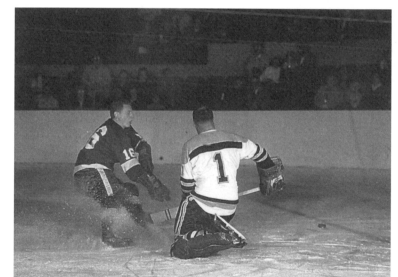

Centre Bruce MacGregor snaps a wrist shot past the outstretched right leg of Boston Bruins goalie Bob Perreault, one of 11 goals MacGregor scored during the 1962-63 season. MacGregor was just 19 when the Wings called him up from their Edmonton Flyers Western Hockey League farm club late in the 1960-61 season on February 24, 1961, but saw significant ice time during the Stanley Cup final that season against the Chicago Blackhawks. In Game 4 of the series, MacGregor drove a puck through the legs of Blackhawks goalie Glenn Hall to give the Wings a 2-1 victory and square the best-of-seven set at 2-2. It was the first goal MacGregor ever scored in an NHL uniform, but the news wasn't all good. Chicago won the next two games to take the series and the Cup.

Detroit centre Metro Prystai scoots along the boards, looking to avoid the check of Boston Bruins defenceman Jack Bionda. Note the lack of any glass above the boards, meaning Prystai could easily end up over the fence and in the lap of some unsuspecting spectator. Acquired from Chicago in 1950, Prystai scored 20 goals in each of his first two seasons with the Wings. From Yorkton, Saskatchewan, Prystai was one of a number of Detroit stars during the 1950s who hailed from that province, including Production Line stars Gordie Howe (Floral) and Sid Abel (Melville).

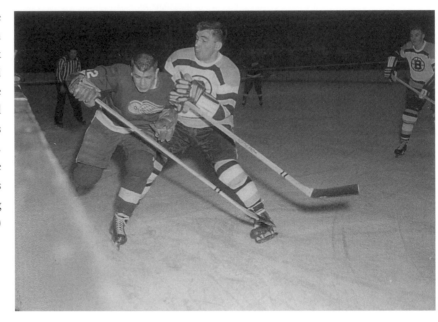

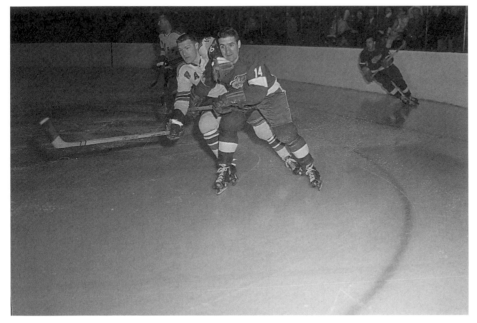

Who said there was no clutching and grabbing in the old days? New York Rangers centre Earl Ingarfield has his left glove gripping the shoulder of Red Wings centre Jerry Melnyk, while his right arm envelopes Melynk's stick. Melnyk made his Detroit debut during the 1956 Stanley Cup playoffs, but his biggest moment as a Wing came during the 1960 postseason, when he tallied after 1:54 of overtime to give Detroit a 2-1 victory over the Toronto Maple Leafs in Game 4 of their Stanley Cup semi-final series. That tied the set at 2-2, but the Leafs won the next two games to take the best-of-seven set.

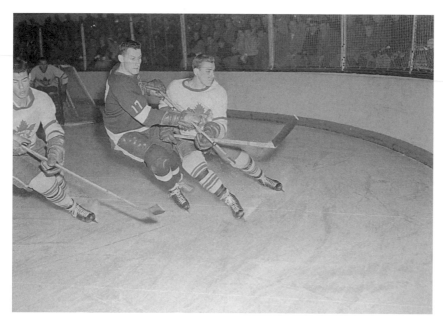

Detroit right-winger Bill Dineen finds himself on the verge of a puck battle with two young future stars of the Toronto Maple Leafs. He's about to deliver a cross-check to the torso of left-winger Dick Duff, and then it will be off to the races for the puck with centre Bob Pulford. This trio of talent combined to win a dozen Stanley Cups. Dineen captured a pair with the Wings (1953-54, 1954-55), while Pulford was a four-time winner with Toronto (1961-62, 1962-63, 1963-64, 1966-67). Duff won two Cups as a Leaf (1961-62, 1962-63) and four more with the Montreal Canadiens (1964-65, 1965-66, 1967-68, 1968-69).

109

Chicago defenceman Gus Mortson (2) gives Detroit centre Earl (Dutch) Reibel a rough ride into the boards as Blackhawks left-winger Glen Skov (14) moves in, hoping to corral the bouncing puck. Born in Wheatley, Ont., Skov was a solid checker for the Red Wings from 1949-55, winning three Stanley Cups during that span. His Detroit days came to an end on May 28, 1955, when Skov was traded to Chicago by Detroit with Tony Leswick, John Wilson and Ben Woit for Dave Creighton, Gord Hollingworth, John McCormack and Jerry Toppazzini. Skov and Detroit teammate Marty Pavelich were both part of unique NHL brother combinations during their playing days. Skov's brother Art was an NHL referee, while Pavelich's brother Matt was a Hall of Fame NHL linesman.

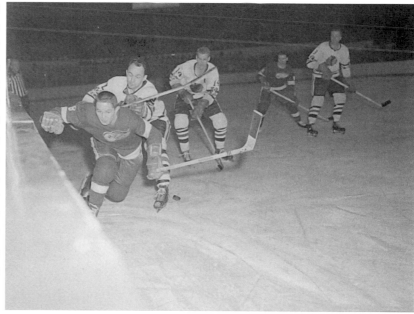

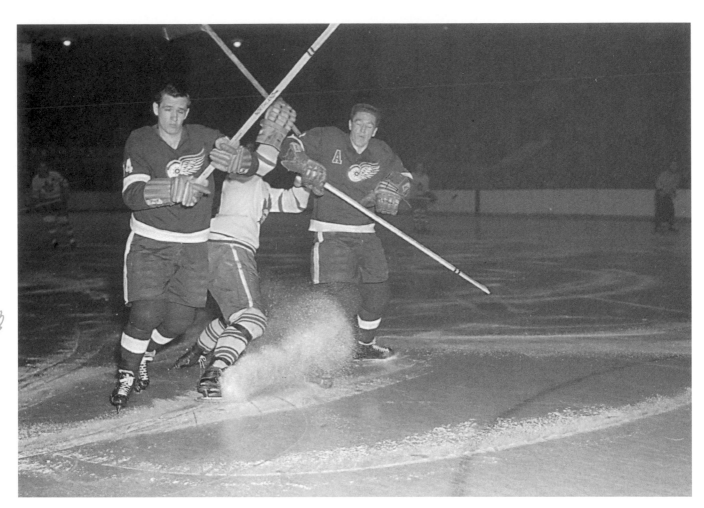

This unfortunate Toronto Maple Leaf is the victim of the Detroit version of the Malachi Crunch, as he gets a going-over from the elbows of Red Wings defenceman Marcel Pronovost and left-winger Lorne Ferguson. A 45-goal scorer for the AHL's Hershey Bears in 1953-54, Ferguson jumped to the Boston Bruins the next season and was a 20-goal producer. He never achieved those offensive heights again and was dealt to Detroit with Murray Costello for Real Chevrefils and Jerry Toppazzini on Jan. 17, 1956. Ferguson produced decent 13-10-23 totals during the 1956-57 campaign, his only full season as a Red Wing, but was on the move again the following season, traded to Chicago by Detroit with Earl Reibel, Billy Dea and Bill Dineen for Bob Bailey, Nick Mickoski, Hec Lalande and Jack McIntyre on Dec. 17, 1957.

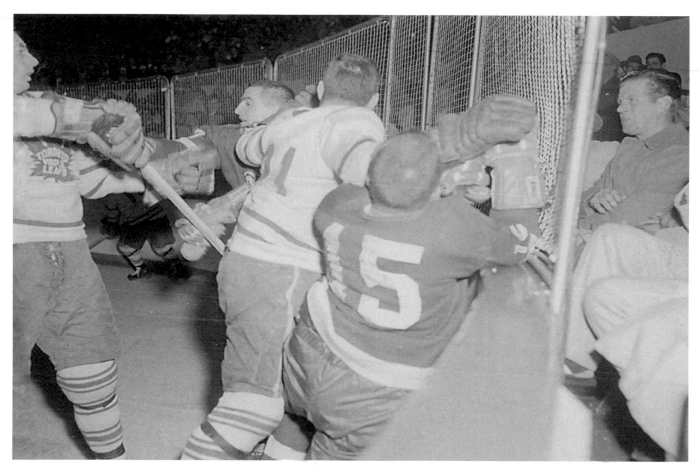

There's mayhem in the corner at Olympia Stadium: not an uncommon occurrence when the Wings clashed with the Toronto Maple Leafs. Perhaps this explains why the fan just to the other side of the chicken wire is so calmly watching the action. Leafs winger Tod Sloan is a bull in a china shop, sending Detroit left-winger Don Poile (15) spilling with his right elbow, while his eyes focus on Red Wings centre Forbes Kennedy. No stranger to the rough stuff, Kennedy is otherwise engaged in a jousting match with Leafs forward Ron Stewart.

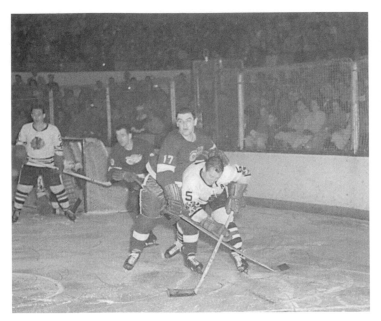

Detroit centre Forbes Kennedy gives Chicago defenceman Jimmy Thomson a rough ride as Red Wings right-winger Bob Bailey moves off in pursuit of the puck. That's Chicago defenceman Gus Mortson (2) standing guard in front of the Blackhawks' net. Acquired from Chicago in the July 23, 1957 deal that sent Ted Lindsay and Glenn Hall to the Blackhawks, Kennedy was a revelation in his first Detroit season, producing 11-17-28 totals in 70 games, as well as a team-leading 135 penalty minutes, including a $100 NHL fine for pushing linesman Matt Pavelich, brother of Red Wings forward Marty Pavelich, during a January 30, 1958 game against the Montreal Canadiens. But he scored just one goal in 67 games during the 1958-59 campaign, and after that Kennedy bounced up and down between Detroit and the minor leagues until he was traded to Boston for Andre Pronovost on December 3, 1962.

112

Detroit defenceman Bob Goldham is doing what he did best, working in close quarters to prevent Boston Bruins centre Fleming Mackell from getting anywhere on the ice. Lorne Ferguson (14) admires his teammate's work. Early in his NHL career, Goldham helped Toronto win the 1941-42 Stanley Cup from Detroit, but after a 1950 trade with Chicago, he helped young Wings defencemen such as Marcel Pronovost and Al Arbour mature into solid performers, teaching them the finer points of playing the point in the NHL.

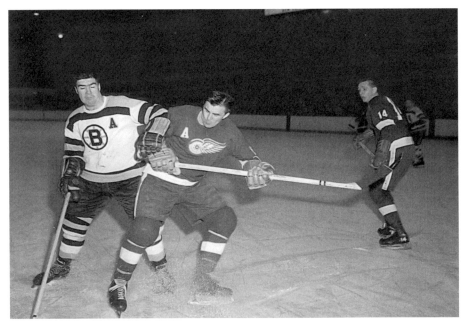

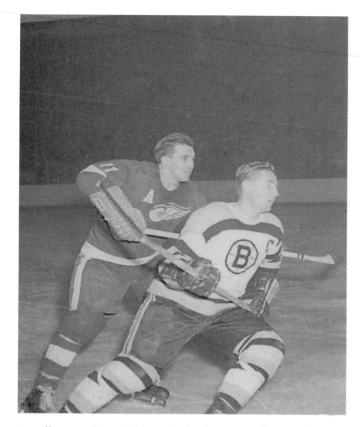

113

A stellar member of Detroit's checking unit during the glory days of the 1950s, along with Tony Leswick and Metro Prystai, Red Wings alternate captain Marty Pavelich is covering Boston Bruins captain Ed Sandford like a proverbial blanket. Pavelich was a Red Wing his entire NHL career. He signed a pro contract with the Wings on September 9, 1947 and after 740 NHL games for the Wings, when Detroit GM Jack Adams offered him a $7,000 base contract to play in the minors for the 1957-58 season, Pavelich announced his retirement from the game on August 30, 1957.

Detroit right-winger Leo Labine could do a lot more than just throw up snow on the ice. Known as a swashbuckling player with a fiery temperament, Labine was a gritty type who wasn't afraid to go into the other team's rink and stir the pot. Labine estimated he required more than 250 stitches during his career. His solution for those who got too close to him on the ice? "I gave them a stick sandwich," Labine once explained to a reporter. "The only thing that eats wood is a beaver, and I haven't seen any beavers playing hockey."

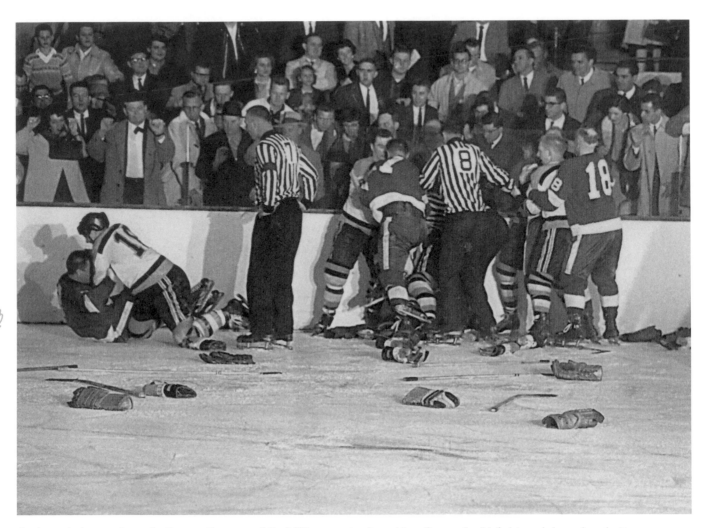

Sticks and gloves askew, the Boston Bruins and Red Wings are in the midst of a good, old-fashioned donnybrook. Boston centre Charlie Burns (19) falls on top of Detroit defenceman Marcel Pronovost under the watchful eyes of referee John Ashley (7), while Bruins defenceman Ted Green has a firm grip on the sweater of Detroit's Claude Laforge (17). Wings defenceman Gerry Odrowski (18) ensures that Boston rearguard Pat Stapleton isn't getting involved, but the main event is obscured from view by linesman Neil Armstrong (8). Those legs sticking out belong to Boston's Dick Meissner and Detroit's Gordie Howe, who amazingly drew the only fighting majors from this melee.

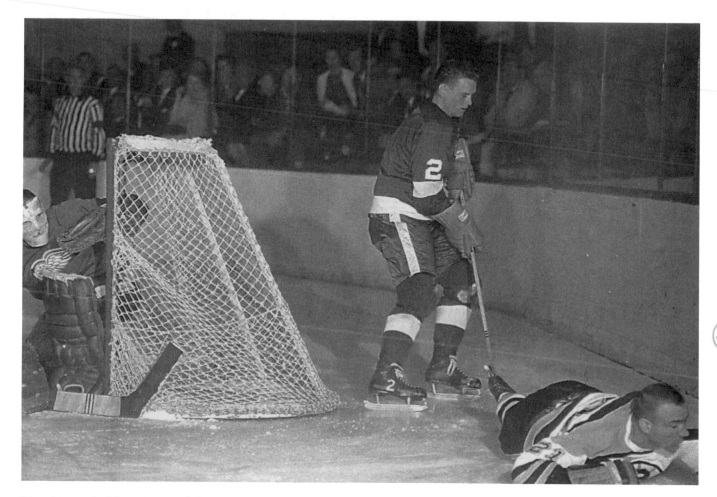

The ultimate bad boy, Detroit defenceman Howie Young feigns innocence after spilling Boston Bruins forward Jerry Toppazzini to the ice. Even Wings goalie Terry Sawchuk can't mask his surprise at Young's belligerence. During the 1962-63 season, Young obliterated the NHL single-season penalty-minute mark, serving 273 minutes of sin bin time. The previous mark of 202 minutes was established by New York Rangers defenceman Lou Fontinato in 1955-56. Young was such a miscreant presence, his dirty deeds earned him a spot on the cover of *Sports Illustrated*.

Larry Jeffrey (21) gains a step on New York Rangers forward Dave Balon and heads off in pursuit of a dump-in. Jeffrey was a hard-nosed, defensive-minded left-winger in Detroit's back-to-back Stanley Cup finals in 1963 and 1964. An unlucky sort, he underwent nine surgeries on his knees. Jeffrey wore sweater No. 21 when he debuted with the Wings because Highway 21 led to his home in Goderich, Ontario.

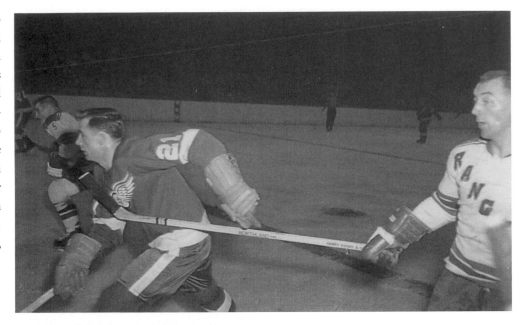

116

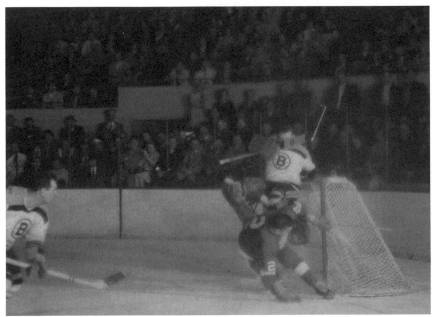

Detroit defenceman Howie Young is doing what he did best—causing mayhem—as he crashes into Boston Bruins goaltender Ed Johnston, who leaps to avoid the collision. Bruins defenceman Leo Boivin looks on. A six-time penalty-minute leader during his career, Young was a battler on the ice, but off the ice he struggled with alcoholism. A Red Wing from 1960-63, his drinking cost Young his spot with the Wings, but in 1966, the club moved to reacquire him, and Young served a second stint in Detroit from 1966-68. "Talent never had any bearing on Howie's position with Detroit," Wings coach-GM Sid Abel said upon making the deal to bring Young back to the Red Wings.

Chapter Five:
Wheeling and Dealing

THE RED WINGS WON THE FRANCHISE'S FIRST STANLEY CUPS in back-to-back seasons from 1935 to 1937. The next season, they missed the playoffs, and this prompted Detroit coach-GM Jack Adams to form a theory about hockey teams.

Good ones, he figured, had a shelf life of five years before they grow stale. "I'll never hesitate to bust up a champion again," Adams vowed after the 1937-38 campaign. He remained faithful to this vow throughout the Original Six era.

Many times, the swaps met expectations. When Terry Sawchuk came along, he moved goalie Harry Lumley to Chicago. Likewise, the arrival of Red Kelly and Marcel Pronovost made Bill Quackenbush and (Black) Jack Stewart expendable along the blue line.

"The Wings are stronger," Adams claimed, and three more Stanley Cup wins between 1952-55 appeared to prove his point. "Even a great team such as we had could be better. And a better team is what we have now."

Finishing first in the NHL for seven straight seasons from 1948-49 through 1954-55, it was hard to debate his theory.

"A lot of people criticize the old man, but he made some deals which worked out," Pronovost pointed out. Adams had reshaped the Detroit club that played in the finals six times in the 1940s and won Stanley Cups in 1950, '52, '54 and '55.

"The (Pete) Babando deal (with Boston in 1949) got us a Stanley Cup in 1950 when Babando scored the winner in Game 7 in overtime," Pronovost said. "George Gee won the face-off on that goal, and he came over in a deal with Chicago."

Applying his time-tested theory again shortly after Detroit's 1955 Cup triumph, Adams traded eight players from the championship squad in a span of six days. "They devastated the team with trades,"' Gordie Howe said of the move.

By the time the club reported for training camp in the fall, only 10 players—Howe, Ted Lindsay, Earl Reibel, Alex Delvecchio, Marty Pavelich, Kelly, Bill Dineen, Bob Goldham, Pronovost and Larry Hillman—were left from the team which had won the Stanley Cup.

Citing up-and-comers such as goalie Glenn Hall, defenceman Hillman and forwards Norm Ullman, John Bucyk and Bronco Horvath, Adams was confident his moves would again pay long-term dividends. "If all of them come through, we'll be all right for the next few years," Adams said.

This time, others weren't as sold on his solution. Pronovost felt that the radical changes destroyed a team that still had the potential for more title-winning campaigns. "He definitely took the heart and character out of that team with those deals and he didn't get much in return," Pronovost said of Adams.

The moves continued when the winning didn't. In 1957, Adams traded Lindsay and Hall to Chicago. Hall was the reason Sawchuk had been let go, but now the club dealt the promising Bucyk, a future Hall of Famer, to Boston to get Sawchuk back. Norris Trophy-winning defenceman Kelly was shipped to Toronto.

"If a player gets too big for our club," Adams said, "then he doesn't belong on it."

Often referred to as the Branch Rickey of hockey, Adams—like the legendary GM of baseball's Brooklyn Dodgers—was never afraid to pull the trigger on a deal. "You just learn from experience," he explained. "There are lots of trades in baseball and not enough in hockey."

Adams also seldom fretted over the outcome of one of his transactions. "Certainly, everybody makes mistakes in trades," Adams said. "But no matter what you give up, the trade is a success if you get what you want.

"I've never had regrets about any trade I've made."

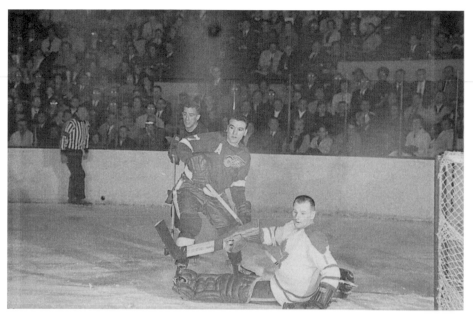

Detroit centre Norm Ullman stops on the doorstep of Toronto Maple Leafs goalie Johnny Bower just seconds after Bower kicks away a shot, and both have their eyes fixed on the puck's path. Bob Dillabough, in the background, is also eyeing the loose biscuit. Ullman was involved in one of the biggest blockbuster trades in Red Wings history on March 3, 1968, when he was traded to Toronto by Detroit with Floyd Smith, Paul Henderson and Doug Barrie for Frank Mahovlich, Pete Stemkowski, Garry Unger and the rights to Carl Brewer.

119

Before he was Mr. Goalie, he was a Red Wing. Shown here guarding the net for the Chicago Blackhawks, Glenn Hall wore the Winged Wheel from 1952-57, backstopping Detroit to the 1955-56 Stanley Cup final. Dealt to Chicago following the 1956-57 season, Hall led them to the 1960-61 Stanley Cup title, beating the Red Wings in a six-game final series.

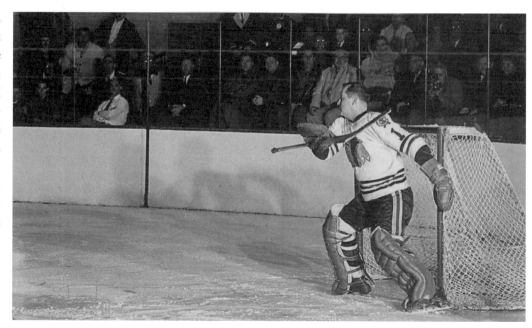

Red Wings goalie Terry Sawchuk lunges for the puck, but it sails wide of his net. Wings defenceman Warren Godfrey is stationed in front of the net to help protect Sawchuk from would-be attackers. The Wings acquired Godfrey from Boston on May 3, 1955 in a nine-player deal that saw Sawchuk go to the Bruins. The Bruins reclaimed Godfrey from the Wings in the June 4, 1962 NHL Intra-League draft, then traded him back to Detroit for defenceman Gerry Odrowski on Oct. 10, 1963.

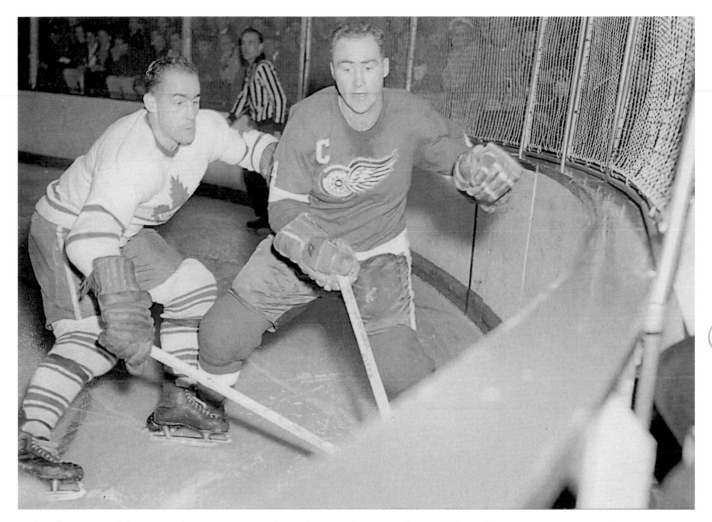

Red Kelly captained the Wings from 1956-58, and won four Stanley Cups playing defence for the team. Traded by the Wings to the Toronto Maple Leafs for Marc Reaume on Feb. 10, 1960, Leafs coach Punch Imlach moved Kelly to centre, and he won four more Cups with the Leafs playing his new position. Gary Aldcorn, the Toronto forward pursuing Kelly into the corner here, was claimed by Detroit from the Leafs in the June 10, 1959 NHL Intra-League draft. Playing left wing on Gordie Howe's line, Aldcorn scored a career-high 22 goals during the 1959-60 season. But he never equaled those numbers and was dealt along with Murray Oliver to the Boston Bruins for Vic Stasiuk and Leo Labine on Jan. 23, 1961.

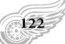

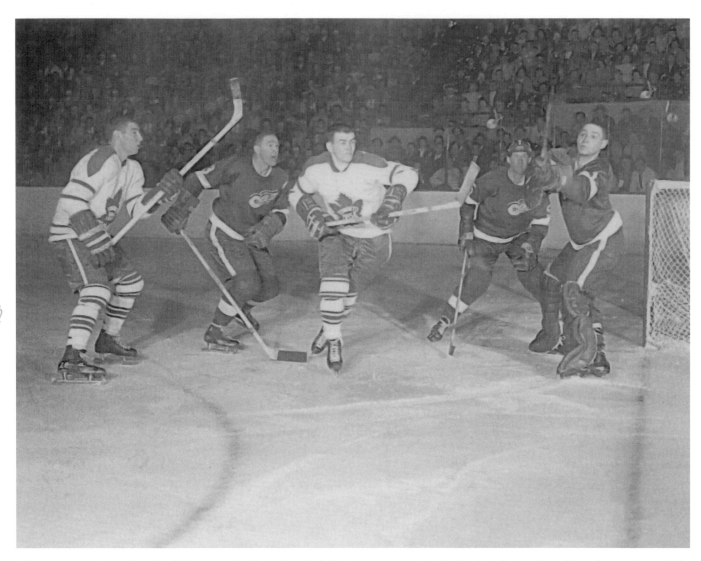

All eyes are on the puck as Red Wings goalie Terry Sawchuk is about to snare it with his glove hand. Dave Keon bursts through for Toronto along with teammate Bob Pulford, while Detroit defenceman Marcel Pronovost looks to protect his goaltender. The Leafs would claim Sawchuk from Detroit in the 1964 NHL Intra-League draft and would trade for Pronovost one year later. In 1966-67, all four of these players would play key roles as the Leafs won their most recent Stanley Cup.

Earl Reibel gets inside position on Toronto's Sid Smith and Jim Morrison and snaps a shot past Maple Leafs goalie Ed Chadwick. Winner of the Eddie Powers Trophy with the Windsor Spitfires as OHA Junior A scoring champion in 1949-50, Reibel debuted with the Wings in 1953, but after being part of two Stanley Cup champions with Detroit, he was traded to Chicago with Bill Dea, Bill Dineen and Lorne Ferguson for Hec Lalande, Nick Mickoski, Bob Bailey and Jack McIntyre on December 17, 1957.

123

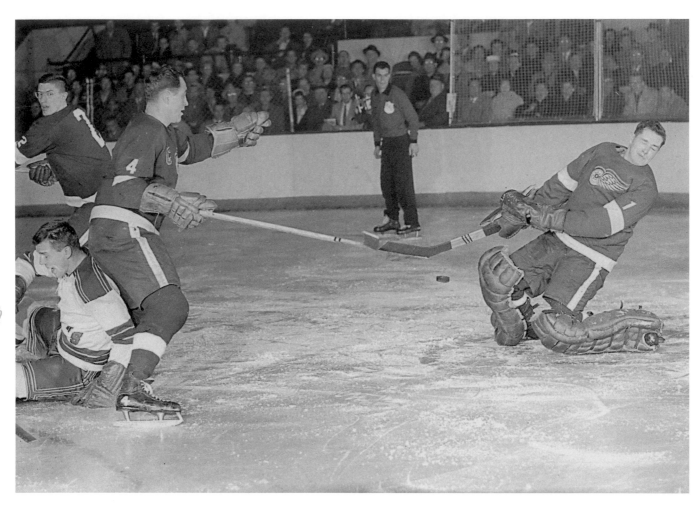

In the days before goalie masks, sometimes closing your eyes and hoping for the best was an effective puckstopping method, as Glenn Hall demonstrates. Detroit defenceman Red Kelly (4) seems to be pointing at the puck, while partner Al Arbour (2) is too busty defending to see what's going on behind him. Hall was 23 when he became Detroit's regular goaltender in the fall of 1955, after the two-time defending Stanley Cup champion Wings dealt Terry Sawchuk to Boston. "I think I'll like it here," Hall said of the NHL. I've waited a long time to get here."

After winning his third Stanley Cup in four years as Detroit's goalie, Terry Sawchuk found himself with a new home. Red Wings GM Jack Adams, knowing he had Glenn Hall waiting in the wings, shipped Sawchuk to Boston as part of a nine-player deal. Things didn't go well for Sawchuk in Boston. He suffered an attack of mononucleosis, then a nervous breakdown, and announced his retirement from the game midway through the 1956-57 season. Reacquired that summer by Adams, Sawchuk returned to the Detroit net for the 1957-58 campaign, and Hall was dealt to Chicago.

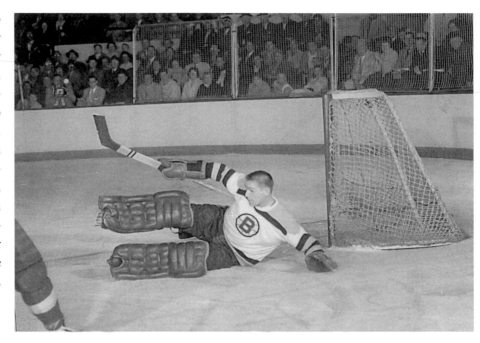

125

Detroit defenceman Pete Goegan (2) guards the slot area in front of the net for Red Wings goalie Terry Sawchuk as Toronto's Billy Harris (15) lurks nearby, while rearguard partner Marcel Pronovost (3) prevents another Maple Leafs player from crowding the crease area. On Feb. 16, 1962, the Wings dealt Goegan to the New York Rangers for defenceman Noel Price. On Oct. 8, 1962, the Wings dealt Price back to the Rangers for Goegan.

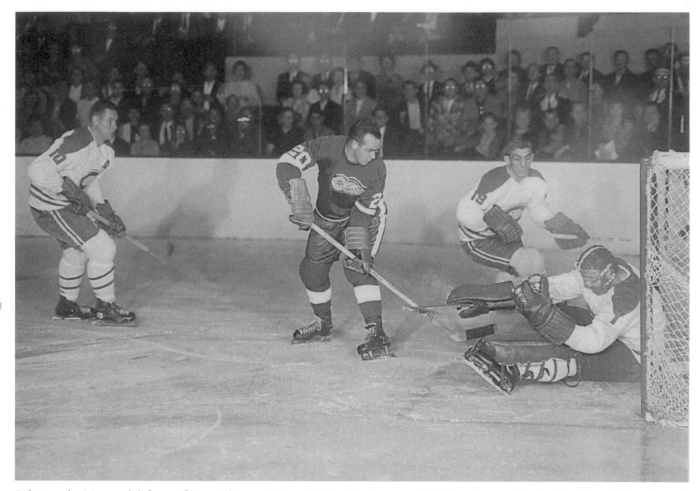

Splitting the Montreal defence of Tom Johnson (10) and Dollard St. Laurent (19), Detroit centre Parker MacDonald flips the puck high into the net over the glove of Canadiens goalie Jacques Plante. Claimed by Detroit from New York Rangers in the NHL Intra-League Draft on June 8, 1960, MacDonald skated on a line with Gordie Howe during a glorious 1962-63 season in which he scored 33 goals and collected 61 points, both career highs. The Wings dealt MacDonald to Boston with Albert Langlois, Ron Harris and Bob Dillabough for Ab McDonald, Bob McCord and Ken Stephanson on May 31, 1965. Thinking he might rekindle the magic, Wings GM Sid Abel reacquired MacDonald from the Bruins for Pit Martin on December 30, 1965. This time, though, there was no spark. MacDonald scored just eight times over the next two seasons and was let go to the Minnesota North Stars in the NHL Expansion Draft on June 6, 1967.

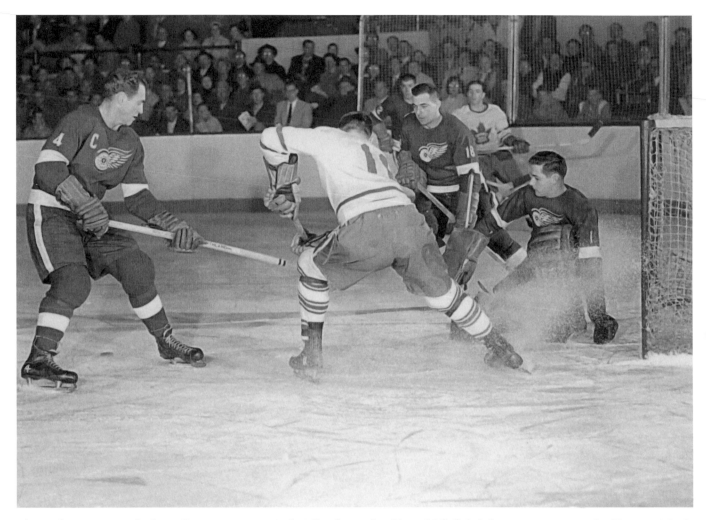

The puck squirts past the legs of Detroit captain Red Kelly after goalie Glenn Hall foiled this scoring attempt by Toronto Maple Leafs centre Tod Sloan. Spying the puck is Gord Hollingworth, Kelly's defence partner. Though he only played 93 games in a Red Wings uniform between 1955-58, Hollingworth was involved in one of the biggest trades in franchise history on May 28, 1955, when he was dealt to Detroit by Chicago with Jerry Toppazzini, John McCormack and Dave Creighton for Tony Leswick, Glen Skov, Johnny Wilson and Benny Woit. Hollingworth was forced to retire from hockey in 1962 when he was diagnosed with leukemia. He died February 2, 1974 at the age of 40.

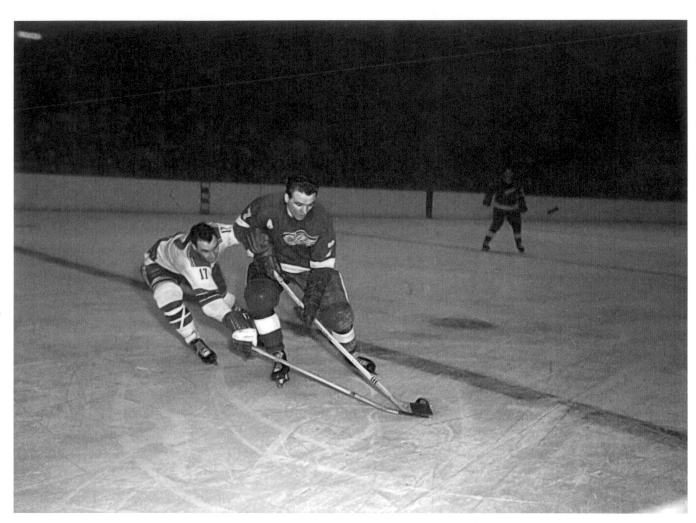

128

One of the game's best stickhandlers, Red Wings centre Norm Ullman deftly uses the blade of his stick to protect the puck from the determined checking of New York Rangers left-winger Dean Prentice. The two would become teammates in Detroit when Prentice was traded to Detroit by Boston with Leo Boivin for Gary Doak, Ron Murphy, Bill Lesuk and future considerations (Steve Atkinson, June 6, 1966) on February 16, 1966. Both would play with the Wings in the 1966 Stanley Cup final, as Detroit lost to Montreal in six games. Prentice (22 seasons) and Ullman (20 seasons), both share another bond—each played 20 years in the NHL without winning the Cup.

Floyd Smith is Johnny-on-the-spot, but his shot from the side of the net is easily turned away by New York Rangers goalie Gump Worsley. A right-winger who played 281 games in a Red Wings uniform from 1962-68, Smith arrived from the New York Rangers via the NHL Intra-League Draft on June 6, 1962, and departed through one of the most famous trades in NHL history on March 3, 1968, when the Wings sent Smith, Paul Henderson, Doug Barrie and Norm Ullman to the Toronto Maple Leafs for Frank Mahovlich, Pete Stemkowski, Garry Unger and the NHL rights to Carl Brewer.

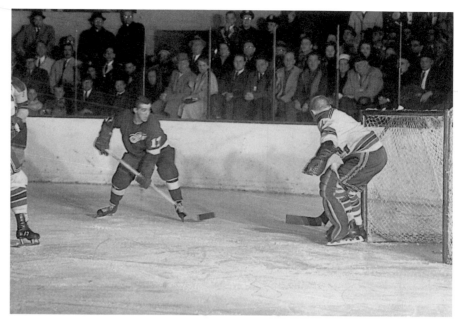

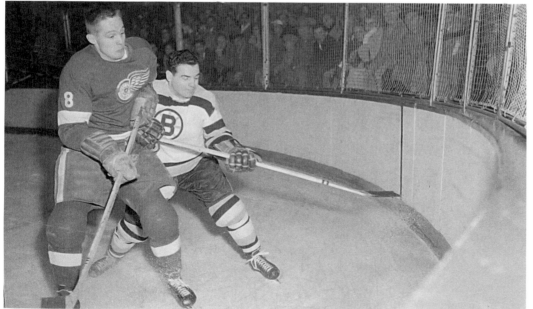

Detroit centre Earl Reibel battles for position with Hall of Fame Boston defenceman Leo Boivin in the oval-shaped Olympia Stadium corner. Traded by Detroit to Chicago in 1957, Reibel was flipped to the Bruins in the summer of 1958, becoming Boivin's teammate. Boivin, meanwhile, moved to the Wings from the Bruins on Feb. 16, 1966, and played for Detroit's 1966 Stanley Cup final team.

A offensive foray by Red Wings forward Marty Pavelich is giving Toronto Maple Leafs goaltender Harry Lumley fits. Lumley backstopped Detroit to the 1949-50 Stanley Cup final. On July 13, 1950, Chicago sent Bob Goldham, Jim Henry, Gaye Stewart and Metro Prystai to Detroit for Al Dewsbury, Lumley, Jack Stewart, Don Morrison and Pete Babando. At the time, it was the largest trade in NHL history.

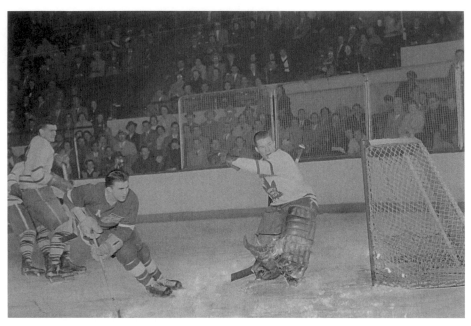

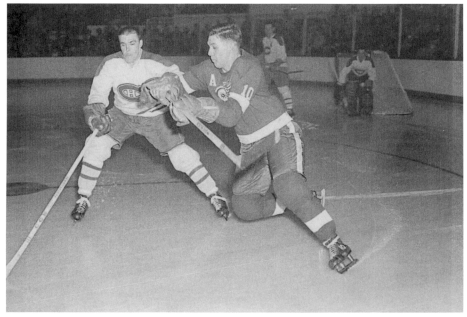

Montreal Canadiens defenceman Jean-Guy Talbot moves into position for a tussle with Red Wings centre Alex Delvecchio. While Delvecchio played all 24 of his NHL seasons with Detroit—a league record for a one-team player—Talbot saw much more of the league. In fact, during the 1967-68 season, he played for three teams. After starting the season with the Minnesota North Stars, Talbot was dealt to the Red Wings on Oct. 19, 1967 for Dave Richardson, Bob McCord and Duke Harris. He played just 32 games as a Red Wing and was claimed on waivers by the St. Louis Blues on Jan. 13, 1968.

Terry Sawchuk is down and all over this shot from Montreal's Bobby Rousseau, thanks in part to the impression Detroit defenceman Doug Barkley has left on Rousseau. Gilles Tremblay hopefully awaits a rebound, but Sawchuk has wisely directed the puck away from the front of his net. The Wings thought they were adding a future All-Star when they sent John McKenzie and Len Lunde to Chicago for Barkley on June 5, 1962. He finished second behind Toronto's Kent Douglas in the 1962-63 voting for the Calder Trophy, which goes to the NHL's top rookie, but glory was short-lived for Barkley. Battling Chicago's Doug Mohns for the puck during a January 30, 1966 game, Mohns sought to lift Barkley's stick, but missed, and the blade of his stick carried on up into Barkley's right eye. Surgery was unable to save his sight, and Barkley's career was over at the age of 29.

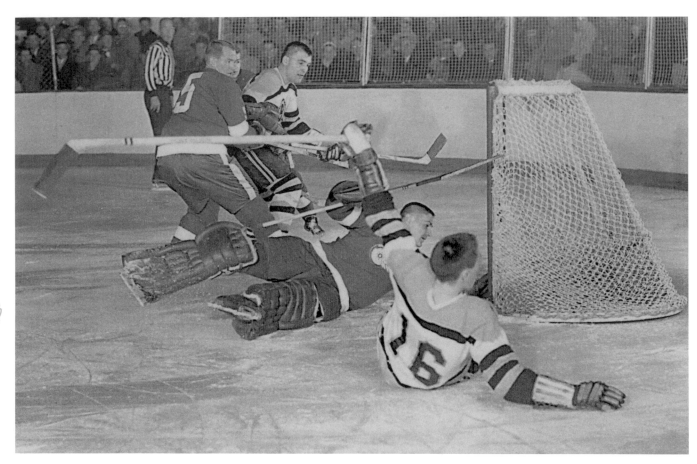

Down on the ice, Boston Bruins right-winger Leo Labine nonetheless raises his stick in celebration of the goal he's just scored on Red Wings goalie Terry Sawchuk. What's unique about this photo is that all four players pictured suited up during their NHL careers as both Bruins and Red Wings. Defenceman Warren Godfrey (5) came to Detroit June 3, 1955 in the nine-player deal that sent Gilles Boisvert, Real Chevrefils, Norm Corcoran and Ed Sandford to Detroit for Marcel Bonin, Lorne Davis, Sawchuk, Godfrey and Vic Stasiuk. Boston claimed Godfrey in the June 4, 1962 NHL Intra-League Draft, then dealt him back to the Wings on October 10, 1963 for journeyman defenceman Gerry Odrowski. The guy driving to the net for the Bruins enjoyed a Hall of Fame career in Boston, but many forget that John Bucyk played his first 104 NHL games as a Red Wing. On June 10, 1957, the Wings reacquired Sawchuk from the Bruins in exchange for Bucyk and a sum of cash. Labine, meanwhile, was dealt to Detroit by Boston with Stasiuk for Gary Aldcorn, Murray Oliver and Tom McCarthy on January 23, 1961.

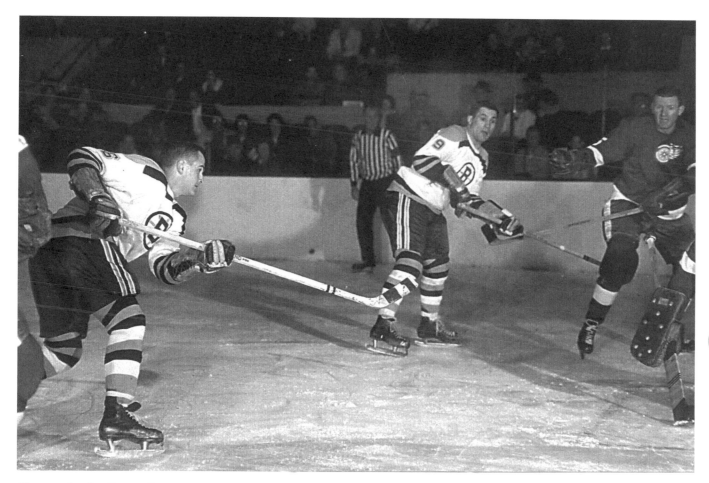

Alone in the slot, Boston Bruins centre Murray Oliver rifles a drive at Detroit goalie Dennis Riggin. Boston left-winger John Bucyk and Detroit defenceman Doug Barkley watch the action unfold. Both Oliver and Bucyk broke in with the Red Wings Winner of the Red Tilson Award as the MVP of the OHA Junior A Series with the Hamilton Tiger Cubs during the 1957-58 season, Oliver graduated to the Wings for a seven-game stint that season, and played for Detroit into the 1960-61 season, when he was dealt to the Bruins with Gary Aldcorn for Vic Stasiuk and Leo Labine on January 23, 1961. Bucyk debuted with Detroit during the 1955-56 season, and was traded to Boston for Terry Sawchuk on June 10, 1957. He played 21 seasons in Boston and was inducted into the Hockey Hall of Fame in 1981. The oldest NHLer to record a 50-goal season at 35 years, 10 months of age, Bucyk scored his milestone 50th goal March 16, 1971 in an 11-4 win over Detroit.

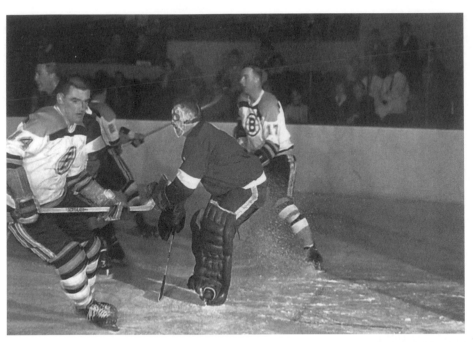

The puck is headed the other way after Detroit goalie Dennis Riggin foils a scoring foray by Boston Bruins forwards Forbes Kennedy (14) and Don McKenney (17) during action from the 1962-63 season. Detroit defenceman Marcel Pronovost is also leaving the zone. Centre Kennedy (1957-62) was already a former Wing at this time, while McKenney was a couple of seasons away from coming to Detroit. He'd be claimed on waivers from the Toronto Maple Leafs by Detroit on June 8, 1965.

The race is on for the puck in the Toronto zone between Maple Leafs defenceman Hugh Bolton and Red Wings centre Earl Reibel. While playing for Detroit's Windsor Spitfires OHA Junior A affiliate, Reibel became the first player in that league's history to surpass the 100-point plateau, accumulating 129 points during the 1950-51 season. He made the grade with the Red Wings in 1953-54, and led the team in scoring with 25-41-66 totals in 1954-55. The Lady Byng Trophy winner with Detroit in 1955-56, Reibel was traded to the Chicago Blackhawks with Billy Dea, Bill Dineen and Lorne Ferguson for Hec Lalande, Nick Mickoski, Bob Bailey and Jack McIntyre on December 17, 1957 in the midst of an eight-goal season. Claimed from Chicago by the Boston Bruins in the June 3, 1958 NHL Intra-League Draft a year later, Reibel was out of the NHL for good a year after that, scoring just six times in 63 games for Boston during the 1958-59 season.

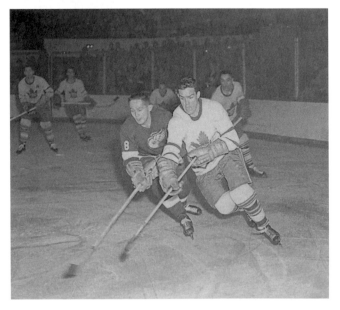

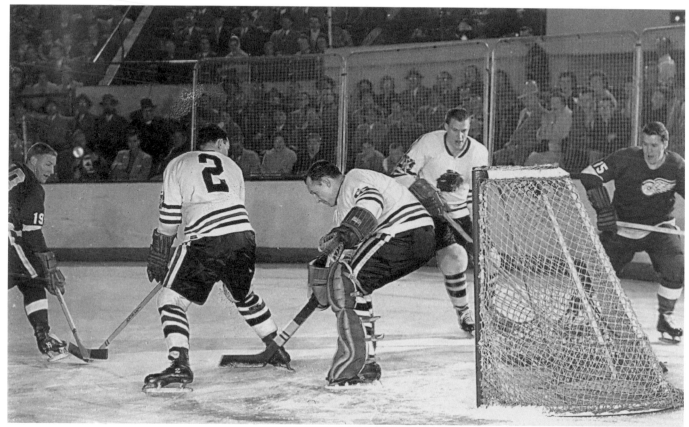

135

Everyone is looking for the puck in tight around the Chicago Blackhawks net as Detroit centre Murray Costello (19) shoots, but it's guaranteed that the puck isn't in the net. Acquired from the Boston Bruins with Lorne Ferguson for Gerry Toppazzini and Real Chevrefils, Jan. 17, 1956, Costello played 27 games in a Red Wings uniform in 1956-57 but never recorded a point. Looking back at goalie Al Rollins is defenceman Gus Mortson (2). He played his final NHL season as a Red Wing in 1958-59, collecting one assist in 36 games after Chicago dealt him to Detroit on September 3, 1958 for future considerations. By comparison, centre Billy Dea (15) was an offensive dynamo with Detroit. Acquired by Detroit from the New York Rangers with Aggie Kukulowicz and cash for Dave Creighton and Bronco Horvath on August 18, 1955, Dea produced 15-15-30 totals for the Wings during the 1956-57 campaign. He was traded to Chicago by Detroit with Bill Dineen, Lorne Ferguson and Earl Reibel for Nick Mickoski, Bob Bailey, Hec Lalande and John McIntyre on December 17, 1957, but returned to the Wings 12 years later when the Pittsburgh Penguins traded him for defenceman Mike McMahon on October 28, 1969.

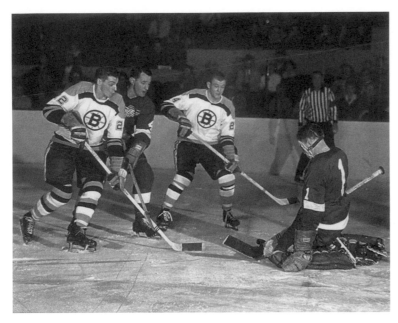

Detroit defenceman Bill Gadsby gets a stick on Boston Bruins defenceman Irv Spencer's backhand shot, which is easily parried aside by Wings goalie Dennis Riggin. Bruins centre Bobby Leiter has eyes for the juicy rebound. The Wings thought Gadsby was so nice, they tried to trade for him twice. On February 5, 1960, the Wings sent Red Kelly and Billy McNeill to the New York Rangers for Gadsby and Eddie Shack, but the deal was voided two days later when Kelly and McNeill both failed to report to New York. Finally, on June 12, 1961, a deal was consummated between the two teams, sending minor-leaguer Les Hunt to the Rangers for Gadsby. It was a sweet deal for Detroit. While Hunt never played an NHL game, future Hall of Famer Gadsby helped Detroit reach the Stanley Cup final four times before retiring in 1966.

136

In alone on Detroit goalie Glenn Hall, lanky Montreal Canadiens left-winger Bert Olmstead snaps a low shot that gets under Hall's glove, but the Red Wings netminder drops down his left pad in time to make the save. Although he never played a game for the Red Wings, Olmstead, a Hall of Famer who won four Stanley Cups with the Canadiens and another with the Toronto Maple Leafs, was actually Detroit property for 17 days in 1950. The Chicago Blackhawks traded Olmstead and Vic Stasiuk to the Red Wings for Lee Fogolin Sr. and Stephen Black on December 2, 1950. Then on December 17, 1950, Detroit dealt Olmstead to Montreal for speedy forward Leo (The Gazelle) Gravelle.

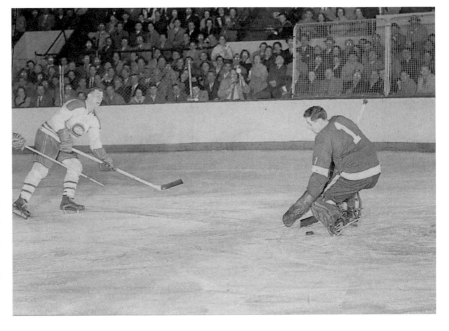

Wheeling and Dealing

Montreal Canadiens centre Connie Broden is sandwiched between Red Wings defenceman Red Kelly and goalie Glenn Hall as he looks to get a bead on the unidentified Detroit player moving out from behind the net with the puck. Both Kelly and Hall would come back to haunt the Wings after being traded away. Dealt to Chicago in the summer of 1957, Hall would backstop the Blackhawks to a six-game victory over the Red Wings in the 1961 Stanley Cup final. Kelly, shipped to Toronto in 1960, contributed to the Leafs' back-to-back Stanley Cup final series wins over the Red Wings in 1963 and 1964.

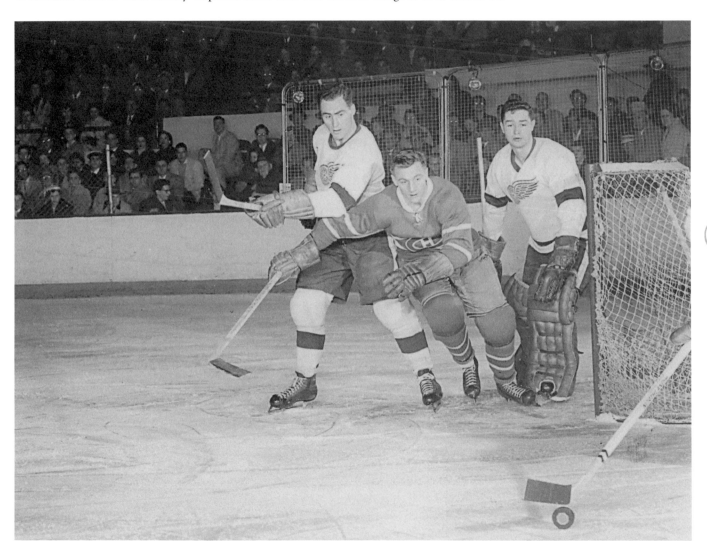

138

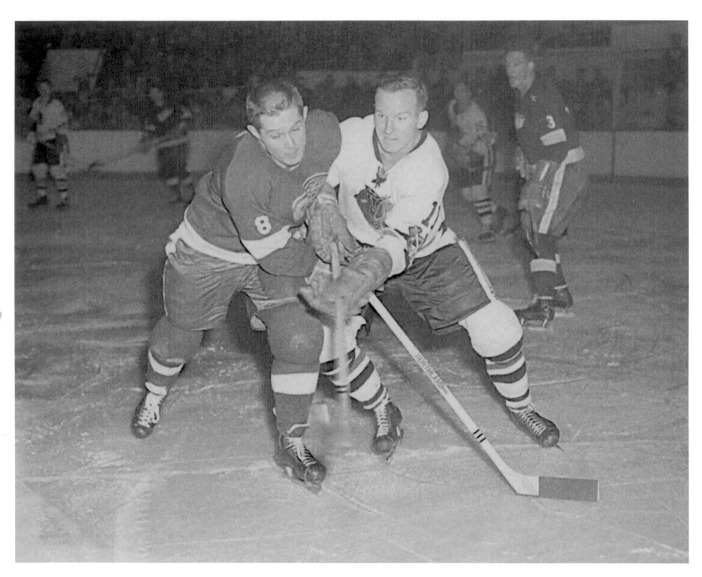

Detroit centre Earl (Dutch) Reibel and Chicago left-winger Jack McIntyre battle in close quarters during the 1957-58 season. On December 17, 1957, the Wings acquired McIntyre from the Blackhawks and few players in club history enjoyed a better debut in the winged wheel. McIntyre scored twice in his first game with Detroit, leading the Red Wings to a 3-2 victory over Toronto.

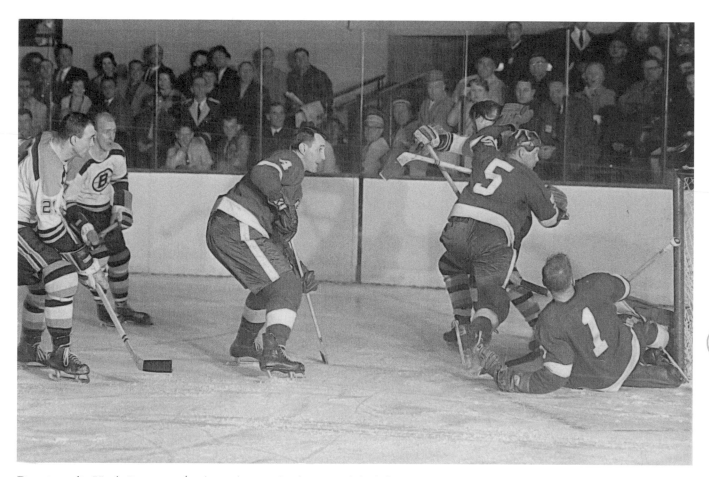

Detroit goalie Hank Bassen stacks the pads to make the save while defenceman Warren Godfrey (5) ensures that Boston Bruins centre Charlie Burns won't be getting to the rebound. Note that both Godfrey and Burns are wearing helmets, a rarity during the days of Original Six NHL play. Detroit defenceman Bill Gadsby has a bead on the loose puck, just ahead of Boston forwards Jerry Toppazzini (21) and Cliff Pennington. Pennington is the only player in the photo who was never a Red Wing. Burns played for Detroit during the 1959-60 season, while Toppazzini was twice acquired by Detroit. After just 40 games in Motown, Toppazzini was dealt to Boston by Detroit with Real Chevrefils for Murray Costello and Lorne Ferguson on January 17, 1956. Toppazzini again became Detroit property on October 10, 1964, when Chicago shipped him there for Hank Ciesla, but this time, the Wings never recalled Toppazzini from Pittsburgh of the AHL, where he played the entire 1964-65 season. The Los Angeles Blades of the Western Hockey League claimed Toppazzini from the Wings in the June 9, 1965 Reverse Draft.

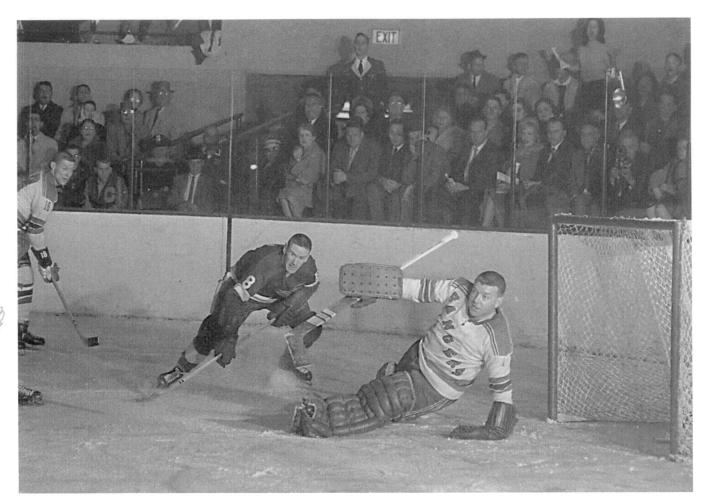

140

New York Rangers goalie Gump Worsley kicks away a shot as Detroit right-winger Leo Labine lurks nearby, hoping for a rebound. Rangers right-winger Ken Schinkel (18) looks on helplessly. Labine won a Memorial Cup with the Barrie Flyers in 1950-51 and was a two-time NHL All-Star Game participant (1955, 1956) as a Boston Bruin. The Wings added him to their line-up late in his career, dealing Gary Aldcorn, Murray Oliver and Tom McCarthy to the Bruins on January 23, 1961 for Labine and fellow veteran forward Vic Stasiuk. Clinging to fourth place in the standings at the time, but winners of just one of their last 11 home games, Wings GM Jack Adams felt the veteran experience of Labine and Stasiuk would help turn things around, and he looked like a genius when Detroit ended up playing Chicago in the 1961 Stanley Cup final.

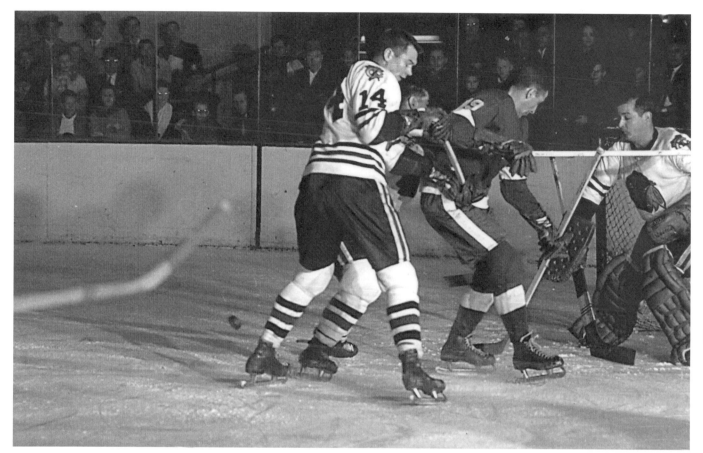

The object of their affection—the puck—skids harmlessly away from the Chicago Blackhawks net, but everyone seems preoccupied elsewhere. Chicago goalie Glenn Hall closes his eyes as the stick of Detroit centre Marc Boileau (19) dangles near his maskless face, while Blackhawks left-winger Ab McDonald (14) applies the hook to Boileau's midsection. MacDonald punished the Wings in the spring of 1961, scoring the Cup-winning goal against them for Chicago in Game 6 of the final series, but five years later, after he was acquired from the Boston Bruins with Bob McCord and Ken Stephanson for Bob Dillabough, Ron Harris, Albert Langlois and Parker MacDonald on May 31, 1965, he'd help Detroit reach the 1966 final, where the Wings lost in six games to the Montreal Canadiens. Lost to the Pittsburgh Penguins in the June 6, 1967 NHL expansion draft, McDonald re-emerged as a Red Wing for 19 games during the 1971-72 season after he, Bob Wall and Mike Lowe were the future considerations in the Feb. 22, 1971 deal that sent defenceman Carl Brewer from Detroit to the St. Louis Blues.

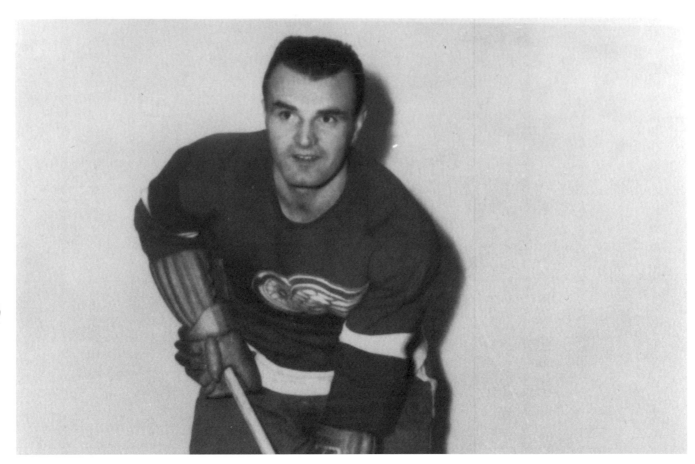

142

He came to Detroit in one blockbuster trade and left a year later in another major deal, but in between, Pete Babando scored one of the most famous goals in franchise history. On Aug. 14, 1949, Detroit GM Jack Adams shipped All-Star rearguard Bill Quackenbush and forward Pete Horeck to the Boston Bruins for Babando, forward Jimmy Peters Sr., and defencemen Lloyd Durham and Clare Martin. "We have defencemen," Adams explained. "We need forwards. I have watched Peters and Babando since their junior hockey days and they are two players I always have felt would be valuable assets to the Wings." Babando delivered on that billing when he scored Detroit's Stanley Cup-winning goal in 1950, but on July 13, 1950, his Red Wings tenure ended when he was traded to the Chicago Blackhawks as part of an NHL-record nine player transaction. Along with Babando, goalie Harry Lumley, defencemen Al Dewsbury and (Black) Jack Stewart, and forward Don Morrison went to Chicago for forwards Metro Prystai and Gaye Stewart, defenceman Bob Goldham and goalie Sugar Jim Henry.

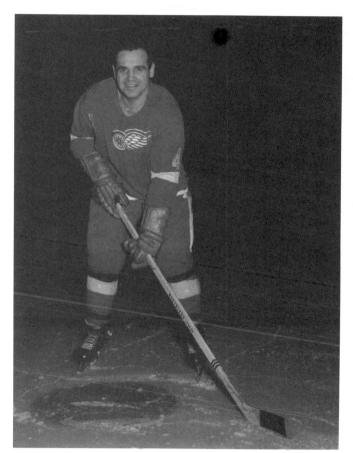

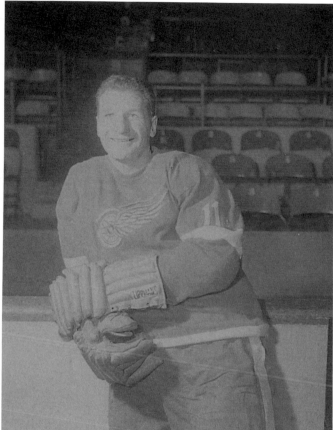

143

Looking for veteran defensive depth to bolster their run to the 1965-66 Stanley Cup final, the Wings made a multi-player deal with the Boston Bruins, where the key piece in the transaction was hard-hitting defenceman Leo Boivin (a Hall of Famer who played with Boston in the 1956-57 and 1957-58 Stanley Cup final series against Montreal, but lost each time). Boivin made it 0-for-3 against the Canadiens when Detroit lost the 1966 final to the Habs, but the deal to the Wings put him back in the play-offs for the first time since the 1958-59 season.

Left-winger Vic Stasiuk is a festival of enamel as he poses for his shot along the boards not long after he arrived for his second tour of duty as a Red Wing. Acquired from the Boston Bruins with Leo Labine for Tom McCarty, Murray Oliver and Gary Aldcorn in the midst of the 1960-61 season, Stasiuk produced a combined 15 goals and 58 points with the two teams that season. A Red Wing previously from 1950-55, Stasiuk won three Stanley Cups and played in five Cup final series in a Detroit uniform. He wore three uniform numbers during his Detroit tenures—22 (1950-52), 19 (1952-55) and 11 (1961-63).

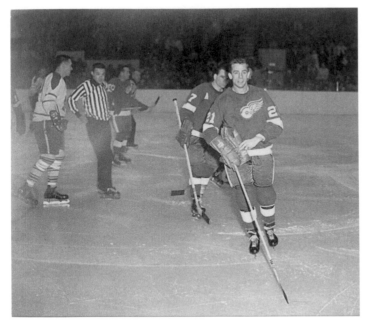

Detroit left-winger Larry Jeffrey grins while heading back to the Red Wings bench on a line change. Norm Ullman (7) and Parker MacDonald (20) are the other Detroit players in the background, while Toronto Maple Leafs captain George Armstrong appears to have an issue with linesman Matt Pavelich. Jeffrey launched his career with the Red Wings in 1961-62 and played in two Stanley Cup finals for the Wings (1962-63, 1963-64) against the Leafs. Dealt to Toronto by Detroit with Marcel Pronovost, Ed Joyal, Aut Erickson and Lowell MacDonald for Andy Bathgate, Billy Harris and Gary Jarrett on May 20, 1965, Jeffrey finally came out on the right side of a Cup final decision with the Leafs in 1966-67. Lost to Pittsburgh in the 1967 NHL expansion draft, then dealt to the New York Rangers, Jeffrey found his way back to the Red Wings on June 17, 1969, when he was traded to Detroit by the Rangers for Sandy Snow and Terry Sawchuk.

144

Chicago Blackhawks left-winger Roy Conacher splits the Detroit defence of Marcel Pronovost (3) and Leo Reise (on ice), but his scoring foray is thwarted by Wings net-minder Terry Sawchuk. A 30-goal scorer in his only season with Detroit, Conacher was dealt to the New York Rangers by Detroit for Ed Slowinski and future considerations on Oct. 22, 1947. But Conacher refused to report, insisting he was retiring from the game. That changed November 1, 1947, when he was dealt to Chicago in a straight cash transaction. Conacher won the NHL scoring title with the Blackhawks in 1948-49, but he's most remembered as the last Detroit player to wear No. 9 before Gordie Howe. Howe switched his sweater number to 9 from 17 following Conacher's departure because single-digit numbered players drew larger, lower sleeping berths on the trains during road trips.

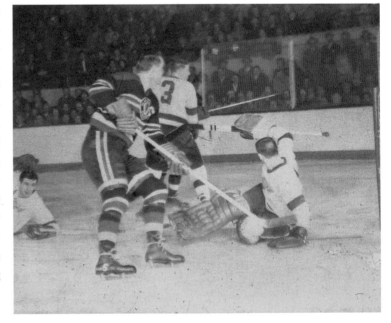

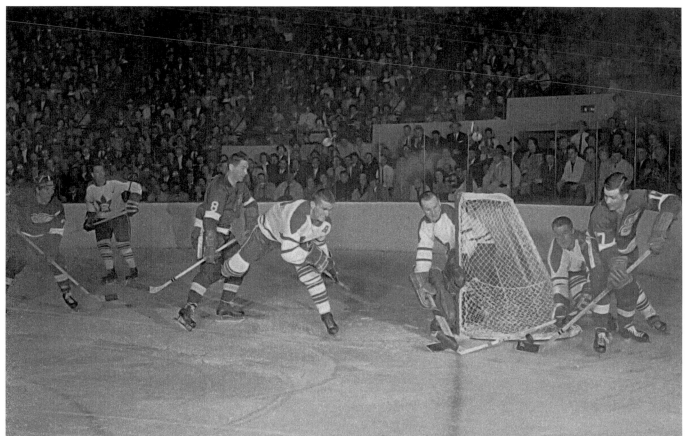

145

Detroit right-winger Floyd Smith (17) circles the Toronto goal, but his attempt to centre the puck to the waiting Lowell MacDonald (8) is thwarted by the stick of Maple Leafs defenceman Tim Horton. Leafs goalie Johnny Bower is also positioned to impede Smith's effort, while Toronto defenceman Allan Stanley adds a third stick to block the passing zone. Detroit defenceman Warren Godfrey swoops in from the point, while Toronto's Ron Stewart watches from afar. Smith arrived in Detroit from the New York Rangers via the June 4, 1962 NHL Intra-League draft and was kept on a yo-yo with the Wings, going up and down between Detroit and the club's Pittsburgh (AHL) farm club during three of his five full seasons with the franchise. After scoring an OHA Junior A Series-leading 46 goals for Hamilton in 1961-62, MacDonald debuted as a Red Wing late in the season. He was traded to Toronto by Detroit with Marcel Pronovost, Eddie Joyal, Larry Jeffrey and Aut Erickson for Andy Bathgate, Billy Harris and Gary Jarrett on May 20, 1965.

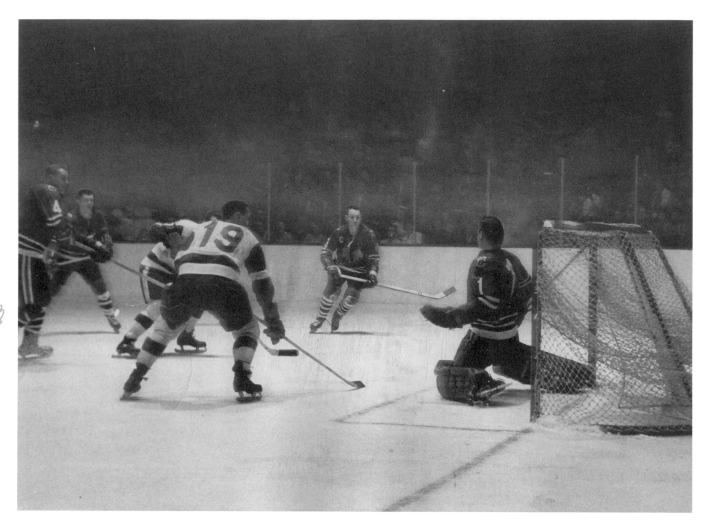

146

Detroit's Paul Henderson (19) and Norm Ullman (7) are both behind the Chicago Blackhawks defence, combining to put this puck past Chicago goaltender Glenn Hall. Chicago's Stan Mikita, captain Pierre Pilote (3) and Elmer (Moose) Vasko are nothing more than interested spectators at this juncture. Henderson and Ullman were part of one of the most famous trades in franchise history when they were sent with Floyd Smith and Doug Barrie to Toronto for Frank Mahovlich, Garry Unger, Pete Stemkowski and the rights to Carl Brewer on March 3, 1968. The two would later become teammates with Pilote, who was also dealt to the Leafs by Chicago after the 1967-68 season.

Chapter Six:

Hey, Weren't You?

MUSIC HAS ITS ONE-HIT WONDERS. Hockey has its one-year wonders. While some players go on to solid, lengthy NHL careers, many more find that the spotlight shines on them only briefly.

Left-winger Jack McIntyre arrived in Detroit from Chicago in 1957 with the reputation as a rugged free-wheeler who on occasion could produce a memorable performance. In his Red Wings debut, McIntyre scored twice in a 3-2 victory over Toronto. He tallied five times in his first five Red Wings games, but finished the season with 15 goals, and by the 1958-59 campaign was in the minor leagues.

There were many brief flashes of brilliance tied to Detroit's Original Six days, and many were part of Gordie Howe's line. In 1959-60, Gary Aldcorn scored 22 goals as the left-winger on Howe's unit. Earl (Dutch) Reibel began his NHL career in 1953-54 on Howe's line and produced a four-point night in his NHL debut. Reibel called it, "The easiest thing in the world" to centre Howe and Ted Lindsay.

Parker MacDonald was a 33-goal scorer for the Wings in 1962-63 and made no bones about the author of his success story. "Never in my wildest dreams did I ever think I'd get anywhere near 30 goals," MacDonald confided. "Why am I scoring so well? Because I'm playing with Gordie Howe and Alex Delvecchio."

Delvecchio, Detroit captain from 1962-73, believed that the key to success for any newcomer was establishing a comfort zone. "The players were great guys," Delvecchio recalled of the Detroit veterans. "They welcomed you as someone who could help the team, not as someone who was going to take their job."

That type of kinship was even extended to raw rookies. "There were no egos," defenceman Red Kelly said. "We were all close friends."

Certainly, among those whose tenure in a Detroit uniform was short, none was easier to spot than defenceman Gerry Odrowski. As a youngster in Trout Lake, Ontario, all of Odrowski's hair fell out when he was nine years old due to a mysterious illness.

Odrowski broke into the NHL with Detroit from 1960-63, then was buried in the minors until the 1967 expansion doubled the size of the NHL from six to twelve teams. Odrowski landed with the California Seals. "If a star gets a whole lot of goals, well, he's exceptional," Odrowski explained of his lot as a journeyman. "There aren't too many of them around. The rest of us are just average."

Another Wing who flamed out thanks to his own demons was defenceman Howie Young. Labeled the next Eddie Shore by GM Jack Adams when he arrived in Detroit in 1961, Young led the NHL with 273 penalty minutes in 1962-63. But Young's on-ice battles were nothing compared to his battle with the bottle. "I've played with a lot of hangovers," Young explained when arriving for a second tour with the Wings in 1966. "Hangovers are worse than injuries."

Bob Goldham had won a Stanley Cup with Toronto over Detroit in 1942 and played in six NHL All-Star Games by the time he was acquired from Chicago in 1950 to anchor a young Red Wings rearguard, taking players like Marcel Pronovost and Al Arbour under his wing. "To this day, I can't understand why he's not in the Hall of Fame," former Wings coach Jimmy Skinner said in 1995. "He was one of the best stay-at-home defencemen the game has ever seen."

Surviving a double skull fracture suffered as a junior with the Toronto Marlboros, Charlie Burns was unique during his one season as a Red Wing in 1959-60 because he wore a helmet, a rarity in those days. "It's terrific to get a chance with Detroit," said Burns, who feared his injury would keep him out of the NHL.

After captaining Chicago to the 1961 Stanley Cup over the Red Wings, Ed Litzenberger was traded to Detroit, where he quickly blossomed and sat third in NHL scoring a month into the 1961-62 campaign with 16 points. "It's like starting a new life," said Litzenberger, who lost his first wife in a car accident in 1960. But with just 20 points through 32 games, Litzenberger was dealt to Toronto, where he'd win two more Stanley Cups—both at the expense of the Wings.

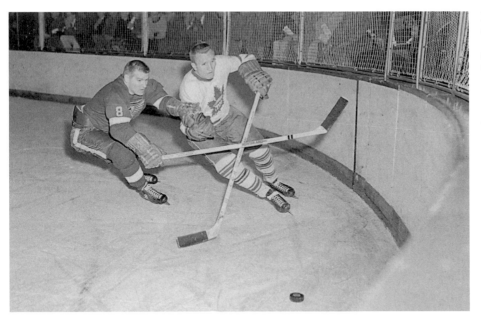

Earl (Dutch) Reibel puts the grab on Toronto's Ron Hurst as they both pursue the puck. Few players enjoyed a better launch to an NHL career than Reibel, who collected an NHL rookie-record four assists against the New York Rangers in a 4-1 win on Oct. 8, 1953. Reibel led the Wings with 66 points during the 1954-55 season, the only time between 1950-51 and 1963-64 that Gordie Howe did not lead the team in scoring. Reibel was awarded the Lady Byng Trophy following the 1955-56 season.

149

Montreal forward Claude Provost slides his shot wide of Glenn Hall's net, as Red Wings defencemen Red Kelly (4) and Larry Hillman arrive too late to make a difference. After watching Hillman in action with Detroit during the 1955 NHL All-Star Game, Montreal Gazette columnist Dink Carroll left impressed. "He looks like a good skater and can drill that puck from the point," Carroll noted. A Stanley Cup winner with the Wings in 1954-55, Hillman also won Cups in Toronto and Montreal and was one of hockey's most travelled competitors, having suited up for 15 different pro teams by the time he retired in 1976.

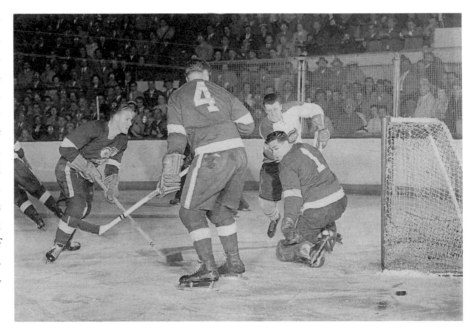

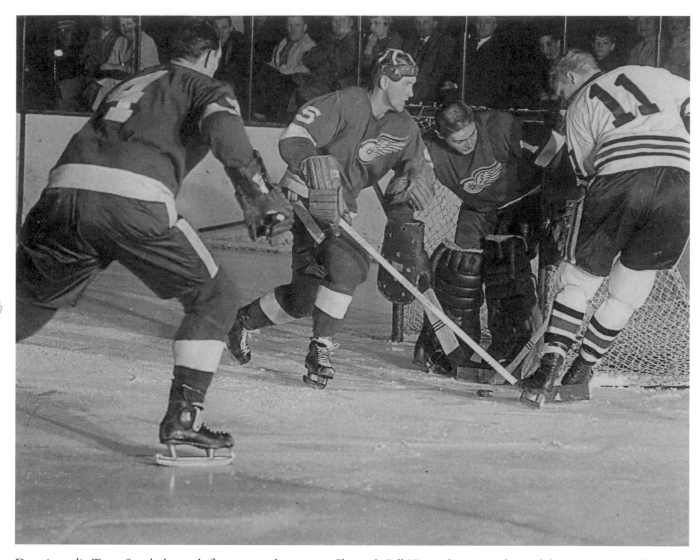

150

Detroit goalie Terry Sawchuk stands firm against his post as Chicago's Bill Hay seeks to jam the puck home. Detroit defenceman Warren Godfrey moves purposefully toward Hay, as does defence partner Bill Gadsby. A Red Wing for 12 seasons, Godfrey wore a helmet ... though as you can see, the leather contraption strapped to his head offered little by way of protection.

Boston Bruins forward Murray Oliver, a former Red Wing, is about to feel the wrath of Detroit defenceman Howie Young. During the 1962-63 season, Young set an NHL record with 273 penalty minutes, and even made the cover of *Sports Illustrated*, billed as "Detroit's bad boy." Skilled and a feared body checker, Young was too undisciplined to maintain a place as an NHL regular. NHL president Clarence Campbell, called upon to fine and suspend Young on more than one occasion, once referred to him as "the worst detriment to the NHL to ever lace up a pair of skates." Young idolized John Wayne and had a brief stint as an actor, playing a bit part in the 1965 World War II film *None But The Brave*, which starred Frank Sinatra.

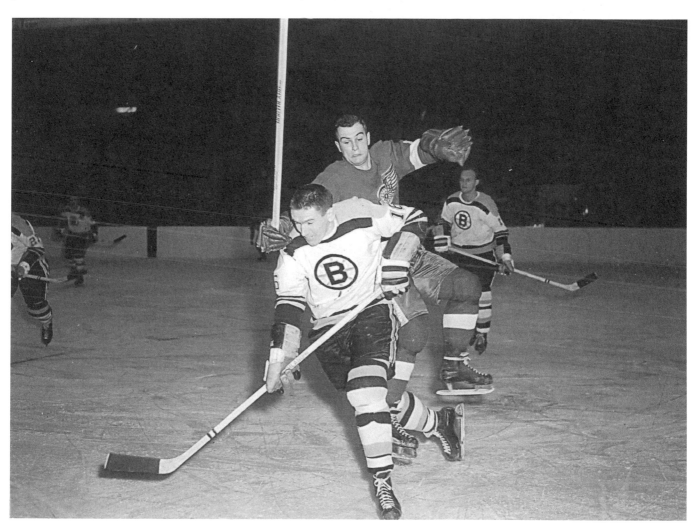

They also serve, who only sit and wait. The scratches from a Detroit home game against the New York Rangers during the 1962-63 season take their seats in the Olympia Stadium press box. Red Wings forward Bruce MacGregor (left), Rangers forward Vic Hadfield (fourth from left) and Detroit goalie Terry Sawchuk (far right) watch the action intently, while Detroit's Vic Stasiuk (third from left) and New York backup goalie Marcel Pelletier engage in conversation.

152

Montreal Canadiens Norris Trophy-winning defenceman Tom Johnson head-mans the puck, fending off the pesky checking of Detroit right-winger Barry Cullen. One of three brothers to play in the NHL, Cullen played just one season with the Wings, the 1959-60 campaign. He broke into the NHL with Toronto, where he teamed with his brother Brian, and was traded to Detroit by Toronto for Frank Roggeveen and John Wilson on June 9, 1959. The third Cullen brother, Ray, played for the Wings during the 1966-67 season.

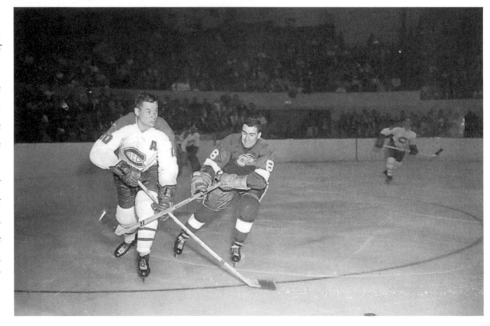

Detroit centre Norm Ullman feels the pain as he takes the stick of Toronto defenceman Al Arbour to the spine, while Bruce MacGregor (16) follows the puck goalward. A journeyman performer, Arbour launched his NHL career with the Wings in 1953-54, and when he was done as a player with St. Louis in 1970-71 he had appeared in six Stanley Cup finals, winning four times. As a coach, he guided the New York Islanders to four successive Stanley Cups between 1979-80 and 1982-83.

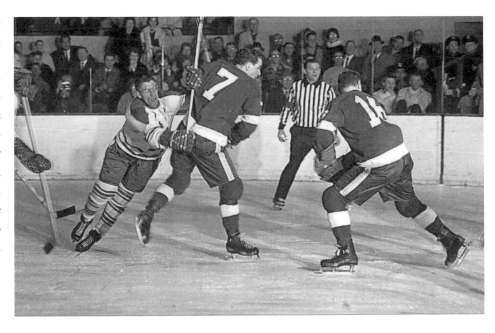

153

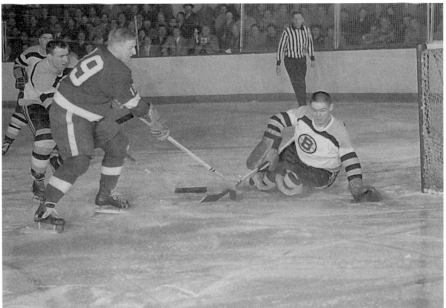

Former Wings goalie Terry Sawchuk, at this point in his career a Boston Bruin, foils Detroit centre Murray Costello on a point-blank chance, then scoops the rebound to his glove to smother the puck. Sawchuk's teammate briefly in Boston, Costello was dealt to the Wings during the 1955-56 season and played two years in Detroit. After his playing days, Costello ruled over the game in Canada, serving as president of the Canadian Amateur Hockey Association from 1979-1998. He's been a vice-president of the International Ice Hockey Federation since 2008, and was inducted into the Hockey Hall of Fame in 2005.

New York Rangers forward Don Marshall (22) has the puck in his skates, but Detroit left-winger Vic Stasiuk (11) has it in his mind that he will dislodge the biscuit. Detroit centre Alex Delvecchio (10) is hoping Stasiuk is right, while Rangers defenceman Doug Harvey (2) is intent on preventing that from happening. Stasiuk is best remembered as one-third of Boston's Uke Line with Johnny Bucyk and Bronco Horvath, but what's often forgotten is that all three members of the famous Bruins forward unit played with the Red Wings during their NHL careers.

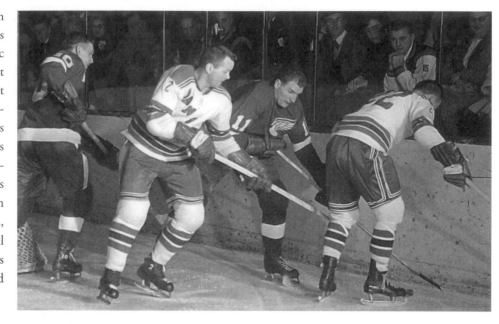

154

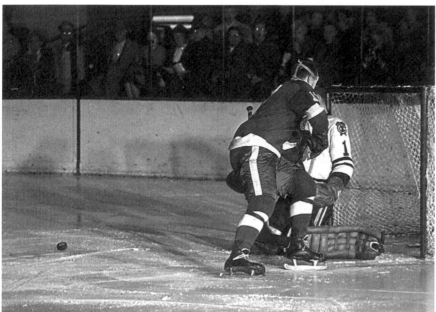

Chicago goalie and former Red Wing Glenn Hall foils Detroit left-winger Claude Laforge on a breakaway, but that's not what makes this photo unique. Look closely and you'll notice that Hall is not wearing a goalie mask, but Laforge is. Even though he wasn't a goalie, Laforge was the first Wings player to wear a goalie mask in an NHL game. Laforge, who had recently suffered a broken cheekbone with Hershey of the AHL, wasn't going to miss his chance when he was called up by Detroit a few days later. On December 28, 1961, Laforge played against Chicago wearing a goalie mask. The following season, Terry Sawchuk became the first Red Wings goalie to wear a mask.

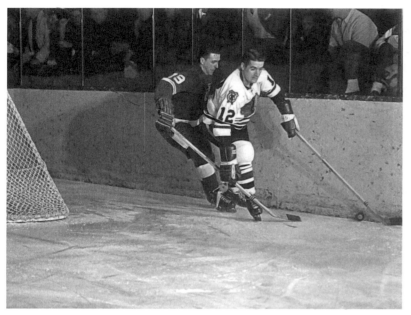

Former Wing Jerry Melynk of the Chicago Blackhawks has the puck, and he also grabs a handful of Marc Boileau's stick to ensure the Red Wings centre won't be getting it on the disk anytime soon. Melnyk scored an overtime goal for the Wings against Toronto at Olympia Stadium during the 1960 playoffs, and it would be the last home-ice goal scored by the Wings in a Stanley Cup OT until 1995. Boileau played 54 games for the Wings during the 1961-62 season, and later coached the Pittsburgh Penguins. His father Rene Boileau played with the New York Americans during the 1925-26 season, and was billed by the team's public relations staff as Rainey Drinkwater, insisting he was the first Native American NHL player when in fact he was a French-Canadian from Quebec.

155

Left-winger Vic Stasiuk (11) and centre Alex Faulkner (12) combine to corral future Hall of Famer Rod Gilbert of the New York Rangers along the boards. Stasiuk served two terms as a Red Wing. Acquired from Chicago in 1950, he played for Detroit until 1955. Traded to Boston that summer, he was reacquired by the Wings in January of 1961 and played with them until 1963. Claimed from Toronto in the 1962 NHL Intra-League Draft, Faulkner made NHL history during the 1963 Stanley Cup final, becoming the first native Newfoundlander to play for Lord Stanley's mug.

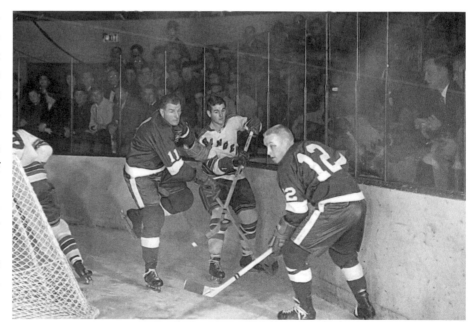

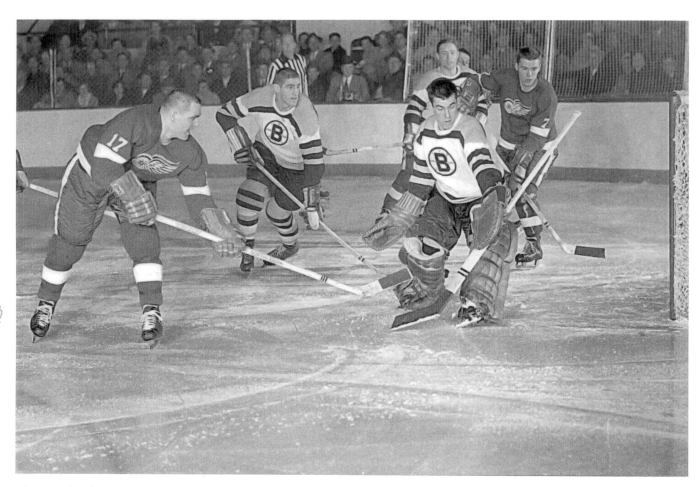

156

Alone in the slot, Detroit centre Forbes Kennedy snaps a shot past Boston Bruins goalie Don Simmons. Kennedy was a rugged centre who in 1960-61 set a WHL record with 10 major penalties, and led the NHL in penalty minutes during the 1968-69 season with 219, a record at the time for centres. Kennedy was the last centre to lead the league in PIM until another former Wing, Sean Avery, did so with the Los Angeles Kings in 2003-04. A Red Wing from 1957-62, Kennedy's biggest moment in that period may have been a save. Working as a lifeguard during the off-season in his hometown of Charlottetown, P.E.I., Kennedy saved a young girl from drowning in August of 1959. You might also notice in the background a young forward wearing No. 7 for the Wings. That's centre Billy Dea, who was the first player to wear the digit after Ted Lindsay was traded to Chicago in the summer of 1957. Dea played for the Wings from 1957-58, and again from 1969-71.

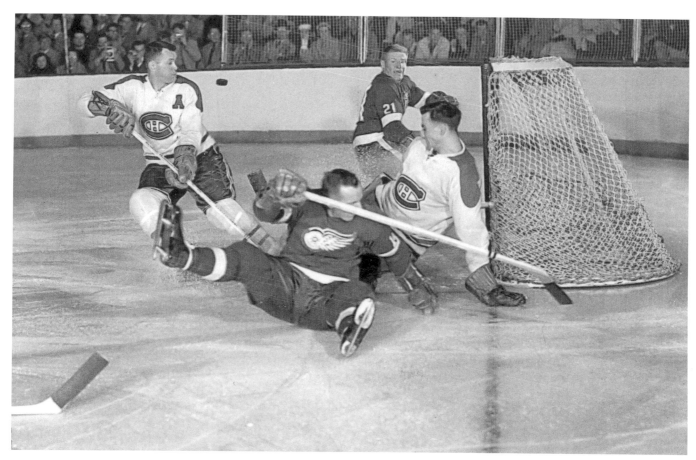

The puck sails toward Montreal defenceman Doug Harvey after goalie Jacques Plante makes a sprawling save, stopping both the disk and Detroit left-winger Nick Mickoski (11). Wings centre Billy McNeill can do little but watch the puck go the wrong way. Traded to Detroit by Chicago with Hec Lalande, Bob Bailey and Jack McIntyre for Bill Dineen, Billy Dea, Lorne Ferguson and Earl Reibel on December 17, 1957, Mickoski was a scratch golfer who won both the Manitoba Amateur (1966) and Manitoba Senior (1983) titles. He was inducted into the Manitoba Sports Hall of Fame in 1985. McNeill was traded to the New York Rangers with Red Kelly for Bill Gadsby and Eddie Shack on February 5, 1960. But when both Kelly and McNeill refused to report, the deal was voided two days later. Claimed by the New York Rangers in the NHL Intra-League draft that summer, McNeill opted to retire. But Detroit reacquired his rights in January of 1961, and he came out of retirement, playing two more seasons with the Red Wings. Hall of Famer Harvey also had a brief fling as a Red Wing, playing two games for Detroit during the 1966-67 season.

Red Wings rearguard Bill Gadsby takes up defensive position against Boston Bruins centre Murray Oliver in front of Detroit netminder Dennis Riggin, as left-winger Val Fonteyne circles back in support. A Red Wing from 1959-63 and again from 1965-67, Fonteyne was the Mr. Clean of the NHL. He accumulated just 26 penalty minutes during 820 games in the league, and set an NHL record by playing 185 consecutive penalty-free games between March 3, 1965 and December 3, 1968.

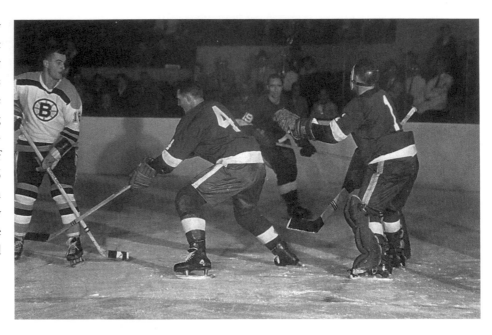

158

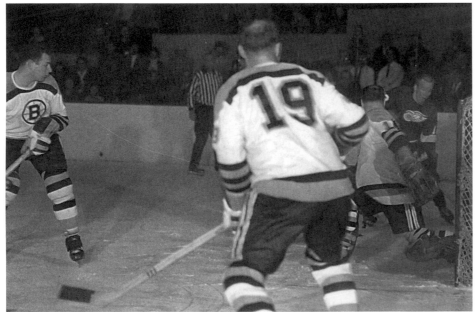

Boston Bruins defencemen Ted Green and Doug Mohns can only watch as Detroit rookie Ron Harris tries to slip a sharp-angled shot past Bruins goalie Bob Perreault. A Wings defenceman from 1962-64 and again from 1968-72, Harris would practice with five-pound weights attached to each of his shin guards, believing that carrying the added weight would strengthen his legs. "If I find my legs feel loggy during a game, then I put the weights on in practice for a while," Harris explained.

Two players who were briefly Red Wings pose along the boards during the 1963-64 NHL season. Centre Ed Joyal (21) broke in with the Wings in 1962-63, and played in the Stanley Cup final that spring and again in 1963-64. He moved to Toronto as part of an eight-player deal with Marcel Pronovost, Larry Jeffrey, Lowell MacDonald and Aut Erickson for Andy Bathgate, Billy Harris and Gary Jarrett. Claimed by Detroit from Buffalo (AHL) in the Inter-League Draft on June 4, 1963, defenceman Ian Cushenan (18) spent just that one season with the Wings before he moved to Chicago with John Miszuk and Art Stratton in exchange for Aut Erickson and Ron Murphy on June 9, 1964. Still, he can claim a unique bit of history. Even though he played just 129 NHL games, Cushenan was a teammate of Gordie Howe in Detroit, Bobby Hull in Chicago and Maurice (Rocket) Richard in Montreal.

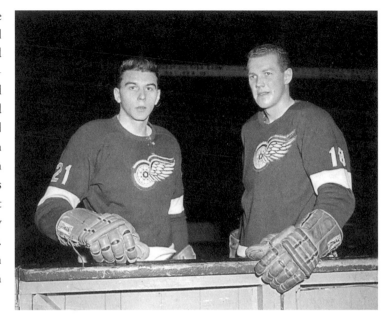

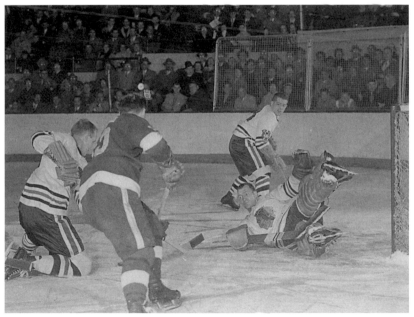

Chicago goaltender Al Rollins slides across his crease to make a spectacular stop on Detroit centre Billy Dea. Dea, who had two separate tenures wearing the Winged Wheel—from 1956-57 to 1957-58 and then from 1969-70 to 1970-71—was part of a couple of famous hockey families. His father Howard Dea was a centre who played in the Western Canada Hockey League with the Edmonton Eskimos (1921-22) and Calgary Tigers (1921-22 to 1923-24). Dea's uncle Murray Murdoch played for the New York Rangers from 1926-37, winning two Stanley Cups and playing in 508 consecutive games to reign as the NHL's iron man until Red Wings forward Johnny Wilson surpassed his mark on March 22, 1959, as Detroit beat the Rangers 5-2.

Original Six Dynasties: Detroit Red Wings

New York Rangers goalie Gump Worsley kicks out a shot by Red Wings centre Norm Ullman. He's closing in on the rebound, and left-winger Gary Aldcorn (11) is positioned in the slot in the hopes of finishing off an Ullman feed. During the 1960-61 season, Aldcorn scored just 2 goals for the Wings, a season after he lit the lamp 22 times. A Memorial Cup winner with the Toronto Marlboros in 1954-55, Aldcorn also played in the 1962-63 Allan Cup final, but his Winnipeg Maroons lost to the Windsor Bulldogs. Aldcorn also played for Canada in the 1965 world hockey championships, scoring five goals in seven games as the Canadians finished fourth.

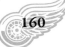

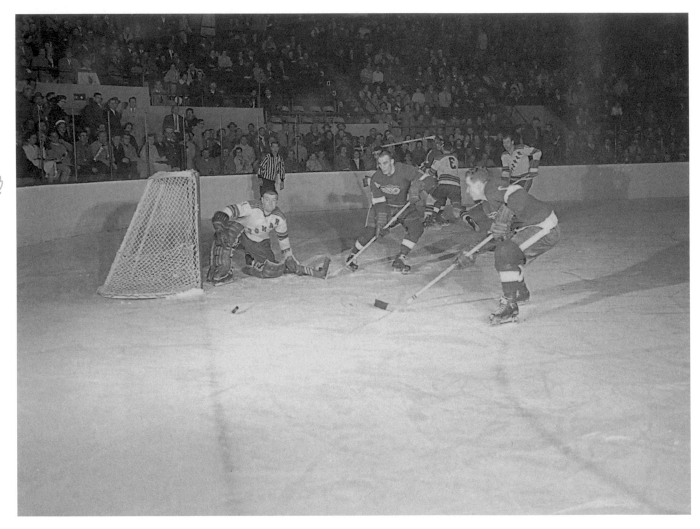

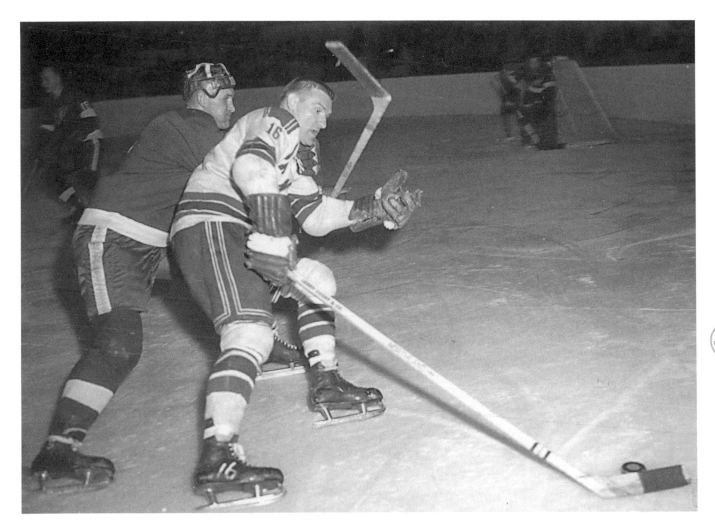

Somewhere out of this frame, a referee's right arm is rising upward. Helmeted Wings defenceman Warren Godfrey puts the grab on New York Rangers centre Earl Ingarfield as Detroit netminder Terry Sawchuk guards his post. Godfrey's defence partner Gerry Odrowski (18) patrols the slot area. Godfrey enjoyed two lengthy stints with Detroit—from 1955-62, and from 1963-68—and wore five different uniform numbers as a Red Wing. He was No. 5 for his entire first tour of Detroit, but upon his return, wore No. 11 in 1963-64, No. 23 in 1964-65, No. 2 in 1965-66, No. 18 in 1966-67 and No. 3 during the 1967-68 campaign. Odrowski was a Wing for three seasons from 1960-63, wearing No. 18 in 1960-61 and 1961-62 and No. 22 during the 1962-63 season.

Detroit left-winger Brian Smith (16) brings down New York Rangers left-winger Eddie Shack as Detroit defenceman Red Kelly seeks to avoid stepping on the fallen players. Kelly's defence partner Pete Goegan watches from a safe distance. Smith saw action on three different occasions with the Red Wings. His first tour came during a four-game stint in 1957-58 which saw him collect a solitary assist. Back for his longest stay during the 1959-60 season, Smith went 2-5-7 in 31 games and was held pointless in five playoff contests as Detroit lost to the Toronto Maple Leafs in the semifinals. The next season, Smith saw action in 26 games, garnering a pair of helpers. In a sense, his was a case of like father, like son. His dad Stu, also a left-winger, made an impressive debut with the Montreal Canadiens during the 1940-41 season, collecting 1-2-3 totals in three regular-season games. He appeared in one playoff game that spring, but just one more game the following year, gaining an assist in that contest to extend his point-per-game ratio. But the elder Smith enlisted in the Canadian Armed Forces after the season and would never play another NHL game.

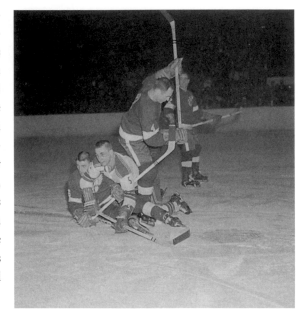

162

Detroit captain Red Kelly puts his shoulder into Toronto Maple Leafs forward Dick Duff as centre Charlie Burns looks over his shoulder to watch the flight of Duff's pass. After helping Canada win the world title in the spring of 1958, Burns signed as a free agent with the Red Wings on September 13, 1958 and played all 70 games as an NHL rookie in 1958-59, producing 9-11-20 totals. Claimed from Detroit by the Boston Bruins in the June 10, 1959 NHL Intra-League draft, Burns enjoyed a 749-game NHL career with the Wings, Bruins, Oakland Seals, Pittsburgh Penguins and Minnesota North Stars, and made history on March 1, 1970. Making his debut as the final player-head coach in NHL history, Burns led the North Stars to an 8-0 rout of the Toronto Maple Leafs.

Terry Sawchuk slides across his crease, puts the paddle down and parries away this shot by Toronto Maple Leafs forward Tod Sloan. Detroit defenceman Gord Strate (18) hurries to his goalie's aid, while Leafs All-Star left-winger Frank Mahovlich, a future Red Wing, peers over his shoulder and debates his next move. Strate played all 61 of his NHL games with the Wings from 1956-59, establishing two marks that no one will seek to break. He went without a point in his career, and that's the most career games any non-goalie has played for the Red Wings without collecting a point. As well, his 45 pointless games during the 1957-58 season set a single-season mark for a Detroit player, breaking the record of 44 that defenceman Percy (Puss) Traub had held since the 1928-29 season.

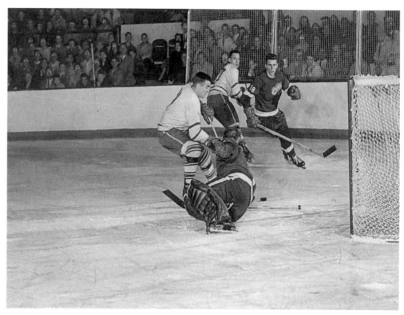

163

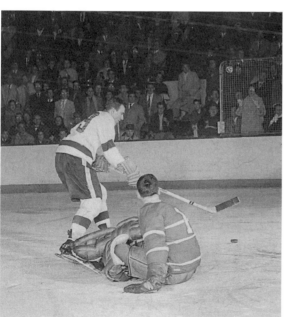

Detroit centre Murray Costello goes to the backhand, but Montreal Canadiens netminder Jacques Plante roams well out of his goal area to deny him. A Red Wing during the 1955-56 and 1956-57 seasons, Costello was part of a unique hockey-playing brother combination that hailed from South Porcupine, Ontario. After his playing days, Murray later served as president of the Canadian Amateur Hockey Association and today is a member of the International Ice Hockey Federation's board of directors. His brother Les, a Stanley Cup winner with the Toronto Maple Leafs in 1947-48 and a two-time Memorial Cup winner with Toronto St. Michael's, retired from pro hockey in the spring of 1950 and became a Roman Catholic priest. Les later founded the Flying Fathers, a troupe of hockey-playing priests who toured the world playing exhibition games and raising millions of dollars for charitable causes. A third brother, Jack Costello, never played in the NHL, but did help the Windsor Bulldogs win the 1962-63 Allan Cup, and later established the hockey program at St. Clair College, leading his teams to five OCAA championships.

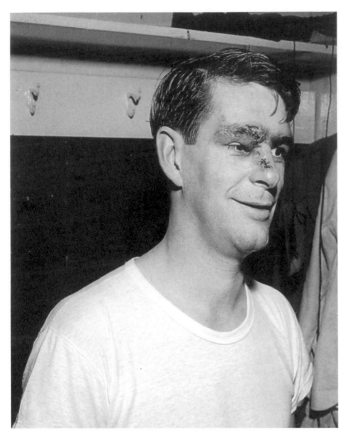

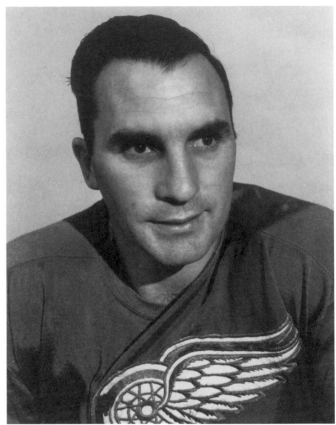

164

Yes, he can still smile, even though he was that close to los-ing an eye. Detroit defenceman Bob Goldham was one of the most fearless shot-blockers in hockey, but this wound wasn't the result of an errant puck. Goldham was caught in the face with a skate blade during a 4-3 victory over the Chicago Blackhawks at Chicago Stadium on February 9, 1951, and 15 stitches were required to close his wound.

In 1952, Dean Prentice, pictured above, and Andy Bathgate helped lead the Guelph Biltmore Mad Hatters to the Memorial Cup title. Fourteen years later, they teamed up in Detroit and helped the Red Wings reach the Stanley Cup final before Detroit fell in six games to the Montreal Canadiens. Prentice never won a Stanley Cup during his 22-season NHL career, and that 1966 spring marked the only time he ever appeared in a final series.

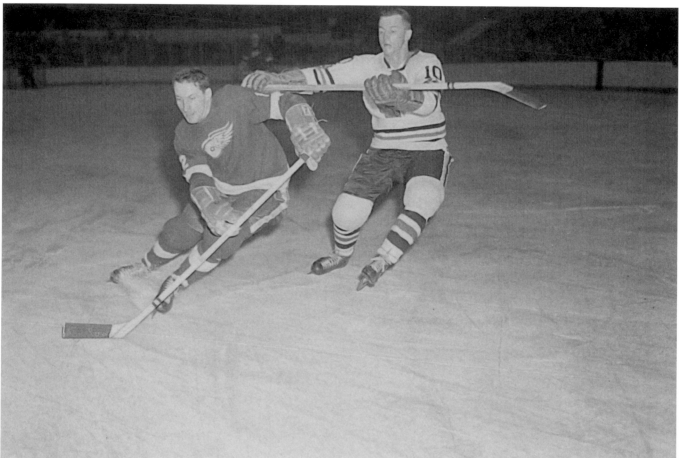

Chicago Blackhawks left-winger Ron Murphy aims his stick with menace toward the back of Detroit left-winger Tony Leswick. Leswick served two tours of duty as a Red Wing during his NHL career. Known as Mighty Mouse, the 5' 7", 160-pound Leswick broke into the NHL with the New York Rangers in 1945, but was traded to Detroit for Gaye Stewart on June 8, 1951. Leswick scored Detroit's Cup-winning goal in 1954 against the Montreal Canadiens, but shortly after Detroit's 1955 Stanley Cup triumph, he was traded to Chicago. Leswick wasn't gone long, as he was reacquired from Chicago in a straight cash deal on August 1, 1956. Murphy also began his NHL days with the Rangers in 1952. After a stop in Chicago, Murphy was shipped to the Wings with Aut Erickson for Art Stratton, John Miszuk and Ian Cushenan on June 9, 1964. Detroit moved Murphy to Boston with Bill Lesuk, Gary Doak and future considerations (Steve Atkinson, June 6, 1966) for Dean Prentice and Leo Boivin on February 16, 1966.

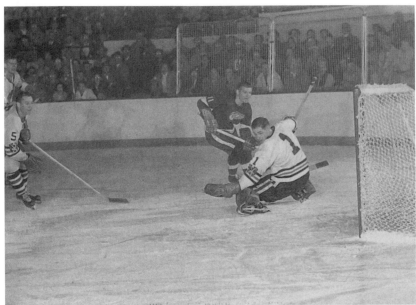

Detroit left-winger Johnny Wilson snaps a low shot just wide of the net, as Chicago Blackhawks goalie Glenn Hall watches the puck sail past the post. Jimmy Thomson and Eric Nesterenko (15) are other interested spectators. Wilson and his brother Larry were recalled from Omaha of the United States Hockey League in time for the 1950 Stanley Cup playoffs, and both got their names inscribed on the Cup that spring. Larry would be traded to Chicago in 1953, and after winning three more Cups in Detroit (1952, 1954, 1955), Johnny would join him there on May 28, 1955. After two seasons as a Blackhawk, Johnny was dealt back to Detroit by Chicago with Forbes Kennedy, Bill Preston and Hank Bassen for Ted Lindsay and Hall on July 23, 1957.

Kicking out his left pad, Detroit goalie Terry Sawchuk is all over this shot by Chicago left-winger Nick Mickoski, wearing the No. 9 that would later be made famous in the Windy City by Bobby Hull. Detroit captain Red Kelly applies the brakes in order to corral the rebound and get the puck to safety in this action from the 1957-58 season. Later that campaign, Mickoski would find himself helping Sawchuk defend. He'd be traded to Detroit by Chicago on December 17, 1957 with Hec Lalande, Bob Bailey and Jack McIntyre for Bill Dineen, Billy Dea, Lorne Ferguson and Earl Reibel. A well-travelled player who also skated with Boston and the New York Rangers, Mickoski played 103 games as a Red Wing before he was traded to Boston by the Wings for Jim Morrison on August 25, 1959.

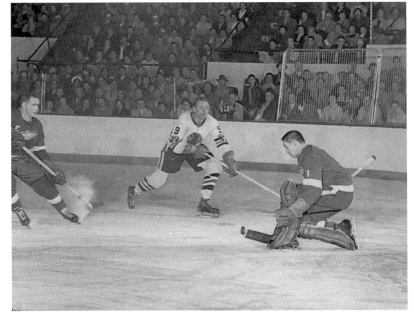

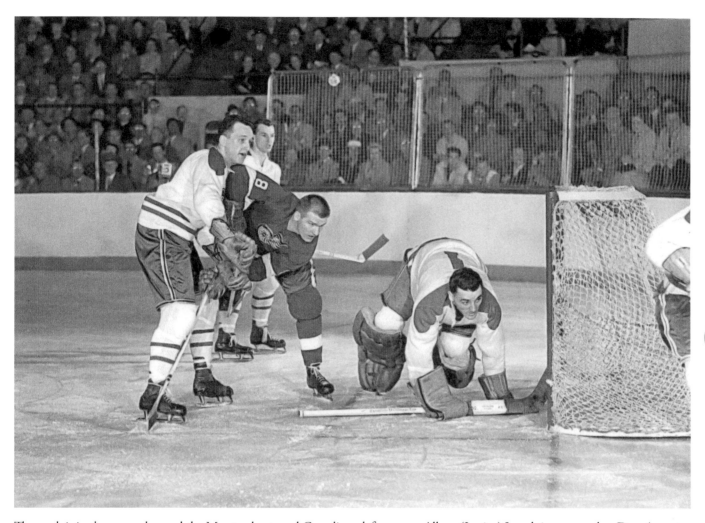

167

The puck is in the corner beyond the Montreal net, and Canadiens defenceman Albert (Junior) Langlois ensures that Detroit centre Earl (Dutch) Reibel isn't going to be part of the conversation for the loose puck as Canadiens goalie Jacques Plante seeks to regain his balance. After winning three Cups as a Canadien, Langlois was dealt to the New York Rangers in 1961. The Rangers in turn shipped the defenceman to the Red Wings on February 14, 1964 for Ron Ingram. Langlois played 82 games as a Red Wing, then was traded to Boston by Detroit with Ron Harris, Parker MacDonald and Bob Dillabough for Ab McDonald, Bob McCord and Ken Stephanson on May 31, 1965.

Wearing No. 11 during his second tour as a Red Wing, left-winger Johnny Wilson turns behind the net of Chicago goalie Glenn Hall, with Blackhawks defenceman Jimmy Thomson making a futile attempt to slow his progress. Wilson returned to Detroit in the July 23, 1957 deal that sent Hall and Ted Lindsay to Chicago. In his first stint with the Wings, he'd worn 23 (1949-50), 17 (1951-52) and 16 (1952-55). Wilson also holds the distinction of coaching both of Detroit's major-league hockey teams—the Wings (1971-73) and the ill-fated Michigan Stags of the WHA, who played their home games at Cobo Arena and lasted just 43 games during the 1974-75 season before relocating to Baltimore on Jan. 23, 1975.

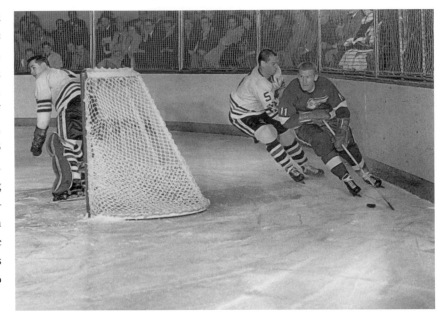

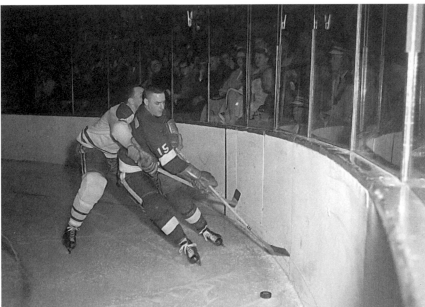

Montreal Canadiens defenceman Albert (Junior) Langlois applies a bear hug to Red Wings right-wing Howie Glover as he works the puck along the boards in the corner. Part of one of Detroit's lesser-known brother combinations—Fred Glover was a Red Wing from 1948-52, winning a Stanley Cup— younger brother Howie arrived in Detroit from Chicago for defenceman Jim Morrison on June 5, 1960. He made his Red Wings debut during the 1960-61 season and put up Cy Young Award-like numbers with 21-8-29 totals in 67 games. But Glover's production was short-lived and he was dealt to Portland of the Western Hockey League in a straight cash transaction on May 27, 1963.

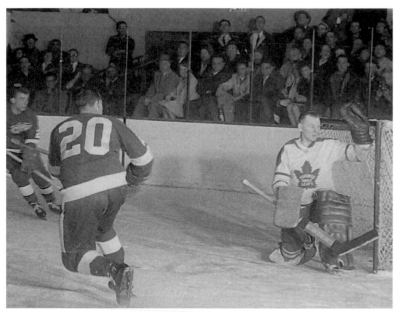

Alone on the slot, Detroit centre Parker MacDonald snaps a high wrist shot into the net past the glove hand of Toronto Maple Leafs goalie Johnny Bower. For one glorious season, everything MacDonald touched turned to goal. He tallied 33 times during the 1962-63 season, good for fifth overall in the league. MacDonald, who'd complained for years of chronic shoulder pain during failed stints to stick with the Leafs and New York Rangers, had the shoulder examined after coming to Detroit. Doctors discovered a piece of metal in the shoulder, part of a broken drill used to perform shoulder surgery on him earlier in his career. His arm strengthened and his goal production blossomed. MacDonald was elected to the Cape Breton Sports Hall of Fame in 1987.

169

Best known for scoring the goal for Detroit that ended the NHL's longest Stanley Cup game back during his rookie season in 1936, Red Wings forward Modere (Mud) Bruneteau went on to enjoy a lengthy and productive NHL career. He formed a solid forward unit alongside Syd Howe and Carl Liscombe as Detroit won the Stanley Cup in 1943. During the 1943-44 season, Bruneteau scored a career-high 35 goals. Five times during his career, he topped the 20-goal plateau. After his playing days, Bruneteau was name coach of Detroit's Omaha farm club in the USHL, where he was the first pro coach of several of Detroit's future stars, including Gordie Howe and Marcel Pronovost.

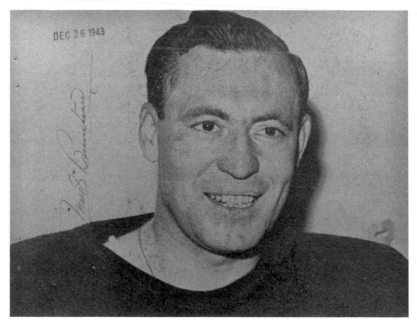

DEC 26 1943

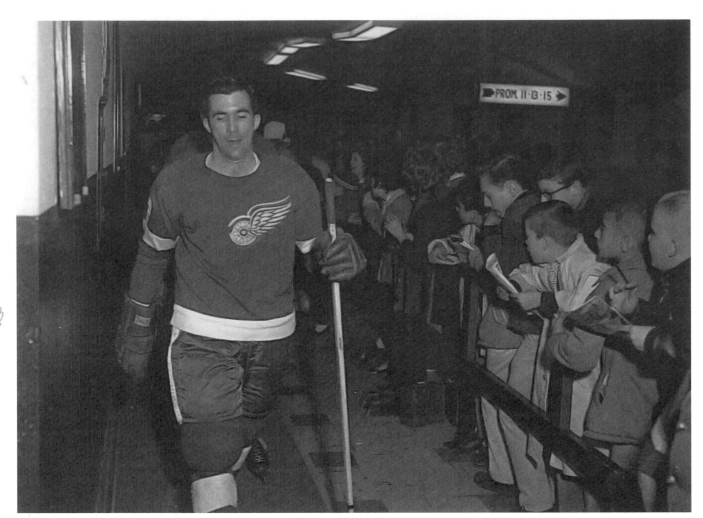

Red Wings GM Jack Adams was of the opinion that if his players had to look the fans in the eyes, then they would never shirk their responsibilities. Here, right-winger Al Johnson leads the team to the ice from the Detroit dressing room past a phalanx of onlookers. A Western Hockey League All-Star during the 1959-60 season, the Wings had high hopes for Johnson when they claimed him during the June 1960 Inter-League draft. He delivered that first campaign, collecting 16 goals and 37 points in 1960-61, and put up 2-2-4 totals in 11 playoff games. But Johnson fell off dramatically the next season, and with five goals in 31 games was shipped to Hershey of the AHL. Johnson played two more games for Detroit in 1962-63, his last year in the NHL.

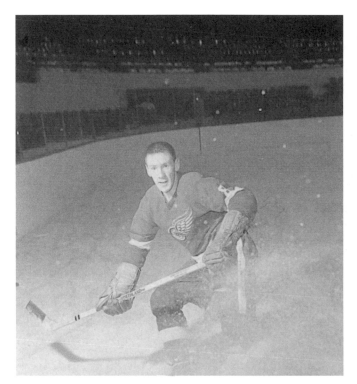

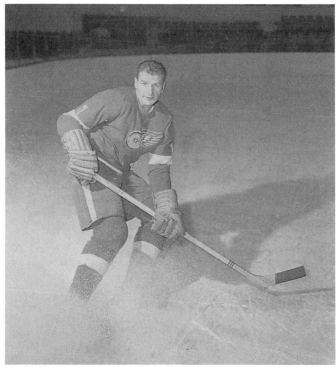

Right-winger Leo Labine throws up a shower of snow in this posed photo shortly after the Red Wings acquired him from the Boston Bruins with Vic Stasiuk for Gary Aldcorn, Murray Oliver and Tom McCarthy on January 23, 1961. After a decade with the Bruins, Labine, a two-time NHL All-Star Game participant as a Bruin, wasn't the player he used to be, and scored only five goals in 72 games for Detroit before he was sent to Los Angeles of the Western Hockey League with Ed Diachuk, Ed Stankiewicz, Lloyd Haddon, Len Haley and Gord Haworth in a straight cash deal on June 5, 1962.

When Vic Stasiuk showed up in Detroit, good things generally happened for the Red Wings. Acquired from Chicago during the 1950-51 season, the Wings won three Cups in the next four seasons with Stasiuk in the line-up. He was especially effective during the 1954-55 postseason, collecting five goals and eight points in 11 games. Traded to Boston the following season, Stasiuk blossomed into a four-time 20-goal scorer, skating on the Bruins' Uke Line with John Bucyk and Bronco Horvath (all of them Detroit property at one time). Stasiuk returned to the Wings in a trade with Boston during the 1960-61 season and helped them to two more Cup finals before leaving the NHL for good in 1963.

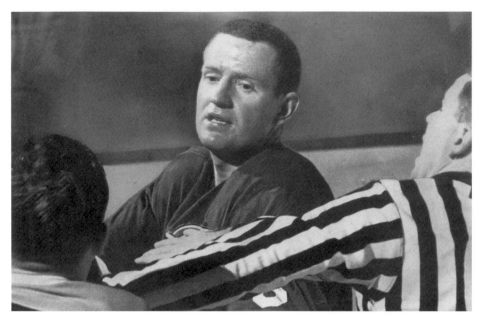

Doug Barkley is ready to tangle with Irv Spencer of the Boston Bruins. The Red Wings were certain that they'd acquired a future All-Star when they grabbed Barkley from the Chicago Blackhawks in a 1962 trade. Barkley joined the Red Wings for 1962-63 and barely missed out on winning the Calder Trophy as the NHL's top rookie in the closest vote of all time. Toronto's Kent Douglas received 99.4 votes to Barkley's tally of 99.2.

Toronto Maple Leafs defenceman Al Arbour disrupts the shot of Detroit right-winger Ed Litzenberger just enough so that the puck sails wide of the net of Leafs goalie Johnny Bower, early in the 1961-62 season. Litzenberger and Arbour would be part of a Stanley Cup first later that spring, as they were teammates on back-to-back Cup winners on different teams. In 1960-61, Litzenberger captained the Chicago Blackhawks to a six-game final series win over the Red Wings. Arbour was a defenceman on the Blackhawks. A Red Wing from 1953-58, Arbour was claimed from Chicago by Toronto in the June 13, 1961 NHL Intra-League Draft. One day earlier, the Wings dealt Jerry Melnyk and Brian Smith to the Blackhawks for Litzenberger, but after 32 games in a Detroit uniform, Litzenberger was placed on waivers and claimed by the Leafs on December 29, 1961.

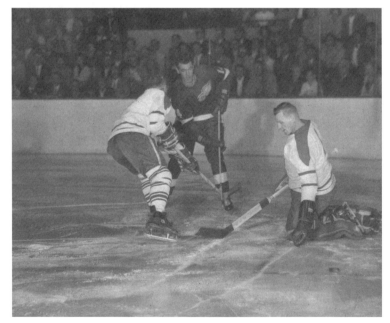

Chapter Seven:
Playoff Passion

IT WAS BILLED AS THE TIME of the Original Six, but when it came to the Stanley Cup playoffs, the era belonged to the Big Three. From the 1942-43 season through the 1966-67 campaign, 24 of the 25 Stanley Cup championships earned were divided among three teams—the Montreal Canadiens (ten), Toronto Maple Leafs (nine) and Detroit Red Wings (five).

During this era, only Montreal (215) appeared in more Stanley Cup games than the 203 played by Detroit, and when it came to first-place finishes, Detroit's 10—including an unsurpassed seven in a row from 1948-49 through 1954-55—were second only to the 12 posted by the Canadiens.

"To win seven league championships in a row, nobody's ever going to defeat that record in hockey," former Detroit captain Ted Lindsay said. "Nobody will ever win it seven years in a row. Not with 30 teams."

More than half the time during the Original Six days, the Red Wings found themselves playing in the Stanley Cup final, appearing in the battle for hockey's ultimate prize on 13 occasions. Perhaps then it should come as no surprise that when the NHL opted to expand from six to 12 teams in 1967, the three players who'd played the most career Stanley Cup games by that point were all prominent Red Wings—Leonard (Red) Kelly (164), Gordie Howe (150) and Marcel Pronovost (134).

Detroit captured its first Stanley Cup of the Original Six era in the first season of six-team play, 1942-43, sweeping the Boston Bruins aside in the minimum four games. Vezina Trophy-winner Johnny Mowers,

who led the NHL in victories (25), shutouts (6) and goals-against average (2.48) that season, posted shutouts in the last two games of the final series. "There's no doubt who won it for us," Detroit forward Joe Carveth said. "Mowers did." Modere (Mud) Bruneteau scored a hat-trick in the series opener, while Don Grosso, known as The Count because of his uncanny resemblance to Dracula, also netted a hat-trick in Game 3 of the set.

The Wings, backstopped by 18-year-old goalie Harry Lumley, the youngest netminder to ever appear in a Stanley Cup final, returned to meet the Toronto Maple Leafs in the 1945 final. The Leafs won in seven games and would continue to be a thorn in Detroit's side throughout the Original Six days.

The Wings were reloading their roster with young talent such as Howe, Kelly and Ted Lindsay in the late 1940s, but fell in back-to-back Cup final sweeps at the hands of the Leafs in 1948 and 1949. Detroit would finally get the better of Toronto in a seven-game Cup semi-final series in 1950, but it cost them Howe, who nearly died after crashing head first into the boards in Game 1 of the set.

The Wings lost Howe for the playoffs. Detroit coach Tommy Ivan moved Kelly up to Howe's spot on the Production Line with Lindsay and Sid Abel and recalled rookie defenceman Marcel Pronovost from Omaha of the United States Hockey League.

In the final, the Wings fell behind 3-2 to the New York Rangers thanks to a pair of overtime goals by Rangers forward Don (Bones) Raleigh. "What I remember when we were down 3-2 was that we had a big meeting in Toledo, where we stayed during the playoffs," Pronovost said.

"Abel was (defenceman Black Jack) Stewart's roommate. Bones Raleigh was playing for New York and he was Sid's check. Jack said, 'Don Raleigh is making a fool out of you.'

"I remember Sid said, 'I was afraid to go to bed that night.'"

Abel scored two goals in Detroit's 5-4 Game 6 victory.

The Wings won 4-3 in Game 7 on Pete Babando's double-overtime goal, the first time the Cup had ever been decided via extra time in Game 7. That spring, it took Detroit the maximum 14 games to win the Cup.

Two years later in 1952, they won again and this time in rapid fashion, becoming the first NHL team to sweep to the title with eight successive victories. "I used to feel sorry for the teams we played the night after we'd lost, because we'd just kick the crap out of them," recalled checking forward Marty Pavelich.

The hero that spring was goaltender Terry Sawchuk. He posted four shutouts in the four home games at Olympia Stadium and finished with an 0.63

goals-against average and a .977 save percentage. "Sawchuk performed as if he were triplets," wrote *Toronto Star* columnist Red Burnett.

Two seasons later, Detroit won a seven-game final over Montreal on Tony Leswick's Game 7 overtime-winning goal. The following spring, the Wings beat the Canadiens again in another seven-game set that saw the home team win all seven games.

That season, the Wings chased down the Habs for first place in the final week of the regular season to gain their record seventh straight finish on top and what would prove to be an all-important home-ice advantage in the playoffs.

"The Yankees had won six (regular-season titles) and we knew that," Kelly said. "We were trying to win that seventh one.

"We had the riot in Montreal (when Detroit beat Montreal by forfeit after Canadiens fans rioted to protest the suspension of Montreal star Maurice Richard) and then we had to play the last game against them in our rink and we couldn't lose. We had to win both games and we did."

That the final two Cups in the run came at the expense of the hated Canadiens only made the champagne sipped from Lord Stanley's mug taste all the sweeter.

"It was quite a rivalry," centre Alex Delvecchio said of the feud with the Habs. "Montreal was our biggest obstacle to winning the Stanley Cup.

"They were a powerhouse. It made you play better, because you wanted to beat them so badly."

The Wings wouldn't win it all again until 1997, and while those teams of the Original Six era are now just a memory, Lindsay would stack them up against any of the NHL's great dynasties.

"We had great skaters," he said. "We had great puckhandlers.

"A lot of people think we were all old fogies back in those days who couldn't skate. We had guys who could skate with anybody today."

175

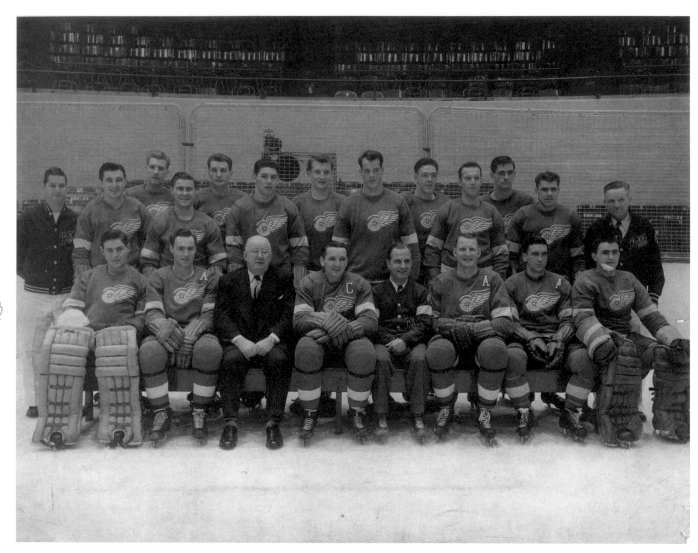

176

The record-setting 1951-52 Stanley Cup champion Detroit Red Wings, the first team in Cup history to go 8-0 in the playoffs. Front Row: Terry Sawchuk; Red Kelly; Jack Adams; captain Sid Abel; coach Tommy Ivan; Leo Reise; Ted Lindsay; Harry McQueston. Middle Row: Trainer Lefty Wilson; Marty Pavelich; Tony Leswick; Alex Delvecchio; Gordie Howe; Enio Sclisizzi; Metro Prystai; trainer Carl Mattson. Back Row: Glen Skov; Vic Stasiuk; Benny Woit; Marcel Pronovost; Bob Goldham.

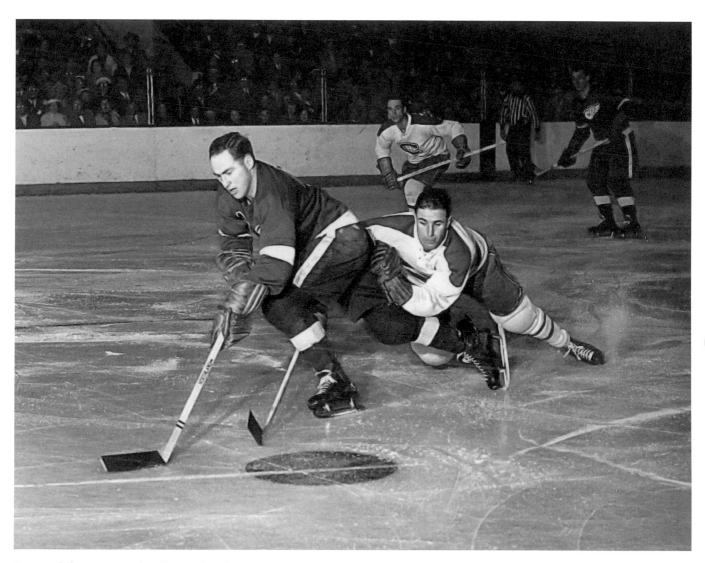

Detroit defenceman Red Kelly is off to the races with the puck and the only option for Montreal Canadiens defenceman Dollard St. Laurent is to attempt a football tackle. During the 1950 Stanley Cup playoffs, after Gordie Howe suffered a season-ending head injury, Detroit coach Tommy Ivan moved Kelly up to Howe's right-wing position alongside Sid Abel and Ted Lindsay on the Production Line.

Wearing a Toronto Maple Leafs uniform, former Red Wings captain Red Kelly is doing his best to impede the path of Detroit's Norm Ullman to the puck. Kelly was part of four Stanley Cup winners with Detroit—in 1950, 1952, 1954 and 1955—then after a 1960 deal to the Leafs, won four Cups with them, helping Toronto beat Detroit in the 1963 and 1964 final series. He played a starring role as Toronto bounced Detroit from the 1960 Stanley Cup semi-finals, setting up two game-winning goals and speaking out about his treatment by Detroit GM Jack Adams prior to his deal to Toronto. "I'm finished with that town, particularly Jack Adams and his hockey team, and if I never get back there, it will be too soon," Kelly said during the series.

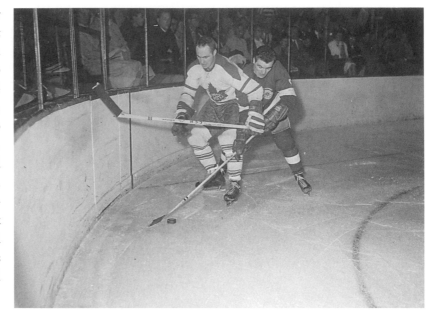

178

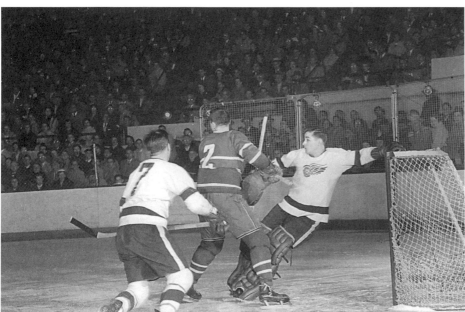

Detroit and Montreal met in the Stanley Cup final in the spring of 1956 for the fourth time in six years, only this time, the outcome was different, as the Canadiens won a five-game series. Here, Canadiens defenceman Doug Harvey cruises through the goal crease, spilling Red Wings goalie Glenn Hall. Ted Lindsay (7) clearly isn't impressed and has a bead on Harvey.

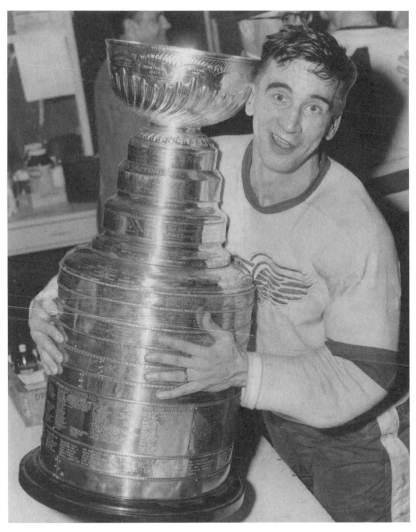

179

Is this man happy or what? Ted Lindsay embraces the Stanley Cup and grins like a little boy on Christmas morning, not long after Tony Leswick's overtime goal had given Detroit the victory over the Montreal Canadiens in Game 7 of the 1954 Stanley Cup final. It was the third of four Stanley Cups Lindsay would win as a Red Wing, and the first he'd led as captain of the team. If you look closely toward the bottom of the silver mug, you can pick out the inscriptions from the Red Wings' 1949-50 and 1951-52 Cup wins.

Detroit's Tony Leswick gets inside position on Montreal's Phil Goyette (20) as Canadiens goaltender Jacques Plante sets for an incoming point shot during action from the 1954-55 Stanley Cup final. One spring earlier, Leswick was the hero of Detroit's 1954 Cup final series win over Montreal, scoring the overtime winner in Game 7 of that epic set.

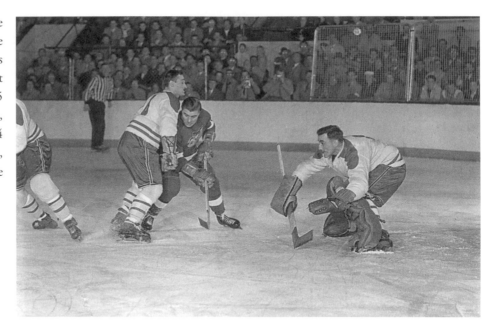

180

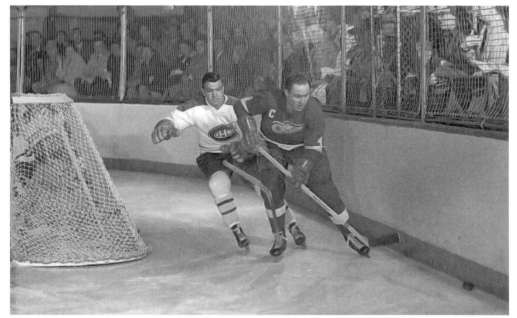

Red Kelly deprives Montreal Canadiens right-winger Bernie (Boom Boom) Geoffrion of the puck and his stick and he circles behind the Montreal net. The Canadiens and Red Wings were arch-rivals during the 1950s, meeting in the Stanley Cup finals four times between 1952-56. The Wings were winners in a four-game set in 1952, and in two seven-game series in 1954 and 1955. The Canadiens took a five-game decision in 1956.

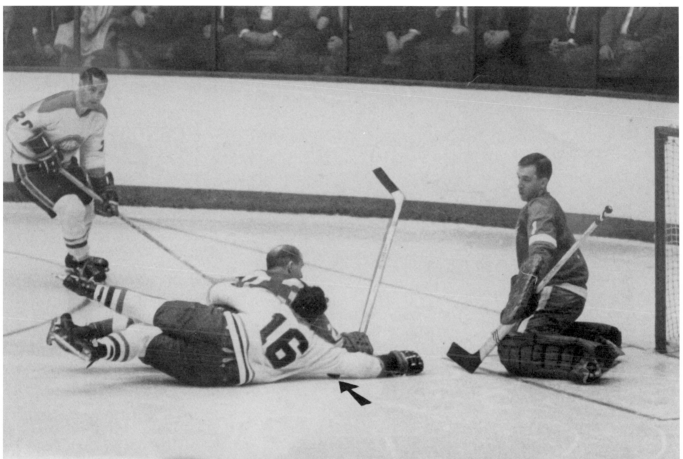

The goal that finished the Wings in the 1966 Stanley Cup final on May 5, 1966 at Olympia Stadium. Note the puck situated under the arm of Montreal Canadiens forward Henri Richard, who is tangled up with Detroit defenceman Gary Bergman. Montreal's Dave Balon, who fed the pass to Richard, swoops in, while Detroit goalie Roger Crozier braces for the save. The two sliding players collided with Crozier, and the puck ended up in the net, giving Montreal a 3-2 win at 2:20 of overtime, and a 4-2 verdict in the best-of-seven series. Bergman, who died in 2000, never was convinced that the goal should have counted, insisting Richard pushed it in with his gloved hand. Crozier was named Conn Smythe Trophy winner as Stanley Cup MVP, the first player from a losing team to be so honoured. But honours would wait some time again for Detroit, which wouldn't make another Stanley Cup final appearance until 1995.

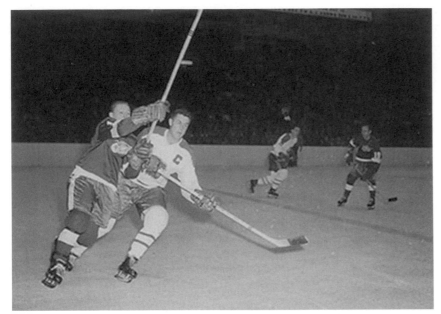

Montreal Canadiens captain Jean Beliveau grimaces as he's given a rough ride from Detroit centre Bruce MacGregor. Coming up through Detroit's junior system in his hometown of Edmonton, MacGregor jumped right into the Wings' line-up in 1960-61 after less than a year of minor-pro seasoning. A three-time 20-goal scorer who potted a career-high 28 tallies during the 1966-67 season, MacGregor played in three Stanley Cup finals as a Wing in the springs of 1963, 1964 and 1966, but never sipped from Lord Stanley's mug as a player. MacGregor was traded to the New York Rangers by Detroit with Larry Brown for Arnie Brown, Mike Robitaille and Tom Miller on February 2, 1971.

Detroit goalie Hank Bassen drops to his knees in order to block this point-blank drive by Chicago Blackhawks superstar Bobby Hull (7). Trailing 3-2 to Chicago in the 1961 Stanley Cup final, Wings coach Sid Abel opted to go with Bassen over Terry Sawchuk for Game 6 of the final series at Olympia Stadium. It looked early like a genius move when Parker MacDonald gave the Wings a 1-0 first-period lead, but Chicago scored five unanswered goals to win 5-1 and take the title for the first time since 1938.

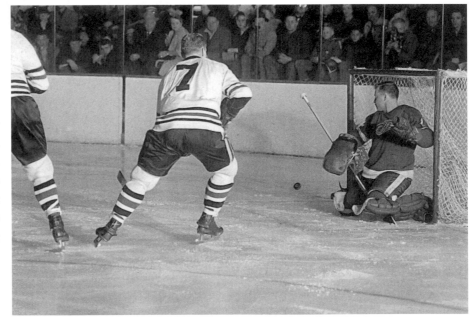

183

The 1955-56 team was the first in eight years not to finish in first place during the NHL regular season. They reached the Stanley Cup final, but lost in five games to Montreal. Front Row: Marty Pavelich; coach Jimmy Skinner; Glenn Hall; GM Jack Adams; captain Ted Lindsay. Second Row: Trainer Lefty Wilson; John Bucyk; Gordie Howe; Alex Delvecchio; Murray Costello; trainer Carl Mattson. Third Row: Metro Prystai; Real Chevrefils; Norm Ullman; Earl Reibel; Bill Dineen. Back Row: Bucky Hollingworth; Lorne Ferguson; Bob Goldham; Marcel Pronovost; Red Kelly.

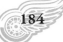

184

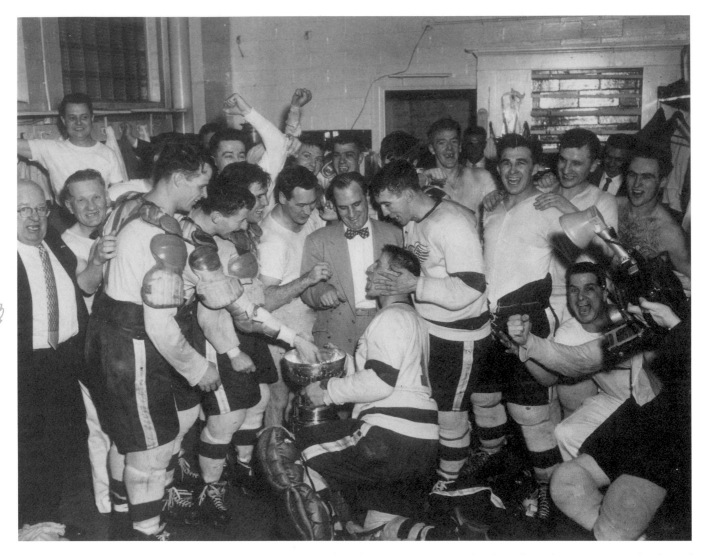

Detroit goalie Terry Sawchuk bows before the Stanley Cup while the Wings worship at the altar of Sawchuk, basking in the glory of their 1951-52 title win. Sawchuk was otherwordly that spring, posting four shutouts as Detroit swept the playoffs with eight straight wins. That's Wings coach Tommy Ivan directly behind the Cup, while GM Jack Adams and Gordie Howe are to the extreme left.

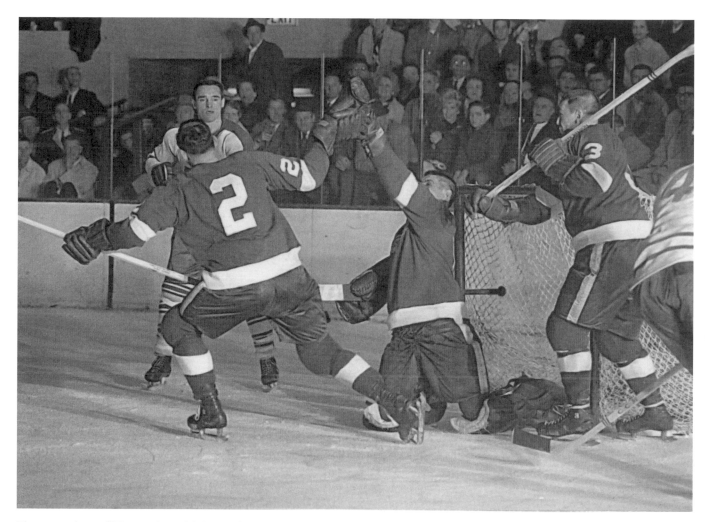

Three members of Toronto's 1966-67 Stanley Cup championship club find themselves amidst the chaos in front of the Detroit net as Wings goaltender Terry Sawchuk snares the loose puck with his glove. Marcel Pronovost (3) watches his goalie's work, while defence partner Pete Goegan is alerted to the presence of Leafs' left-winger Frank Mahovlich. Sawchuk would go to the Leafs in 1964, and Pronovost a year later, where they'd join Mahovlich to become Toronto's most recent Cup champs. But it was a short-lived partnership. Sawchuk was lost to Los Angeles in the 1967 NHL Expansion Draft, while Mahovlich was traded to the Wings in a blockbuster eight-player transaction on March 3, 1968.

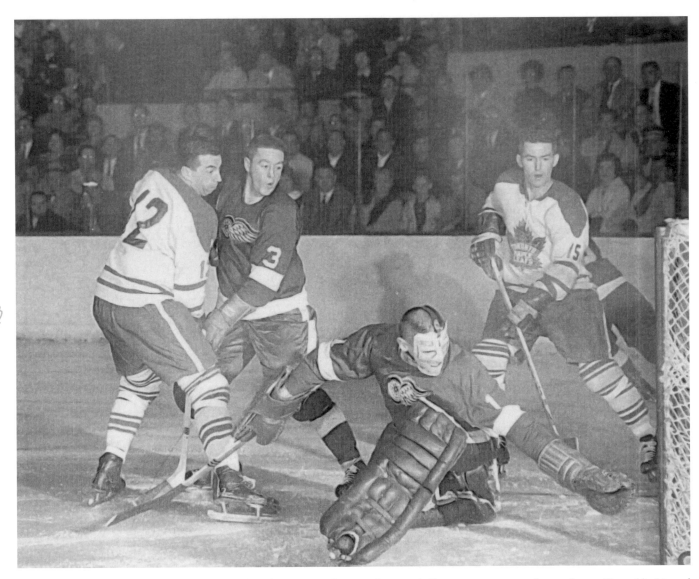

Terry Sawchuk reaches back as the puck shot by Toronto's Ron Stewart (12) just scoots past the goalpost. Detroit's Marcel Pronovost (3) and Toronto's Billy Harris (15) look on in wide-eyed excitement. The Leafs beat the Wings in a five-game Stanley Cup final series in the spring of 1963.

Toronto Maple Leafs right-winger Tod Sloan (11) puts the clamps down on Detroit left-winger Lorne Ferguson (14) as Leafs centre Teeder Kennedy seeks to make off the loose disk. Watching intently are Toronto forward Billy Harris and Detroit defenceman Larry Hillman. Kennedy was the central villain for Toronto in the 1950 semifinal series against Detroit. Wings star Gordie Howe was looking to slam Kennedy into the boards, but the Toronto player sidestepped the check and Howe tumbled head-first into the boards, suffering a life-threatening head injury.

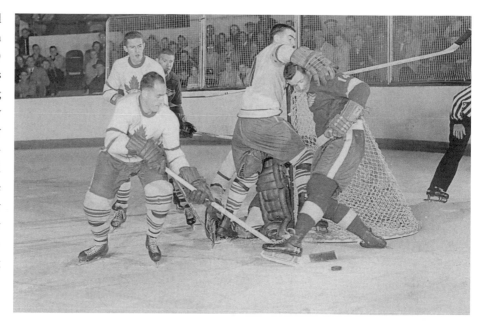

187

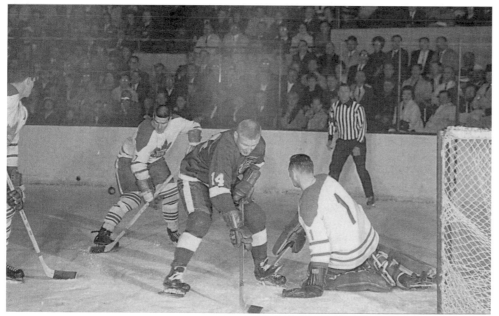

Toronto Maple Leafs goaltender Johnny Bower chops the puck away from Detroit left-winger Len Lunde as Leafs defenceman Tim Horton seeks to gather in the loose puck. The Leafs trailed the Wings 3-2 in the 1964 Cup final series, but rallied to win Game 6 at Olympia Stadium on Bob Baun's overtime goal. They then blanked Detroit 4-0 at Maple Leaf Gardens in Game 7.

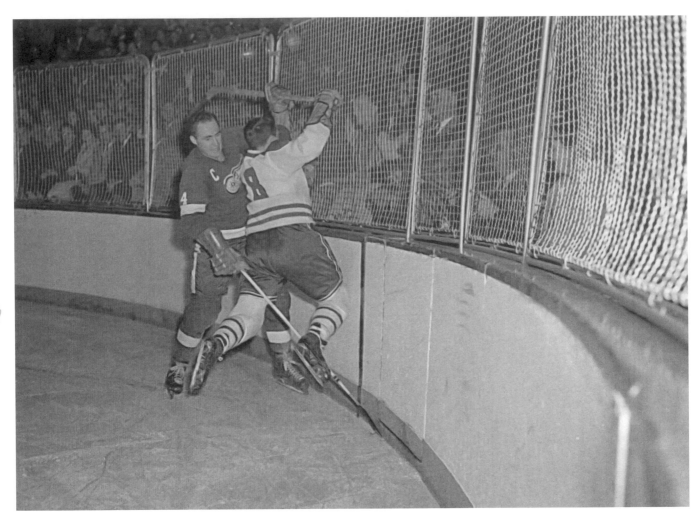

Detroit captain Red Kelly and Montreal Canadiens left-winger Marcel Bonin tangle along the boards, and Bonin raises his arms and stick in order to avoid tasting a mouthful of chicken wire. Both players were Red Wings who own the distinction of winning Stanley Cups with two of the Original Six franchises. Bonin and Kelly were teammates on Detroit's 1954-55 title-winning club. Traded to Boston and then Montreal, Bonin won three Cups as a Canadien, and led the Stanley Cup playoffs with 10 goals in 1958-59. Kelly was a four-time Cup winner in Detroit (1950-52-54-55) and a four-time Cup winner in Toronto (1962-63-64-67). He's the only player in NHL history to win that many Stanley Cups with two separate teams.

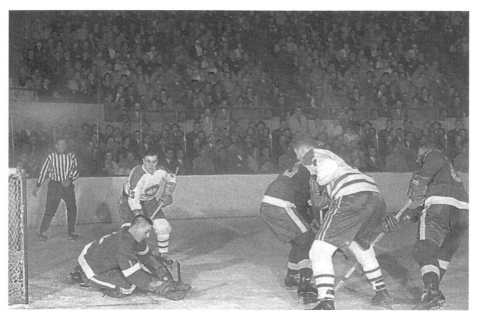

Detroit goalie Terry Sawchuk gets down low to stymie Montreal centre Jean Beliveau (4) as teammate Gilles Tremblay looms for a rebound that isn't going to come to him. In the 1952 Stanley Cup final series, Sawchuk, described by published reports as "the iron fence of hockey," limited the Canadiens to two goals in four games as Detroit swept the series. "In tight games, Terry would just never give up a goal at a crucial time," recalled Fred Huber, the Red Wings' public relations director at the time.

189

The Golden Jet is on the loose behind the Detroit net and defenceman Warren Godfrey is bent on slowing Chicago sniper Bobby Hull down. Hull collected 14 points in the 1961 playoffs, including two goals and four assists in a six-game final series win over the Wings. Hull was a constant thorn in Detroit's side during playoff meetings. In 31 Stanley Cup games against Detroit, Hull scored 22 goals and dished out 18 assists.

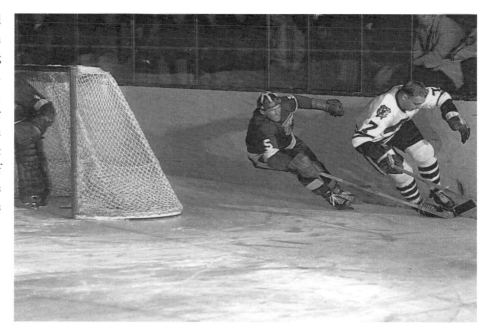

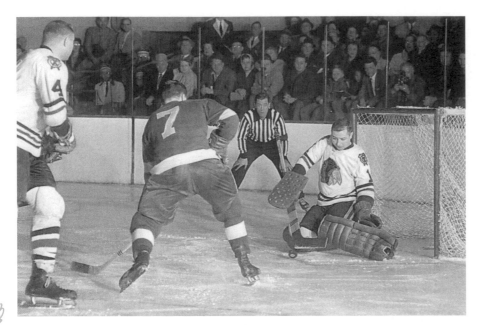

Chicago goalie Glenn Hall gets his stick and puck behind this point-blank drive from Detroit's Norm Ullman as Blackhawks defenceman Elmer (Moose) Vasko watches and hopes for the best. Traded by Detroit to Chicago in 1957, Hall backstopped the Blackhawks to victory over Detroit in the 1961 Stanley Cup final. During his NHL career, Hall took three teams to the Cup final – Detroit (1956), Chicago (1961, 1962, 1965) and the St. Louis Blues (1968, 1969, 1970).

190

Detroit's Larry Jeffrey (21) watches from beyond the check of Toronto defenceman Tim Horton (7) as Maple Leafs goalie Johnny Bower turns aside a shot. Frank Mahovlich (27) swoops in late for support. Jeffrey came up out on the short end of final-series losses to the Leafs in 1963 and 1964, but proved the adage if you can't beat 'em, join 'em. Traded to Toronto in 1965, Jeffrey joined Horton, Bower and Mahovlich on Toronto's 1967 Stanley Cup championship squad.

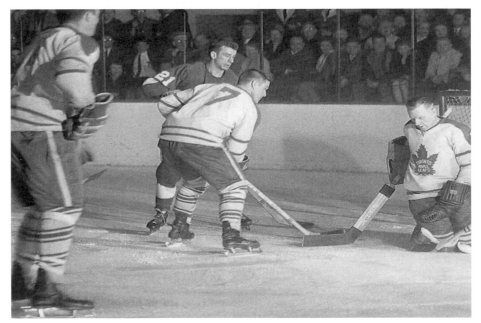

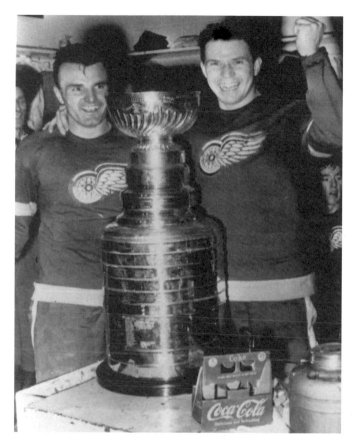

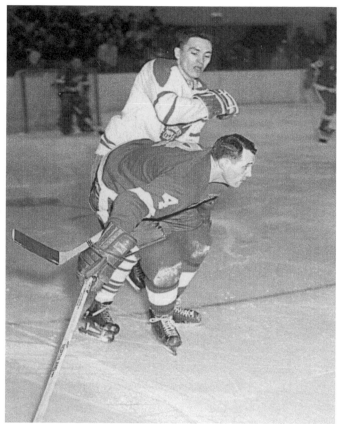

Forward Pete Babando (left) and goalie Harry Lumley, two of the stars of Detroit's 1950 Stanley Cup final win over the New York Rangers, pose with the object of their drive and determination, Lord Stanley's mug. Detroit GM Jack Adams dealt All-Star defenceman Bill Quackenbush to Boston in a six-player deal which brought Babando to Detroit. At 8:21 of the second overtime period of Game 7 against the Rangers, Babando snapped a shot from a face-off in the New York end past Rangers goalie Charlie Rayner to give Detroit a 4-3 triumph. It was the first time the Cup was ever decided by a Game 7 overtime goal.

Detroit defenceman Bill Gadsby and Toronto captain George Armstrong get tangled up leaving the Red Wings zone. Gadsby played 21 playoff games from 1946-61 with Chicago and the New York Rangers, but appeared in three Stanley Cup finals after his trade to the Wings, including final setbacks at the hands of the Maple Leafs in 1963 and 1964. But prior to coming to the Wings, Gadsby had never played for the winning side in a Stanley Cup series during the first 15 seasons of his NHL career.

Detroit centre Alex Delvecchio (10) does his best to screen Boston goalie Don Simmons, but Simmons gets down on the ice and spreads himself out to cover the lower part of the net. With Simmons in goal, the Bruins stunned the first-place Red Wings in the 1957 Stanley Cup semi-finals, whipping Detroit in five games. Later, as back-up goalie with the Toronto Maple Leafs, Simmons was part of the Leafs clubs that stopped Detroit in the 1963 and 1964 Cup final series.

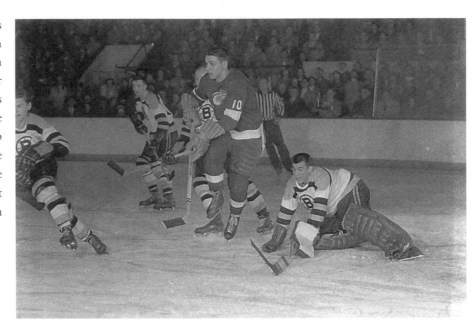

192

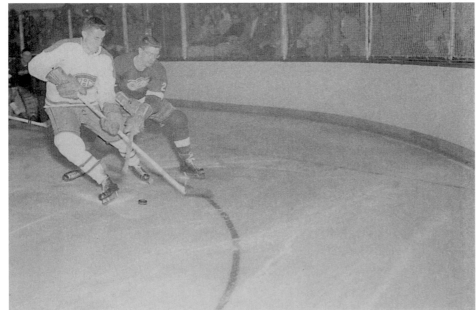

There's a lot of Stanley Cups in this frame as Montreal's Jean Beliveau battles Detroit defenceman Al Arbour for possession of the puck. Playing for the Canadiens, Beliveau was part of 10 Stanley Cup championship teams between 1956-71. Arbour won Stanley Cups as a player with Detroit (1953-54), Chicago (1960-61) and Toronto (1961-62 and 1963-64), then coached the New York Islanders to four successive Stanley Cups from 1980-83.

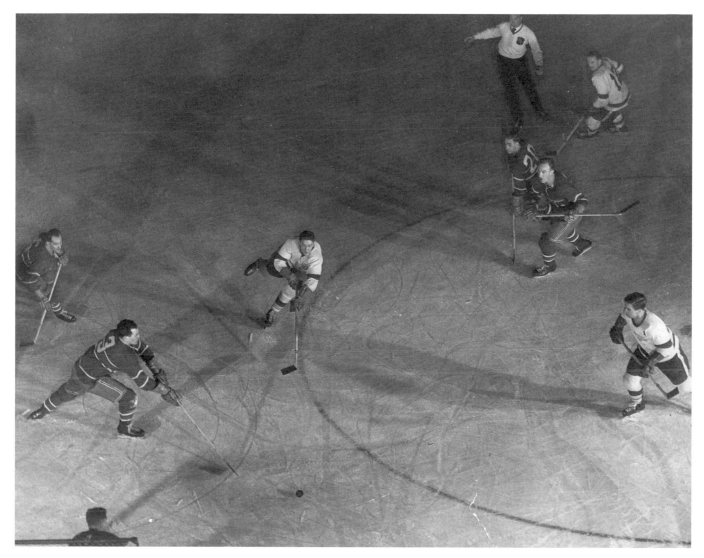

193

Detroit defenceman Marcel Pronovost whips a shot just wide of Montreal goalie Gerry McNeil's net as Canadiens defenceman Butch Bouchard (3) moves in to help his netminder and Detroit captain Ted Lindsay looks for a rebound. Detroit won a seven-game series from the Canadiens in the 1954 final.

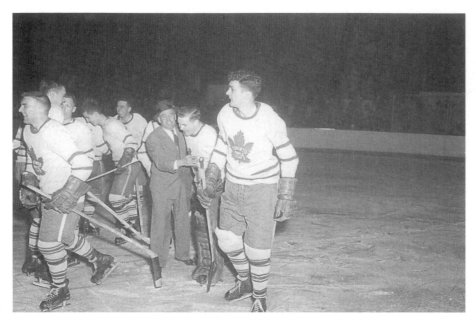

This was a rare sight in the 1950s. Coach King Clancy hugs former Wings netminder Harry Lumley as the Toronto Maple Leafs celebrate a victory over the Red Wings at Olympia Stadium. During postseason play in the 1950s, Detroit downed the Leafs in Stanley Cup semifinal series in 1950, 1952, 1954, 1955 and 1956. Things flipped the other way in the 1960s. Toronto downed Detroit in the 1960 semi-finals and 1963 and 1964 Cup final series. Detroit beat the Leafs once in postseason play in the 1960s, winning the 1961 semi-final set between the two teams.

194

Norm Ullman (7) raises his stick to celebrate a Detroit goal as the puck zips into the net past Leafs goalie Johnny Bower. Carl Brewer (2) arrives too late to help out. During the 1963 final series, Ullman assisted on a goal by Vic Stasiuk in Detroit's only win against Toronto, a 3-2 verdict in Game 3 at Olympia Stadium. After collecting playoff-leading 4-8-12 totals in Detroit's semi-final win over Chicago, the Leafs held Ullman to four assists in the five games of the final round.

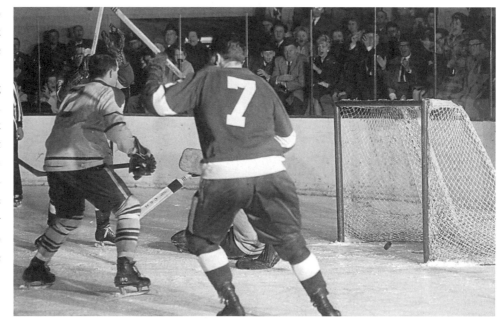

Toronto goalie Johnny Bower watches the puck skid past his net, while Billy Harris (15) and Detroit forward Norm Ullman (7) take note. Bower played 12 Stanley Cup final games against the Red Wings and won eight of them, including a 4-0 shutout of Detroit in Game 7 of the 1964 final series.

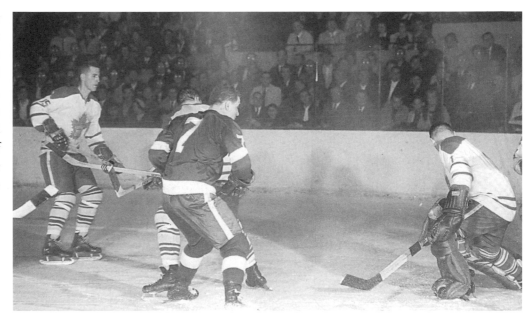

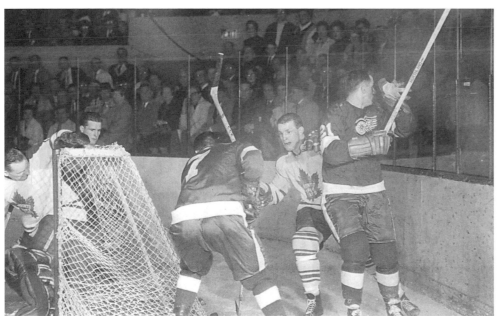

There's not much room to move behind the Toronto net as Detroit's Norm Ullman (7) and Larry Jeffrey (21) duel for space and the puck. Leafs goalie Johnny Bower watches the play intently and it's going to get more crowded, because Toronto defenceman Kent Douglas is hurrying to join the fray. Jeffrey's overtime goal in Game 2 of the 1964 Stanley Cup final series at Toronto's Maple Leaf Gardens evened the series at one game apiece.

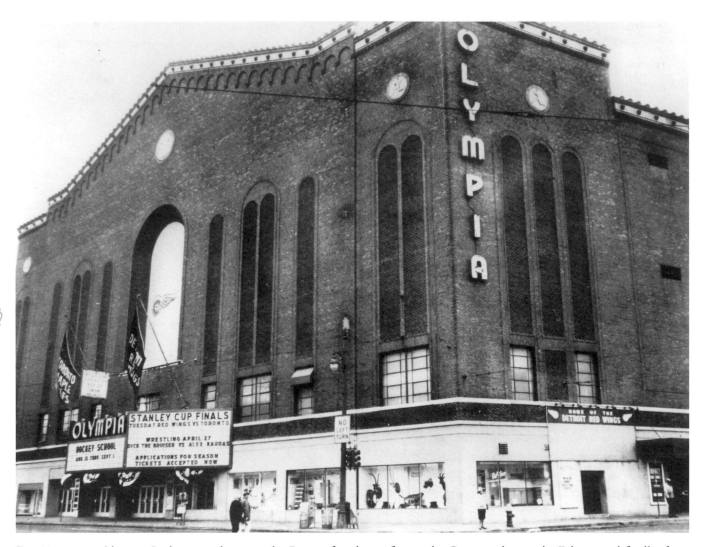

For 52 seasons, Olympia Stadium was home to the Detroit franchise—first as the Cougars, then as the Falcons and finally, from 1932-79, as the Red Wings. Detroit played its first game there in 1927 and its last in 1979. Detroit lifted seven Stanley Cups while playing there and 18 Stanley Cup finals were contested in the unfriendly confines of The Red Barn, with its unique oval-shaped boards. "You'd come out of that tunnel, see Gordie Howe and Ted Lindsay and already feel like you were down 2-0," remembered former Boston forward Willie O'Ree.

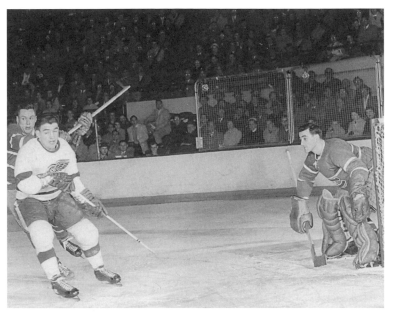

While Montreal Canadiens goalie Jacques Plante sets for the shot, Detroit's Metro Prystai creates traffic in the slot, and Canadiens defenceman Tom Johnson looks to clear out the area. Known as Meatball, Prystai had gone scoreless through seven Stanley Cup games during the 1952 playoffs. But as Detroit downed Montreal in Game 4 of the Cup final series to sweep through the playoffs with an unprecedented eight successive wins, Prystai was the offensive star. He scored the Cup winner on a first-period feed from Alex Delvecchio, won a puck battle with Canadiens defenceman Doug Harvey to set up Glen Skov for the second tally, and closed out the scoring in the third period, stealing the puck from Canadiens forward Paul Meger, deking around defenceman Stan Long, and then driving a shot past Montreal goaltender Gerry McNeil.

A dogged competitor, Ted Lindsay seemed to find even more fire in his belly during big games. Parked on the doorstep in the Montreal end, he tips a shot and forces a big save from Canadiens goalie Jacques Plante. During Game 2 of the 1955 Stanley Cup final, Lindsay set a playoff record, scoring four goals on Plante in Detroit's 7-1 rout of the Habs.

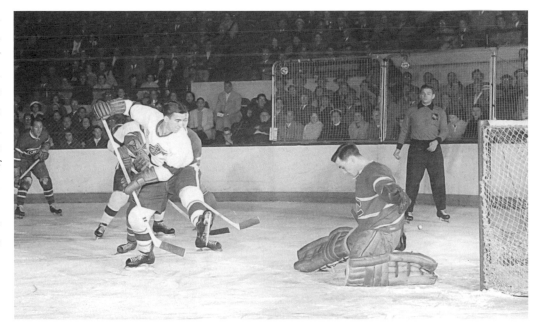

The originator of the butterfly style of goaltending, Chicago's Glenn Hall is down and stopping this shot from Detroit's Bruce MacGregor. Between 1961 and 1966, the Blackhawks and Red Wings met five times in the Stanley Cup playoffs. The Blackhawks won the 1961 final between the two teams and a 1965 semi-final series. Meanwhile, Detroit won semi-final sets in 1963, 1964 and 1966.

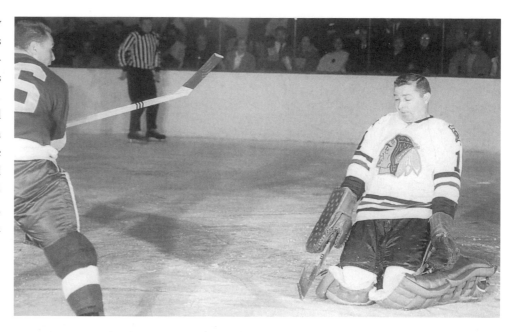

198

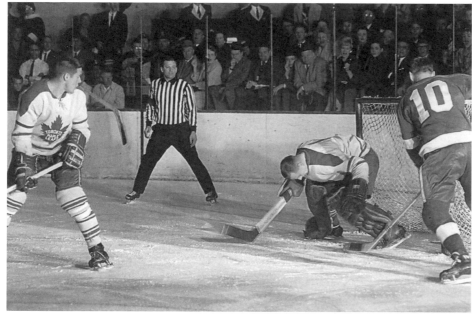

The puck isn't in the frame, but from the worried look on the face of Toronto netminder Johnny Bower, it's probably behind him in the net. Leafs defenceman Tim Horton also looks concerned, while Detroit's Alex Delvecchio moves closer just in case the puck suddenly squirts out. Delvecchio's goal with 17 seconds left in regulation time of Game 3 of the 1964 Stanley Cup final series gave Detroit a 4-3 victory over the Leafs and a 2-1 lead in the set.

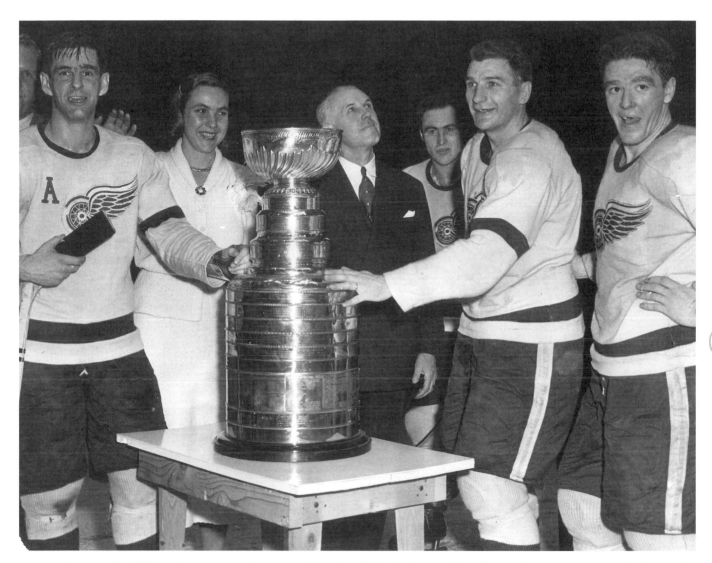

Detroit players Bob Goldham (A on sweater), Vic Stasiuk, Red Kelly (in background) and Marcel Pronovost pose with the Stanley Cup following the Wings' seven-game final series win over Montreal in 1955. Standing behind them are Wings co-owners Bruce and Marguerite Norris and NHL president Clarence Campbell.

Montreal and Detroit played against each other in four Stanley Cup finals between 1952-56, so naturally, there was plenty of bad blood between the two teams. When Detroit won the Cup in the spring of 1954, the Canadiens refused to participate in the traditional post-series handshake. Here, a melee along the boards involves several players, including Detroit defenceman Benny Woit (5) and forward Marcel Bonin (20). Woit worked as a longshoreman during the off-season, while Bonin enjoyed a more interesting summer occupation: he wrestled against a bear with a travelling circus in his native Quebec.

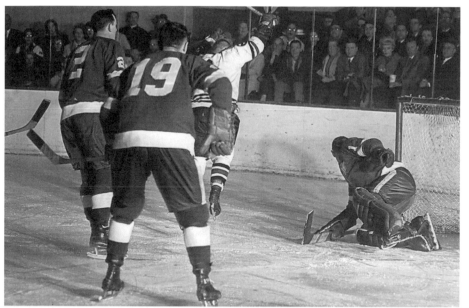

Terry Sawchuk looks anxiously over his shoulder, but the leaping excitement of Chicago forward Murray Balfour is a dead giveaway that he's just scored. Detroit's Pete Goegan (2) and Parker MacDonald (19) arrive too late to thwart Balfour. With the 1961 Stanley Cup final series tied at two games each, Balfour scored twice in Game 5 to lead the Blackhawks to a 6-3 triumph.

Norm Ullman's shot sails wide of the Chicago net, but Detroit teammate Howie Glover (15) already has his stick cocked and ready should a pass come out from behind the goal. Blackhawks goalie Glenn Hall appears to have one eye searching for the puck and the other fixated on Glover. Glover scored the only goal of his Stanley Cup career for Detroit in Game 5 of the 1961 final series against Chicago.

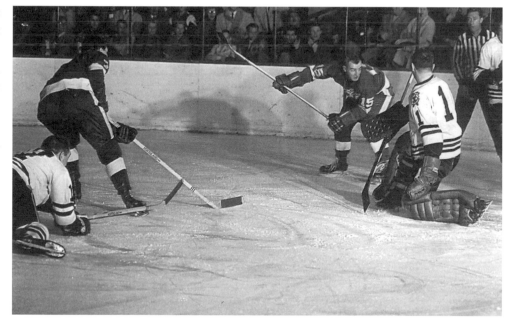

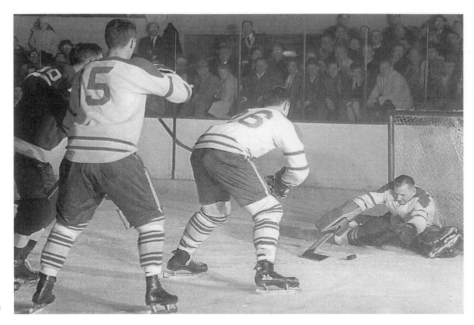

Johnny Bower does the splits to stop Detroit's Alex Delvecchio, and then lurches out with his stick to corral the rebound. Billy Harris (15) keeps Delvecchio in check while Allan Stanley (26) is ready if Bower needs any assistance. Detroit led the 1964 final series 3-2 and the Wings were ahead 4-3 on home ice in Game 6 when Harris scored to force overtime. Bob Baun gave the Leafs the win 2:43 into the extra session and then the Leafs won Game 7 by a 4-0 count behind Bower's shutout netminding.

Chicago's Ab McDonald gets position in the slot between Detroit defencemen Gerry Odrowski and Warren Godfrey (5), but his shot sails wide of Terry Sawchuk's net. McDonald netted the Cup winner as Chicago beat Detroit 5-1 in Game 6 of the 1961 Stanley Cup final series. After the loss, Detroit GM Jack Adams, pointing out that 13 of 18 Chicago players were acquired from other NHL teams, reminded everyone how the league had kept the once-woeful Blackhawks afloat. "The Hawks were practically out of business," Adams said. "All of the teams in the league gave them players or they wouldn't be in the league now."

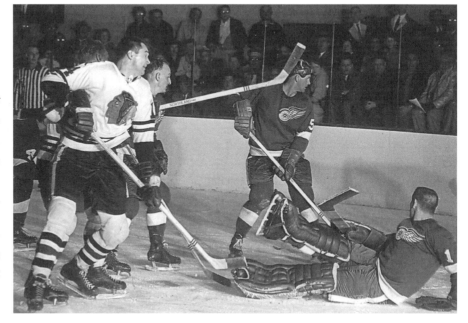

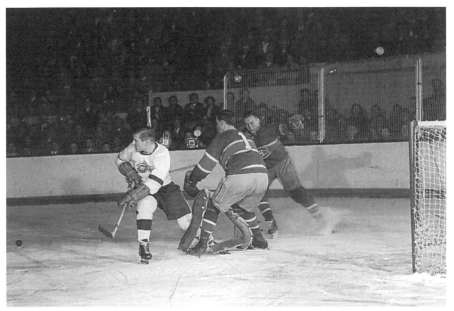

Detroit's Ted Lindsay cuts hard in front of the net to distract Montreal's Jacques Plante as a shot comes quickly toward the Canadiens net. In 23 Stanley Cup final games against the Canadiens, Lindsay scored 12 goals. During the 1955 playoffs, which concluded with Detroit's seven-game final series win over Montreal, the line of Lindsay, Gordie Howe and Earl (Dutch) Reibel combined for 51 points, shattering the Stanley Cup record for points in one playoff year by a forward line. During the 1944 playoffs, Montreal's Maurice (Rocket) Richard, Hector (Toe) Blake and Elmer Lach combined for 48 points.

203

Detroit's Metro Prystai waits at the side of the Montreal net as Canadiens goalie Jacques Plante clears a shot toward teammates Jean-Guy Talbot and Bert Olmstead (15). When the Wings beat the Habs in a seven-game final series in 1955, Montreal lamented that the loss only came about because of the season-long suspension issued to Canadiens star Rocket Richard for attacking Boston's Hal Laycoe and a game official late in the regular season. "He should have got life," Wings captain Ted Lindsay said of Richard.

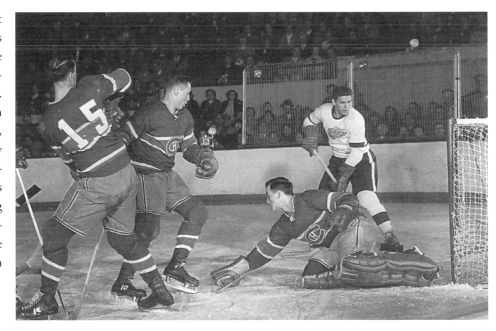

204

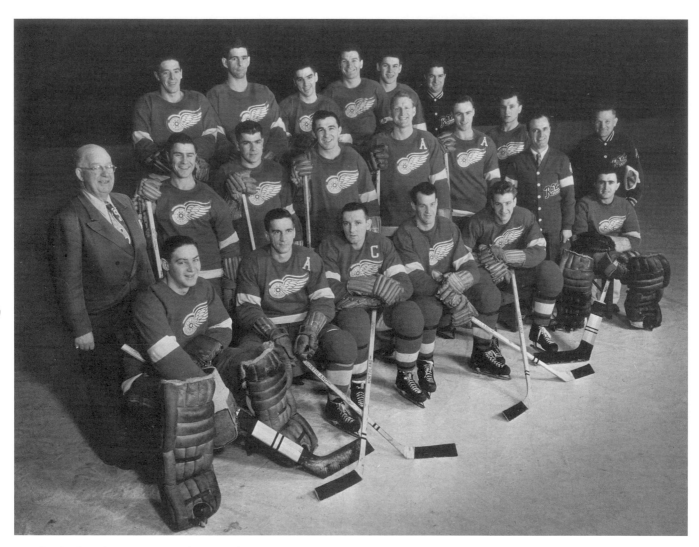

Another look at the 1951-52 Stanley Cup champions. No wonder these guys are smiling. Besides winning the Cup in the minimum eight games, the Wings lost back-to-back games just once all season. Gordie Howe led the NHL with 47 goals and 86 points. Howe added his first Hart Trophy as NHL MVP to his second Art Ross Trophy, while Terry Sawchuk hung up a team-record 12 shutouts, earning the Vezina Trophy. Sawchuk, Howe, Ted Lindsay and defenseman Red Kelly were selected to the NHL's First All-Star Team and all four, along with Sid Abel, played in the NHL All-Star Game.

Detroit goaltender Terry Sawchuk kicks out his right leg to parry a Montreal Canadiens shot away from his net. Sawchuk beat the Canadiens in the 1952, 1954 and 1955 Stanley Cup finals and beat them again with Toronto in 1967. He's one of three goalies in hockey history to defeat the Habs in multiple Stanley Cup final series. Hap Holmes (1916-17 Seattle Metropolitans, 1924-25 Victoria Cougars) and Turk Broda (1946-47 and 1950-51 Toronto Maple Leafs) are the others.

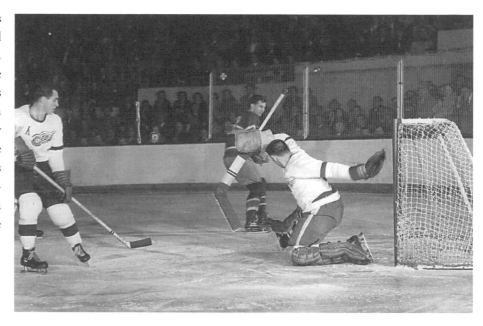

Things often got heated when the Canadiens and Red Wings tangled in the playoffs. Here, referee Bill Chadwick listens as Detroit defence-man Bob Goldham states his case, while Montreal's Henri Richard turns away from the discussion. Often, the rhetoric between the two clubs was as thick as the bad blood. "What chance have we got," Canadiens coach Dick Irvin complained before the 1955 Cup final series between the Habs and Wings. "They've got the players and they've got God on their side. There's nothing left for us."

Montreal's Floyd (Busher) Curry gets ready to snap a shot on goal while Detroit defenceman Al Arbour (5) gets his stick in the shooting lane in order to help out goaltender Glenn Hall. Red Kelly (4) and Bill Dineen can only hope for a positive outcome. Curry collected a goal and two assists as the Canadiens downed Detroit in five games in the 1956 Stanley Cup final. "The Red Wings battled all the way," Montreal coach Toe Blake said after the series. "It was just that we are a little better and we got all the breaks, too."

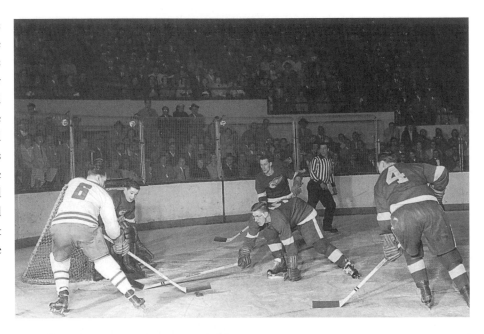

206

Another hard-fought victory over the Red Wings earned, the Montreal Canadiens celebrate their triumph. Jean Beliveau, Bernie (Boom Boom) Geoffrion (5), Doug Harvey (A on sweater) and Jean-Guy Talbot (20) are among the easiest to pick out of the crowd. Beliveau scored twice in Game 4 of the 1956 final series as Montreal won 3-0 at Olympia Stadium to take a 3-1 advantage in the best-of-seven series. Montreal won the set in five games. "I am proud of my players," Wings coach Jimmy Skinner said afterward. "We have a lot of young fellows on our club and I think they did as well as could be expected of them."

Detroit players Marcel Pronovost, Ted Lindsay, Glenn Hall and Gordie Howe move through the traditional handshake with members of the Toronto Maple Leafs following the Wings' five-game Stanley Cup semi-final series in the spring of 1956. The defending champion Wings would be dethroned by Montreal in the final, losing in five games. It was the fourth time in five springs that the Stanley Cup final pitted the Wings against the Canadiens and the first time that the Habs came out on top.

Detroit centre Norm Ullman (7) gets away from his check, Chicago centre Stan Mikita, and whips a shot past Blackhawks goalie Glenn Hall. Ullman was the Blackhawks' personal nightmare during the Stanley Cup playoffs. He collected two hat-tricks and 13 points against Chicago in the 1964 semi-final series between the two teams and established a Stanley Cup record by scoring two goals in five seconds, part of a hat-trick he netted during a 4-2 win over the Blackhawks in Game 5 of their Cup semi-final series on April 11, 1965. Ullman enjoyed two five-point nights against the Blackhawks in postseason play—on April 7, 1963 and again on April 7, 1964.

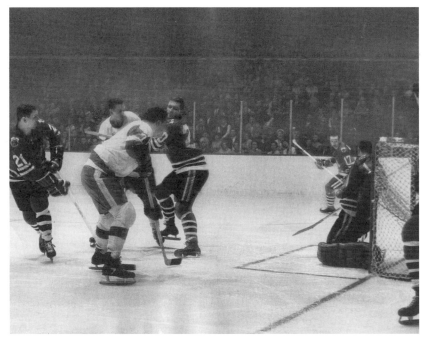

Marcel Pronovost and Ted Lindsay give Detroit coach Tommy Ivan a ride around the rink on their shoulders shortly after the Wings were presented the Stanley Cup following their Game 7 overtime decision over the Montreal Canadiens. Others looking on include Johnny Wilson, to Lindsay's left, and Red Kelly and Detroit GM Jack Adams, to Pronovost's right.



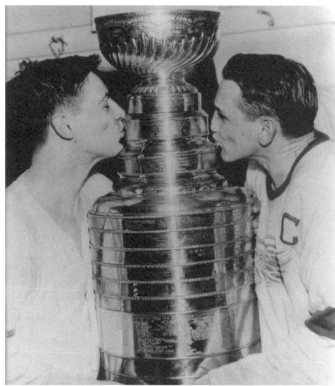

In Game 7 of the 1964 Stanley Cup final, Andy Bathgate scored the Cup-winning goal for the Toronto Maple Leafs in Game 7 of their final series against the Red Wings. In the spring of 1965, the Wings acquired Bathgate in an eight-player deal with the Leafs. The former Hart and Art Ross Trophy winner sparked Detroit to the 1965-66 final against Montreal. Bathgate collected five goals in Detroit's six-game semi-final series win over Chicago that spring. Teammate Gordie Howe credited a switch between him and Bathgate on the Detroit power play for the latter's offensive outburst. "It could be because he and I swapped positions," Howe explained. "I'm back on the point now and Andy was moved up to the wing."

Detroit goalie Terry Sawchuk and Wings captain Sid Abel pucker up and plant simultaneous kisses on the Stanley Cup as the club celebrates its record 1951-52 triumph, which saw the Wings win Lord Stanley's mug in the minimum eight games. That was Abel's last hurrah as a Red Wings player. He moved to Chicago to become player-coach of the Blackhawks in the summer. But it was the first Stanley Cup win for Sawchuk, who entered the hospital immediately after the Cup victory to have bone chips removed from his right elbow. "I didn't say anything about it," Sawchuk explained. "I didn't want people to think I was alibiing in case I didn't play well in the playoffs."

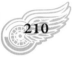

Red Wings goalie Bob Champoux looks through his net at the puck that is behind the cage while Detroit defenceman Marcel Pronovost flattens Chicago forward Ken Wharram. Doug Barkley, Pronovost's defence partner, races in to help his goalie. Just past the five-minute mark of the first period of Game 2 of Detroit's 1964 Stanley Cup semi-final series with the Blackhawks at Chicago Stadium, Terry Sawchuk was felled by a pinched nerve in his shoulder and standby goalie Champoux (pronounced Shom-poo), who'd played the regular season with Cincinnati of the Central League, stepped in and backstopped the Wings to a 5-4 victory in the only game he'd ever play in a Detroit uniform. "What I really needed was confidence," Champoux explained to *Associated Press*. "Gordie Howe came up to me and said, 'Do your best.' That gave me a lift."

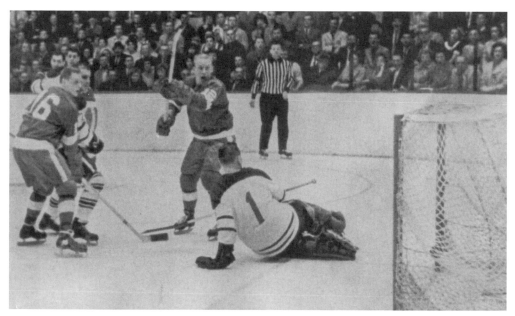

Alex Faulkner (12) raises his stick in celebration of his goal during Detroit's 3-2 win over the Toronto Maple Leafs in Game 3 of the 1963 Stanley Cup final at Olympia Stadium. Teammate Bruce MacGregor (16) watches as the puck sails past Toronto goaltender Johnny Bower. The joy would be short-lived for the Wings, though. This was their only victory over the Leafs in the series, as the reigning Cup champion Toronto defended its title with a five-game triumph.

211

Detroit netminder Roger Crozier is down on the ice with the puck and there's mayhem all around his goal crease during this 1966 Stanley Cup semi-final series. Detroit defenceman Bill Gadsby (4) tangles to the side of the net with Chicago Blackhawks forward Bill Hay (11), while Detroit's Gordie Howe (9) and Pete Goegan exchange differences of opinion with Chicago's Pat Stapleton (12) and Ken Hodge (14). Blackhawks forwards Eric Nesterenko (15) and Bobby Hull appear uncertain as to whether they should join the melee. Detroit won this set from the Blackhawks in six games.

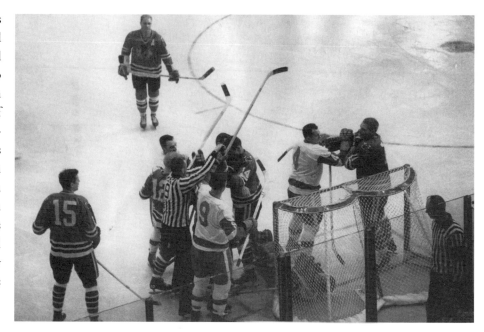

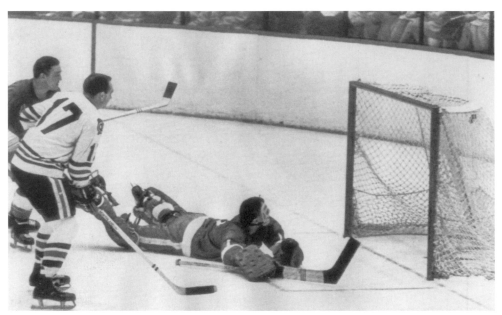

Red Wings netminder Terry Sawchuk can only look up in frustration as this shot from Chicago's Kenny Wharram (17) flies high into his net during Game 6 of their 1964 Stanley Cup semi-final series at Olympia Stadium. Detroit defenceman Marcel Pronovost arrives too late to be of assistance. But Detroit would have the last laugh, winning this game 7-2, and then taking Game 7 at Chicago Stadium by a 4-2 count to advance to the Stanley Cup final against the Toronto Maple Leafs.

This quick shot by Detroit's Parker MacDonald gets past sliding Chicago goalie Glenn Hall during Game 3 of the 1964 Stanley Cup semi-final series, also at Olympia Stadium. Gordie Howe (9) provides traffic for the Wings, while the Chicago defenders are Al MacNeil (19) and Wayne Hillman (20). The Blackhawks would rally for a 3-2 overtime decision in this game to claim a 2-1 series lead, but Detroit eventually captured the set in seven games.

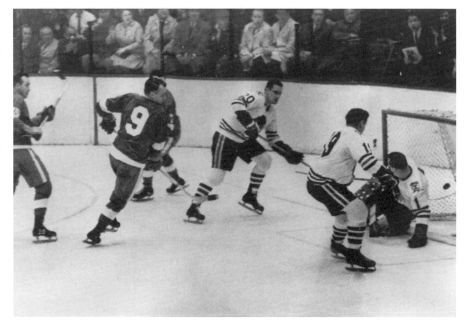

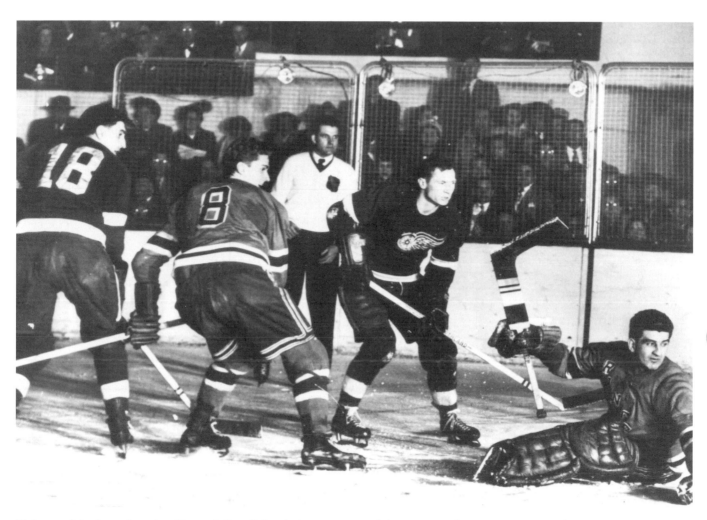

He's out of the frame here, but Detroit's Pete Babando has just snapped the 1950 Stanley Cup-winning goal past New York Rangers netminder Charlie Rayner, who is looking back over his shoulder at the puck headed into his net. Detroit's Gerry (Doc) Couture (18) and George Gee provided traffic in front of the net, while Rangers defenceman Allan Stanley can do little to help out his goalie.

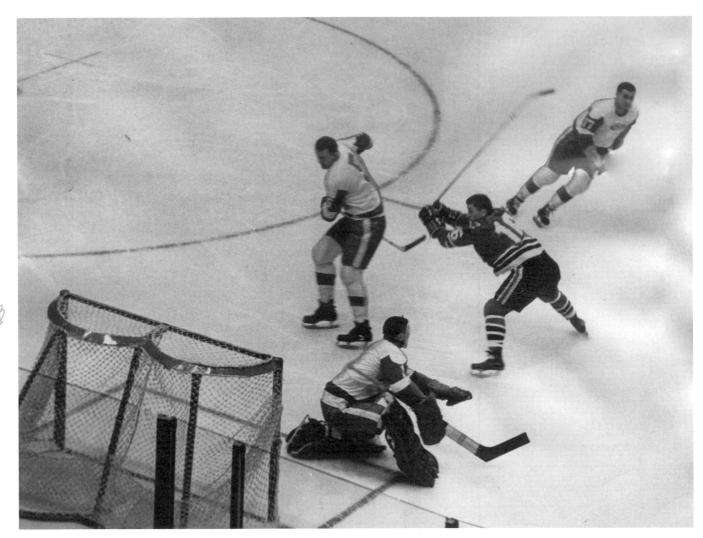

Detroit defenceman Doug Barkley (5) appears to have done something to get under the skin of Chicago forward Chico Maki (16) in front of the Red Wings net. Detroit goalie Terry Sawchuk ignores the fuss as he clears a shot safely away from his net and Red Wings forward Floyd Smith is also oblivious to the tussle as he sets off after the puck. It's no wonder that there would be bad blood between the Wings and Blackhawks. Between 1961-66 the two teams met in five Stanley Cup series, playing in 32 playoff games against each other.

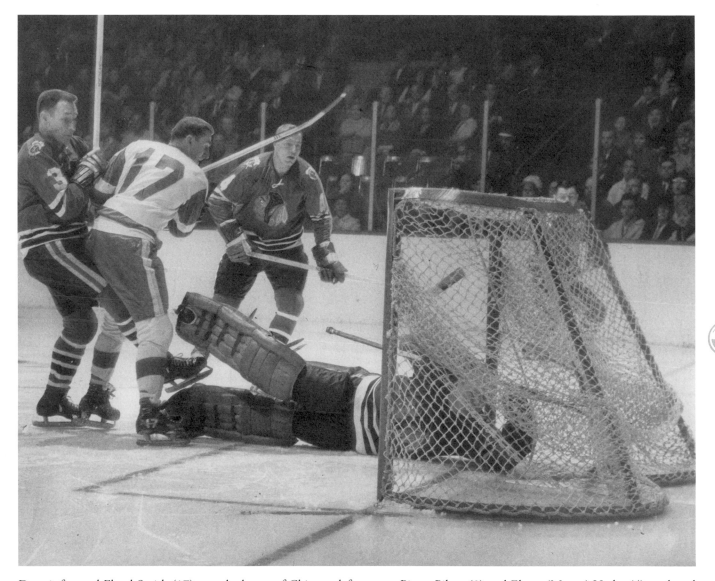

Detroit forward Floyd Smith (17) gets the better of Chicago defencemen Pierre Pilote (3) and Elmer (Moose) Vasko (4) to shovel the puck past sprawling Blackhawks goalie Glenn Hall. Smith opened the scoring in Game 7 of the 1964 semi-final series between the two teams at Chicago Stadium, paving the way for a 4-2 triumph by the Red Wings.

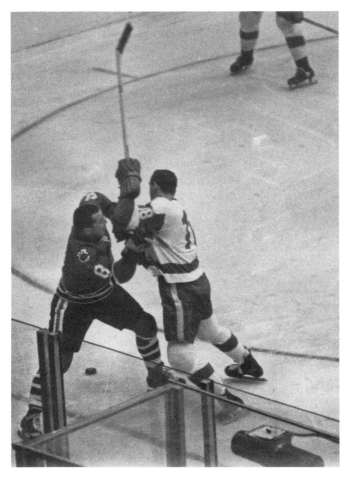

The puck seems immaterial as Detroit defenceman John Miszuk (18) and Chicago forward Murray Balfour (8) duel in the corner during Game 7 of the 1964 Stanley Cup semi-final series, a game won 4-2 by the Red Wings. Miszuk saw his only action as a Red Wing that season, appearing in 42 regular-season games and three playoff contests—Games 6 and 7 of this series and Game 3 of the Cup final series against Toronto.

Marguerite Norris dances with her father James Norris. It was James Norris who purchased the Detroit Falcons franchise in 1932 and renamed the team the Red Wings. When he died in 1952, his daughter took over as president of the franchise and when the Wings captured back-to-back Stanley Cups in 1953-54 and 1954-55, she became the first woman to have her name inscribed on Lord Stanley's mug.

NHL president Clarence Campbell, Red Wings co-owners Bruce and Marguerite Norris and Wings GM Jack Adams study the hardware won by the club, including the Norris Trophy, named in honour of James Norris, Bruce and Marguerite's father, and the Prince of Wales Trophy. The other guys in the photo also now have trophies named after them. The Clarence Campbell Bowl goes to the NHL Western Conference champions, while the Jack Adams Award is presented to the NHL's top coach. Adams was hired to coach the then Detroit Cougars in 1927 and stayed on the job with the team as coach until 1948, while serving as GM from 1927-62.

Things went from bad to worse for Detroit during Game 4 of the 1966 Stanley Cup semi-final against the Montreal Canadiens. En route to a 2-1 loss to the Habs at Olympia Stadium and squandering their 2-0 lead in the best-of-seven set, the Wings also lost goaltender Roger Crozier on this play when Canadiens forward Bobby Rousseau (15) fell and crashed Crozier's left leg against the goalpost. The Detroit netminder suffered a sprained left knee and twisted left ankle. Crozier had to leave the game and was replaced between the pipes by Hank Bassen. With Crozier ailing, Montreal rallied to win the series in six games.

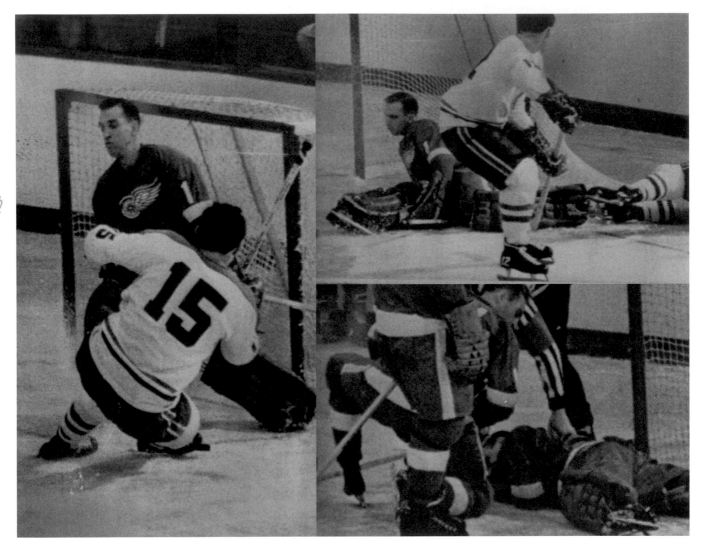

Chicago Blackhawks centre Stan Mikita is airborne thanks to a devastating open-ice body check by Detroit's Bill Gadsby, who is also falling to the ice. Acquired by Detroit in a 1961 trade, Gadsby helped the Wings reach the Stanley Cup final in 1963, 1964 and 1966, all after semi-final triumphs over the Blackhawks (the team he broke into the NHL with back in 1946-47). As a Red Wing, Gadsby became the first NHL defenceman to reach 500 points and on Feb. 5, 1966, he became the first player in NHL history to have played at least 300 games with three different teams (Detroit, Chicago, New York). When he took the ice for his first game of the 1965-66 season, Gadsby joined teammate Gordie Howe and former Boston Bruin Dit Clapper as the NHL's only 20-year men.

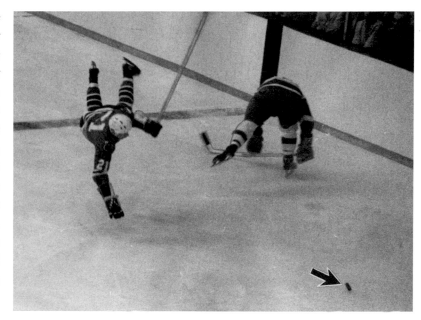

219

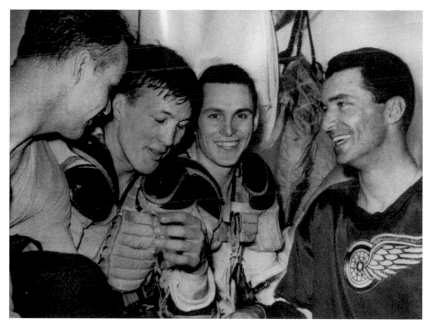

A 5-1 drubbing of the Chicago Blackhawks in Game 4 of the 1966 Stanley Cup semi-finals completed to pull Detroit even in the series at two wins apiece, the game's goal scorers join in celebration. Single-goal scorers Gordie Howe and Bryan Watson (left) and Andy Bathgate (in Detroit sweater) surround two-goal sniper Paul Henderson. Watson, nicknamed Bugsy, was the quiet hero of Detroit's six-game series win, limiting Chicago's powerful 54-goal scorer Bobby Hull to a pair of tallies during the six games. "Yeah, I was out there to bother him," Watson said. "My job was too keep him off the scoresheet."

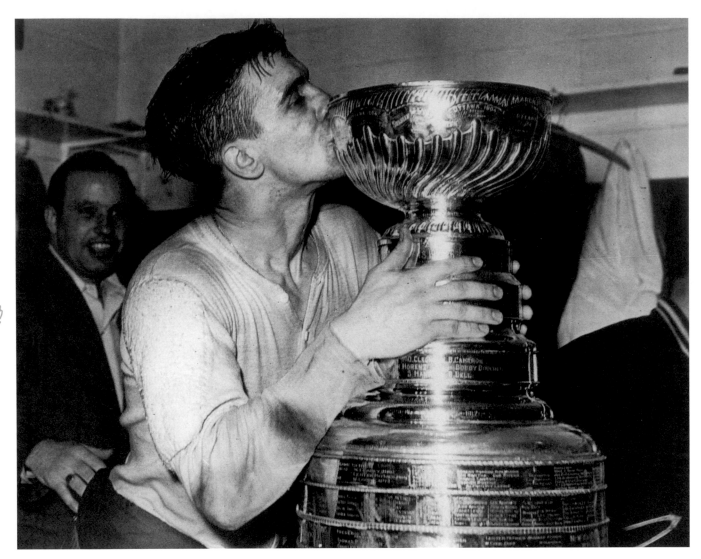

Detroit captain Ted Lindsay plants a big, sweet kiss on the bowl of Lord Stanley's mug. Lindsay played in eight finals and was part of four Cup wins as a Red Wing. Unwittingly, after Detroit's 1954-55 triumph over Montreal, he launched a Stanley Cup tradition that continues today. He scooped the trophy up off the table where it was situated at centre ice and skated around the Olympia Stadium rink so that fans could get a better look. "It was an impulsive sort of thing," Lindsay recalled.

Statistics

Detroit Red Wings Original Six Scoring Statistics (1942-67)

Player	Position	Regular Season					Playoffs				
		GP	G	A	P	PIM	GP	G	A	P	PIM
Gordie Howe	RW	1325	649	852	1501	1436	150	65	91	156	216
Alex Delvecchio	C	1090	328	536	864	294	117	35	67	102	29
Ted Lindsay	LW	862	335	393	728	1423	123	44	44	88	181
Norm Ullman	C	817	294	409	703	526	80	27	47	74	61
Red Kelly	D	846	162	310	472	253	94	16	21	37	35
Sid Abel	C	437	153	224	377	288	64	21	22	43	46
Marcel Pronovost	D	983	80	217	297	717	118	7	23	30	90
Marty Pavelich	LW	634	93	159	252	454	91	13	15	28	74
Joe Carveth	RW	277	96	120	216	41	48	15	14	29	20
Parker MacDonald	C	361	94	122	216	135	50	8	6	14	12
Earl (Dutch) Reibel	C	306	74	141	215	287	35	6	14	20	4
Metro Prystai	C	413	91	123	214	120	43	12	14	26	8
Bruce MacGregor	C	413	97	98	195	104	51	8	14	22	32
Johnny Wilson	LW	379	79	100	179	108	56	12	11	23	7
Syd Howe	C/LW	168	73	106	179	31	19	3	4	7	2
Floyd Smith	RW	290	75	101	176	96	44	12	11	23	16

Player	Position	Regular Season					Playoffs				
		GP	G	A	P	PIM	GP	G	A	P	PIM
Carl Liscombe	LW	186	90	78	168	56	33	12	10	22	4
Mud Bruneteau	RW	160	87	68	155	215	28	9	8	17	4
Jim McFadden	C	253	64	78	142	202	42	7	9	16	26
Vic Stasiuk	LW	330	52	84	136	200	40	10	10	20	14
Bill Quackenbush	D	313	40	89	129	49	47	2	6	8	4
Glen Skov	C/LW	301	62	61	123	263	43	5	6	11	42
Paul Henderson	RW	220	54	59	113	97	33	5	8	13	16
Bill Gadsby	D	323	18	94	112	478	44	2	14	16	78
(Black) Jack Stewart	D	502	30	79	109	704	80	5	14	19	143
Gerry (Doc) Couture	RW	266	61	46	107	156	38	8	7	15	4
Doug Barkley	D	247	24	80	104	382	30	0	9	9	63
Bob Goldham	D	406	11	92	103	182	53	1	12	13	22
Tony Leswick	RW	302	41	59	100	409	41	8	4	12	71
Warren Godfrey	D	528	23	77	100	527	35	1	3	4	36
Murray Armstrong	C	118	35	64	99	148	24	4	6	10	2
Don Grosso	C/LW	112	37	58	95	29	15	5	2	7	10
George Gee	C	186	41	53	94	129	30	4	10	14	22
Adam Brown	LW	120	52	34	86	113	16	2	2	4	10
Pete Horeck	LW	148	38	46	84	149	26	6	8	14	28
Bill Dineen	RW	282	47	35	82	111	37	1	1	2	18
Val Fonteyne	LW	405	29	53	82	14	45	3	8	11	6
Leo Reise Jr.	D	340	21	61	82	261	52	8	5	13	68
Pete Goegan	D	330	18	63	81	329	33	1	3	4	61
Ed Bruneteau	RW	169	39	41	80	33	28	7	6	13	0
Len Lunde	C	210	28	50	78	39	16	3	2	5	0
Andy Bathgate	RW	130	23	55	78	49	12	6	3	9	6
Jim Conacher	C	117	35	38	73	16	19	5	2	7	4
Jimmy Peters Sr.		163	31	41	72	44	24	0	2	2	0
Bil (Flash) Hollett	D	115	30	42	72	89	24	3	6	9	12
Billy McNeill	RW	257	21	46	67	142	4	1	1	2	4
Jack McIntyre	D	145	38	28	66	24	10	2	2	4	0
Gary Bergman	D	189	12	53	65	310	17	0	4	4	18

222

| | | Regular Season | | | | | | Playoffs | | | |
Player	Position	GP	G	A	P	PIM	GP	G	A	P	PIM
Murray Oliver	C	104	31	32	63	24	6	1	0	1	4
Billy Taylor	C	60	17	46	63	35	5	1	5	6	4
Dean Prentice	LW	87	29	31	60	26	12	5	5	10	4
Gary Aldcorn	RW	119	24	35	59	48	6	1	2	3	4
Larry Jeffrey	LW	170	24	34	58	217	23	4	9	13	36
Ron Murphy	LW	90	30	26	56	42	5	0	1	1	4
Harry Watson	LW	94	27	28	55	14	12	2	0	2	0
Roy Conacher	LW	60	30	24	54	6	5	4	4	8	2
Pat Lundy	C	89	28	23	51	22	16	2	2	4	2
Marcel Bonin	LW	107	20	29	49	67	16	0	3	3	4
Eddie Joyal	C	107	20	29	49	10	25	3	3	6	12
Ted Hampson	C	73	13	36	49	4	-	-	-	-	-
Al Johnson	C/RW	103	21	27	48	28	11	2	2	4	6
Hal Jackson	D	177	16	31	47	202	30	1	2	3	31
Nick Mickoski	LW	103	19	27	46	50	4	0	0	0	4
Jerry Melnyk	C	133	19	26	45	14	23	4	0	4	2
Howie Glover	RW	105	28	16	44	90	11	1	2	3	2
Bud Poile	RW	56	21	21	42	6	10	0	1	1	2
Lorne Ferguson	LW	116	22	20	42	38	15	2	2	4	18
Andre Pronovost	LW	120	20	22	42	72	25	5	7	12	32
Pit Martin	C	119	18	23	41	60	17	1	5	6	16
Fern Gauthier	RW	146	14	27	41	63	20	5	1	6	7
Steve Wochy	RW	54	19	20	39	17	6	0	1	1	0
Billy Dea	LW	98	19	19	38	20	5	2	0	2	2
Howie Young	D	167	7	29	36	548	19	2	4	6	46
Max McNab	C	128	16	19	35	24	25	1	0	1	4
Alex Faulkner	C	100	15	17	32	37	12	5	0	5	2
Claude Laforge	LW	128	15	17	32	46	-	-	-	-	-
Gaye Stewart	LW	67	18	13	31	18	6	0	2	2	4
Eddie Wares	D/RW	47	12	18	30	10	10	3	3	6	4
John Bucyk	LW	104	11	19	30	61	15	1	2	3	8
Bert Marshall	D	118	0	29	29	113	12	1	3	4	16

223

| | | Regular Season | | | | | Playoffs | | | | |
Player	Position	GP	G	A	P	PIM	GP	G	A	P	PIM
Jud McAtee	LW	46	15	13	28	6	14	2	1	3	0
Don Morrison	C	53	10	16	26	6	3	0	1	1	0
Leo Boivin	D	85	4	22	26	94	12	0	1	1	16
Jim Morrison	D	70	3	23	26	62	6	0	2	2	0
John McKenzie	RW	75	11	13	24	63	2	0	0	0	0
Ab McDonald	LW	55	8	16	24	8	10	1	4	5	2
Benny Woit	D	262	6	18	24	122	41	2	6	8	18
Reg Sinclair	C/RW	69	11	12	23	36	3	1	0	1	0
Bill Jennings	RW	41	9	14	23	12	4	0	0	0	0
Bep Guidolin	LW	62	12	10	22	78	2	0	0	0	4
Enio Sclisizzi	LW	67	12	9	21	26	13	0	0	0	6
Stephen Black	LW	69	7	14	21	53	13	0	0	0	13
Connie Brown	C	23	5	16	21	6	-	-	-	-	-
Charlie Burns	C	70	9	11	20	32	-	-	-	-	-
Ed Litzenberger	C/RW	32	8	12	20	4	-	-	-	-	-
Albert (Junior) Langlois	D	82	2	18	20	120	14	0	0	0	12
Pat Egan	D	23	4	15	19	40	-	-	-	-	-
Fred Glover	C	61	9	9	18	25	8	0	0	0	0
Leo Labine	RW	72	5	13	18	19	11	3	2	5	4
Earl Seibert	D	43	5	12	17	28	14	2	1	3	4
Ray Cullen	C	27	8	8	16	8	-	-	-	-	-
Don Poile	C	66	7	9	16	12	4	0	0	0	0
Lee Fogolin Sr.	D	125	5	11	16	138	21	0	1	1	26
Rod Morrison	RW	34	8	7	15	4	3	0	0	0	0
Les Douglas	C	34	5	10	15	6	10	3	2	5	2
Al Arbour	D	149	2	13	15	160	13	0	2	2	10
Cully Simon	D	101	4	10	14	112	14	0	1	1	6
Clare Martin	D	114	3	11	14	26	12	0	1	1	0
Doug McCaig	D	83	5	8	13	19	5	0	1	1	4
Barry Cullen	RW	55	4	9	13	23	4	0	0	0	2
Bob Bailey	RW	36	6	6	12	41	5	0	2	2	2
Pete Babando	LW	56	6	6	12	25	8	2	2	4	2

		Regular Season					Playoffs				
Player	Position	GP	G	A	P	PIM	GP	G	A	P	PIM
Gerry Odrowski		138	2	10	12	69	12	0	0	0	6
Lowell MacDonald	LW	46	5	6	11	10	1	0	0	0	2
Marc Boileau	C	54	5	6	11	8	-	-	-	-	-
Tony Bukovich	C/LW	17	7	3	10	6	6	0	1	1	0
Alex Motter	D	50	6	4	10	42	5	0	1	1	2
Brian S. Smith	LW	61	2	8	10	12	5	0	0	0	0
Ron Ingram	D	50	3	6	9	50	-	-	-	-	-
Tom McCarthy	LW	36	4	4	8	8	-	-	-	-	-
Jerry Toppazzini	RW	40	1	7	8	31	-	-	-	-	-
Murray Hall	RW	13	4	3	7	4	2	0	0	0	0
Al Dewsbury	D	34	4	3	7	10	7	0	3	3	12
Real Chevrefils	LW	38	3	4	7	24	-	-	-	-	-
Jimmy Orlando	D	40	3	4	7	99	10	0	3	3	14
Don McKenney	C	24	1	6	7	0	-	-	-	-	-
Bob Wall	D	40	3	3	6	34	7	0	0	0	2
Larry Hillman	D	59	1	5	6	59	13	0	1	1	6
Jim Hay	D	75	1	5	6	22	9	1	0	1	2
Gord Hollingworth	D	93	1	5	6	66	3	0	0	0	2
Lloyd (Red) Doran	C	24	3	2	5	10	-	-	-	-	-
Ebbie Goodfellow	D	11	1	4	5	4	-	-	-	-	-
Bob McCord	D	23	1	4	5	43	-	-	-	-	-
Billy Harris	C	24	1	4	5	6	-	-	-	-	-
Pete Mahovlich	C	37	1	4	5	16	-	-	-	-	-
Lorne Davis	RW	22	0	5	5	2	-	-	-	-	-
Doug Roberts	RW	14	3	1	4	0	-	-	-	-	-
Irv Spencer	D	30	3	1	4	12	15	0	0	0	6
Clare (Rags) Raglan	D	33	3	1	4	14	-	-	-	-	-
Bill Thomson	C/RW	5	2	2	4	0	2	0	0	0	0
Len Haley	RW	30	2	2	4	14	6	1	3	4	6
Roly Rossignol	RW	9	1	3	4	6	-	-	-	-	-
Ken Kilrea	LW	14	1	3	4	0	2	0	0	0	0
Chuck Holmes	RW	23	1	3	4	10	-	-	-	-	-

225

		Regular Season					Playoffs				
Player	Position	GP	G	A	P	PIM	GP	G	A	P	PIM
Lou Jankowski	C/RW	23	1	3	4	0	1	0	0	0	0
Larry Wilson	C	21	0	4	4	12	4	0	0	0	0
John MacMillan	RW	23	0	4	4	6	4	0	1	1	2
Keith Allen	D	28	0	4	4	8	5	0	0	0	0
Lou Marcon	D	60	0	4	4	42	-	-	-	-	-
Rollie McLenahan	D	9	2	1	3	10	2	0	0	0	0
Nakina (Dalton) Smith	C	10	1	2	3	0	-	-	-	-	-
Leo Gravelle	RW	18	1	2	3	6	-	-	-	-	-
Art Stratton	C/LW	5	0	3	3	2	-	-	-	-	-
Hy Buller	D	9	0	3	3	6	-	-	-	-	-
Billy Reay	C	4	2	0	2	0	-	-	-	-	-
John Holota	C	15	2	0	2	0	-	-	-	-	-
Butch McDonald	C/LW	3	1	1	2	0	-	-	-	-	-
Carl (Winky) Smith	RW	7	1	1	2	2	-	-	-	-	-
Jimmy Peters Jr.	C	9	1	1	2	2	-	-	-	-	-
Stu McNeill	C	10	1	1	2	2	-	-	-	-	-
Bob Falkenberg	D	16	1	1	2	10	-	-	-	-	-
Larry Thibeault	LW		4	0	2	2	2	-	-	-	-
Hec Lalande	C	12	0	2	2	2	-	-	-	-	-
John Miszuk	D	42	0	2	2	30	3	0	0	0	2
Cummy Burton	RW	43	0	2	2	21	3	0	0	0	0
Marc Reaume	D	47	0	2	2	10	2	0	0	0	0
Hank Bassen	G	99	0	2	2	28	5	0	0	0	0
Terry Sawchuk	G	721	0	2	2	138	84	0	0	0	26
Joe Fisher	RW	1	1	0	1	0	1	0	0	0	0
Dick Behling	D	2	1	0	1	2	-	-	-	-	-
Bernie Ruelle	LW	2	1	0	1	0	-	-	-	-	-
Bill McCreary		3	1	0	1	2	-	-	-	-	-
Frank Bennett	LW/D	7	1	0	1	2	-	-	-	-	-
Larry Zeidel	D	28	1	0	1	22	5	0	0	0	0
Wayne Muloin	D	3	0	1	1	2	-	-	-	-	-
Ron Harris	D	4	0	1	1	7	-	-	-	-	-

226

Player	Position	Regular Season					Playoffs				
		GP	G	A	P	PIM	GP	G	A	P	PIM
Gerry Ehman	RW	6	0	1	1	4	-	-	-	-	-
Cliff Simpson	C	6	0	1	1	0	2	0	0	0	2
Tony Licari	RW	9	0	1	1	0	-	-	-	-	-
Gerry Brown	LW	10	0	1	1	2	-	-	-	-	-
Noel Price	D	20	0	1	1	6	-	-	-	-	-
Gus Mortson	D	36	0	1	1	22	-	-	-	-	-
Gerry Abel	LW	1	0	0	0	0	-	-	-	-	-
Craig Cameron	RW	1	0	0	0	0	-	-	-	-	-
Dwight Carruthers	1	0	0	0	0	-	-	-	-	-	
Lude Check	LW	1	0	0	0	0	-	-	-	-	-
Jimmy Franks	G	1	0	0	0	0	-	-	-	-	-
Harrison Gray	G	1	0	0	0	0	-	-	-	-	-
Dick Healey	D	1	0	0	0	2	-	-	-	-	-
Earl Johnson	LW	1	0	0	0	0	-	-	-	-	-
Brian Kilrea	C	1	0	0	0	0	-	-	-	-	-
Real Lemieux	LW	1	0	0	0	0	-	-	-	-	-
Dave Lucas	D	1	0	0	0	0	-	-	-	-	-
Tom McGrattan	G	1	0	0	0	0	-	-	-	-	-
Bill Mitchell	D	1	0	0	0	0	-	-	-	-	-
Edward Nicholson	D	1	0	0	0	0	-	-	-	-	-
Nels Podlosky	LW	1	0	0	0	0	7	0	0	0	4
Dave Rochefort	C	1	0	0	0	0	-	-	-	-	-
Pat Rupp	G	1	0	0	0	0	-	-	-	-	-
Bob Solinger	RW/LW	1	0	0	0	0	-	-	-	-	-
Barry Sullivan	RW	1	0	0	0	0	-	-	-	-	-
Ross (Lefty) Wilson	G	1	0	0	0	0	-	-	-	-	-
Ralph (Red) Almas	G	2	0	0	0	0	5	0	0	0	0
Norm Corcoran	C/RW	2	0	0	0	0	-	-	-	-	-
Doug Harvey	D	2	0	0	0	0	-	-	-	-	-
Red Kane	D	2	0	0	0	0	-	-	-	-	-
Wayne Rivers	RW	2	0	0	0	0	-	-	-	-	-
Ted Taylor	LW	2	0	0	0	0	-	-	-	-	-

| | | Regular Season | | | | | | Playoffs | | | | |
Player	Position	GP	G	A	P	PIM		GP	G	A	P	PIM
Carl Wetzel	G	2	0	0	0	0		-	-	-	-	-
Ed Zeniuk	D	2	0	0	0	0		-	-	-	-	-
Rudy Zunich	D	2	0	0	0	2		-	-	-	-	-
Gilles Boisvert	G	3	0	0	0	0		-	-	-	-	-
Bart Crashley	D	3	0	0	0	2		-	-	-	-	-
Bo Elik	LW	3	0	0	0	0		-	-	-	-	-
Dave Gatherum	G	3	0	0	0	0		-	-	-	-	-
Roger Lafreniere	LW	3	0	0	0	4		-	-	-	-	-
Vic Lynn	D/LW	3	0	0	0	4		-	-	-	-	-
Howie Menard	C	3	0	0	0	0		-	-	-	-	-
Butch Paul	C	3	0	0	0	0		-	-	-	-	-
Bob Perreault	G	3	0	0	0	0		-	-	-	-	-
Thain Simon	D	3	0	0	0	0		-	-	-	-	-
Doug Baldwin	D	4	0	0	0	0		-	-	-	-	-
Gary Doak	D	4	0	0	0	12		-	-	-	-	-
Gary Jarrett	LW	4	0	0	0	0		-	-	-	-	-
Hugh Millar	D	4	0	0	0	0		1	0	0	0	0
Dennis Olson	C	4	0	0	0	0		-	-	-	-	-
Ed Sandford	LW	4	0	0	0	0		-	-	-	-	-
Jim Watson	D	4	0	0	0	6		-	-	-	-	-
Ian Cushenan	D	5	0	0	0	4		-	-	-	-	-
John Hendrickson	D	5	0	0	0	4		-	-	-	-	-
Guyle Fielder	C	6	0	0	0	2		4	0	0	0	0
Calum MacKay	LW	6	0	0	0	0		-	-	-	-	-
Normie Smith	G	6	0	0	0	0		-	-	-	-	-
Ed Stankiewicz	C	6	0	0	0	2		-	-	-	-	-
Dunc Fisher	RW	8	0	0	0	0		-	-	-	-	-
Lloyd Haddon	D	8	0	0	0	2		1	0	0	0	0
John Sherf	LW	8	0	0	0	6		-	-	-	-	-
Gordon Sherritt	D	8	0	0	0	12		-	-	-	-	-
Bob Dillabough	C	9	0	0	0	4		6	0	0	0	0
Gene Achtymichuk	C	12	0	0	0	0		-	-	-	-	-

	Regular Season						Playoffs				
Player	Position	GP	G	A	P	PIM	GP	G	A	P	PIM
Bill Folk	D	12	0	0	0	0	4	-	-	-	-
George Gardner	G	12	0	0	0	0	-	-	-	-	-
Dale Anderson	D	13	0	0	0	6	2	0	0	0	0
Dennis Riggin	G	18	0	0	0	0	-	-	-	-	-
Murray Costello	C	27	0	0	0	4	4	0	0	0	0
Connie Dion	G	38	0	0	0	0	5	0	0	0	0
Johnny Mowers	G	57	0	0	0	2	11	0	0	0	0
Gord Strate	D	61	0	0	0	34	-	-	-	-	-
Glenn Hall	G	148	0	0	0	16	15	0	0	0	10
Roger Crozier	G	207	0	0	0	14	22	0	0	0	2
Harry Lumley	G	324	0	0	0	40	54	0	0	0	12
Bob Champoux	G	-	-	-	-	-	1	0	0	0	0
Gord Haidy	RW	-	-	-	-	-	1	0	0	0	0
Doug McKay	LW	-	-	-	-	-	1	0	0	0	0
Gilles Dube	LW	-	-	-	-	-	2	0	0	0	0
Steve Hrymnak	D	-	-	-	-	-	2	0	0	0	0
Gerry Reid	C	-	-	-	-	-	2	0	0	0	2
Fido Purpur	RW	-	-	-	-	-	7	0	1	1	4

Detroit Red Wings Original Six Goaltending Statistics (1942-67)

	Regular Season						Playoffs					
Goaltender	GPI	MIN	GA	SO	GAA	W-L-T	GPI	MIN	A	SO	GAA	W-L
Terry Sawchuk	734	43029	1754	85	2.44	348-240-137	84	5465	209	11	2.51	47-37
Harry Lumley	324	19432	885	26	2.73	163-107-54	54	3416	129	6	2.26	24-30
Roger Crozier	207	12058	574	19	2.85	94-81-27	22	1214	54	1	2.59	9-11
Glenn Hall	148	8880	317	17	2.14	74-45-29	15	904	43	0	2.86	6-9
Hank Bassen	99	6819	274	3	2.99	34-39-19	5	274	11	0	2.41	1-3
Johnny Mowers	57	730	153	6	3.13	25-20-12	11	719	27	2	2.25	8-3
Connie Dion	38	2280	119	1	3.13	23-11-4	5	300	17	0	3.40	1-4
Jimmy Franks	17	1020	69	1	4.06	12-23-7	-	-	-	-	-	-

Goaltender	GPI	MIN	GA	SO	GAA	W-L-T	GPI	MIN	A	SO	GAA	W-L
George Gardner	24	1154	69	0	3.59	7-8-2	-	-	-	-	-	-
Dennis Riggin	18	985	54	1	3.29	6-10-2	-	-	-	-	-	-
Normie Smith	6	360	18	0	3.00	4-1-1	-	-	-	-	-	-
Dave Gatherum	3	180	3	1	1.00	2-1-0	-	-	-	-	-	-
Bob Perreault	3	180	9	1	3.00	2-1-0	-	-	-	-	-	-
Tom McGrattan	1	8	0	0	0.00	0-0-0	-	-	-	-	-	-
Ross (Lefty) Wilson	1	16	0	0	0.00	0-0-0	-	-	-	-	-	-
Pat Rupp	1	60	4	0	4.00	0-1-0	-	-	-	-	-	-
Harrison Gray	1	40	5	0	7.50	0-1-0	-	-	-	-	-	-
Ralph (Red) Almas	2	120	8	0	4.00	0-1-1	5	263	13	0	2.97	1-3
Carl Wetzel	2	32	4	0	7.50	0-1-0	-	-	-	-	-	-
Gilles Boisvert	3	180	9	0	3.00	0-3-0	-	-	-	-	-	-
Bob Champoux	-	-	-	-	-	-	1	55	4	0	4.36	1-0

Detroit Red Wings Original Six Coaching Statistics (1942-67)

	Regular Season					Playoffs			
Coach	GP	W	L	T	PCT	GP	W	L	PCT
Sid Abel	663	275	283	105	.493	65	29	32	.446
Tommy Ivan	470	262	118	90	.653	67	36	31	.537
Jack Adams	260	124	93	43	.559	39	18	21	.461
Jimmy Skinner	247	123	78	46	.591	26	14	12	.538

Index

232

233

234

Photo Credits:

Detroit Times Archive: 19, 21-27, 29-33, 37, 41, 42, 44-47, 48-67, 74-93, 97-116, 119-141, 143-146, 149-172, 177-182, 187-192, 194, 195, 197, 198, 200-203, 205, 206, 211, 212, 214, 215, 218, 219;

Dwayne LaBakas: 20, 43, 71-73, 142, 143, 191, 209, 210, 213;

Marcel Pronovost: 6, 14, 17, 18, 28, 34-38, 47, 68, 71, 73, 93, 94, 164, 169, 172, 176, 183, 184, 193, 196, 199, 204, 207, 208, 216, 217, 237.

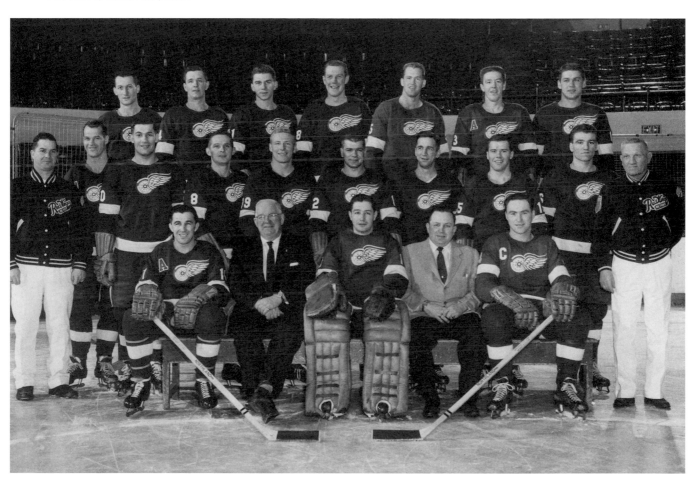

Acknowledgements

THE AUTHOR WISHES TO THANK Dan Wells, Chris Andrechek and Tara Murphy of the Biblioasis team for their tireless work in bringing this project to fruition. As well, thanks to Dwyane LaBakas and Marcel Pronovost for helping fill in the gaps in this photo story. And most of all, thanks to the *Detroit Times* for years of sensational photos that brought hockey's most memorable era to life.

CURRENTLY THE SPORTS COLUMNIST for the *Windsor Star*, Bob Duff has covered the NHL since 1988 and is a contributor to *The Hockey News* and MSNBC. com. Duff's book credits include: *Marcel Pronovost: A Life in Hockey*, *The China Wall: The Timeless Legend of Johnny Bower*, *Hockey Dynasties*, *Without Fear*, *Nine: Salute to Mr. Hockey*, *On the Wing: A History of the Windsor Spitfires*, and *The Hockey Hall of Fame MVP Trophies and Winners*. Duff lives in Cottam, Ontario, with his wife Shira and daughter Cecilia.